A Sprinkling of Gold

The Lacquer Box Collection
of Elaine Ehrenkranz

Barbra Teri Okada

A Sprinkling of Gold

The Lacquer Box Collection
of Elaine Ehrenkranz

Barbra Teri Okada

The Newark Museum

©1983 The Newark Museum
Published by the Newark Museum
49 Washington Street
P.O. Box 540
Newark, New Jersey 07101

Designed and Produced by
Michael B. Glass & Associates, Inc.
53 Bacon Road
P.O. Box 245
Old Westbury, New York 11568

Color Separations by
Spectra Graphic, Inc.

Type set in Souvenir by
Michael B. Glass & Associates. Inc.

Printed in the U.S.A. by
Frank C. Toole & Sons, Inc.,

Photographs of The Collection
were taken by Michael B. Glass
and reproduction rights are copyrighted.

**Library of Congress Cataloging
in Publication Data**

Okada, Barbra Teri.
 A sprinkling of gold.

 Bibliography: p.
 Includes index
 1. Lacquer boxes — Japan — Exhibitions.
 2. Ehrenkranz, Elaine — Art collections — Exhibitions.
 3.Lacquer boxes — Private collections — United States — Exhibitions.
 I. Newark Museum II. Title.
NK9900.7.J3033 1983 745.7′2 83-13516
ISBN 0-932828-10-8
ISBN 0-932828-11-6 (pbk.)

Table Of Contents

"Lacquerware decorated in gold is not something to be seen in a brilliant light, to be taken in at a single glance; it should be left in the dark, a part here and a part there picked up by a faint light. Its florid patterns recede into the darkness, conjuring in their stead an inexpressible aura of depth and mystery, of overtones but partly suggested. The sheen of the lacquer, set out in the night, reflects the wavering candlelight, announcing the drafts that find their way from time to time into the quiet room, luring one into a state of reverie. If the lacquer is taken away, much of the spell disappears from the dream world built by that strange light of candle and lamp, that wavering light beating the pulse of the night. Indeed the thin, impalpable, faltering light, picked up as though little rivers were running through the room, collecting little pools here and there, lacquers a pattern on the surface of the night itself." [1]

Tanizaki Jun'ichirō
(1886-1965)

Note:

[1] Jun'ichirō, Tanizaki. *In Praise of Shadows*. Translated by Thomas J. Harper and Edward G. Seidensticker, New Haven, Conn: Leete's Island Books, 1977, p.14.

Dedication

To Charles A. Greenfield who really started it all; to Ishizawa Masao who always helped and brought the realization of a dream; and to Reiko Suzuki without whom this project could not have been attempted nor completed.

Foreword

The Newark Museum is proud to sponsor the exhibition and catalogue, *A Sprinkling of Gold: The Lacquer Box Collection of Elaine Ehrenkranz*. The extraordinary quality of workmanship and the sophistication of design shown in the boxes in the Ehrenkranz collection demonstrate the highest expressions of this art form. The techniques used in Japanese lacquer are still little understood in the West. Barbra Teri Okada's well researched and finely written introductory essay as well as her comments on individual pieces will help greatly to advance knowledge in this field. Mrs. Okada, who is Special Consultant to the Newark Museum's Japanese collection, has had unique opportunities to document lacquer production in modern times as well as to research the entire history of lacquer craftsmanship in Japan. The Museum is indebted to Mrs. Okada for her devoted work in this exhibition and catalogue and, of course, to Mrs. Ehrenkranz for allowing us to display her exquisite collection.

Samuel C. Miller
Director

Preface

Two childhood loves converged to inspire the formation of my collection — a love for painting and a love for beautiful boxes of all varieties, shapes, and materials. When I discovered painting in my early teens, I was, without realizing it, immediately drawn to the Japanese style of art. A few years later, I became an art student at Cornell University and began painting in earnest. Again, not being fully aware of it, I learned principles of design and aesthetics based on Oriental concepts. Simplicity of design, asymmetry, and restraint all played major roles in my art education.

Years later, when I saw my first Japanese lacquer box, I recall the thought that came to mind —"This has to be the ultimate box!" Never before had I experienced such a perfect union of aesthetics and function. Moreover, I had never seen such technical mastery. It was only a short step from these realizations to my decision to form a collection of these remarkable objects.

As I delved deeper into collecting lacquer boxes, I began to realize what a complex, multifaceted field it was. There were boxes for every need and occasion — tea ceremony, incense, inkstone, letter, cosmetic, and storage boxes, to mention only a few. I found that fascinating legends, many daily activities, and all aspects of nature were represented on boxes. Their tops frequently showed designs that flowed over the sides in continuous patterns. On the undersides of the lids often appeared more exquisite designs rendered in even finer techniques than those surfaces that first met the eye. In short, collecting Japanese lacquer boxes opened up an entire world to me, a world of such depth and dimension that it demanded exploration on many levels.

I bought boxes wherever I could find them. I was always sure of my eye, but through exposure and study I had to learn what was specifically germane to the lacquer aesthetic. Through the years, my taste has changed very little. I am still drawn above all to subtle, imaginative, and unusual pieces. I am far more intrigued by works that create a certain mood and mystery than by those that are remarkable for their technical virtuosity. However, these are certain styles, techniques, and color combinations, that I have begun to appreciate only after gaining some insight into their significance in the historical and aesthetic development of Japanese lacquer art.

I have rarely bought a box that has not reflected my taste. It was not my goal to collect what others considered the most beautiful boxes in the world, but rather to collect fine examples that expressed my personal preferences.

There is always a great sense of satisfaction upon finding a box after searching for years, as in the case of my *suzuri-bako* by Shibata Zeshin. I have always felt that Zeshin was one of the rare geniuses in his field, and I wanted a fine example of his work. I discreetly sent out feelers but nothing surfaced. Finally, just as I was about to despair, an enterprising dealer called from Japan to tell me that my Zeshin had been found. I bought it on faith and was more than pleased when I was presented with it. It certainly ranks as one of my favorites. I have seen more exquisite works by Zeshin — for example, the *inrō* depicting winter cherries in this collection — but I have not seen one that has more appeal for me.

I feel particularly fortunate that Barbra Teri Okada accepted the challenge of writing this book. One of the most confounding aspects in the study of lacquer is the perpetuation of incorrect information, and Ms. Okada will not accept as fact any data that have not met the strict standards of her own research. The major purpose of this book is to add to the body of knowledge of Japanese lacquer art by helping to correct misconceptions and inaccuracies concerning techniques and the dating of styles. The boxes in my collection have provided a vehicle for accomplishing these goals.

Whenever a collection of art is assembled, it is necessary to depend on the assistance of many people. I especially want to express my appreciation to my friend, Edith Kurstin, a dealer whose knowledge, energy, and enthusiasm were essential in helping me form my collection. Special thanks to Michael Glass for the tasteful design and layout of this book and for his outstanding photography, which skillfully captures the essence of the very difficult medium of lacquer. I am most grateful to Valrae Reynolds, Curator of the Oriental Collections of the Newark Museum, for arranging the exhibition and to Samuel C. Miller, Director of the Newark Museum, for his approval and support in this project.

Most of all, I want to thank my husband, Joel, whose enthusiasm was heartening and whose pride in my venture inspired me to persevere. Since Joel was born in Newark, the exhibition's being held at the Newark Museum becomes even more meaningful for us.

A thought to leave with you — Frederick Meinertzhagen wrote in the preface to his book *The Art of the Netsuke Carver*, "Every work of art is a unique thing worthy of preservation. Its owner, as temporary custodian, is entrusted with protecting it as far as possible from damage and decay, and handing it on to posterity for others to enjoy." I strongly adhere to this philosophy and feel gratified to have children who have a deep appreciation and love of Japanese lacquer art. It is my hope that they, and collectors unknown to me, will derive as much pleasure as I have from being temporary custodians of these lacquer treasures.

Elaine Ehrenkranz

Acknowledgements

About three years ago Elaine Ehrenkranz and I were discussing the future of lacquer collecting in the United States and the fact that this particular art form was one of her earliest loves. I suggested that an exhibition of her collection would be an educational opportunity for those interested in lacquer. This exhibition and the accompanying catalogue are the results of that enthusiastic exchange.

As very little information on lacquer and its processing is available in English, almost all research had to be done in Japan. During the course of two and a half years, with extensive communication and five trips to that country, I have received the support of many people who helped supply the necessary information for this undertaking.

In Tokyo: Hirokazu Arakawa, Curator of Lacquers at the Tokyo National Museum, who gave generously of his time and whose manner of teaching through the museum's objects is stamped indelibly on my mind; Kunio Miyata, Chief of Cultural Projects of the Nihon Keizai Shimbun, who arranged for his assistant Katsumi Suzuki to guide me to sources otherwise unavailable, which included visits with Matsuda Gonroku, one of Japan's National Living Treasures in Lacquer; to Masao Ishizawa, retired director of the Yamato Bunkakan Museum in Nara, a friend of mine for years who has guided me constantly; Yoshikuni Taguchi of the Lacquer department at the Tokyo University of Arts, who introduced me to his staff and allowed me to visit classes; Masahiro Masuda, also of the Lacquer Department, who made available the library facilities at the University's Museum: Hachirō Ōuchi, president of the Fujii Urushi Kogie Company Ltd., who generously donated the photographs on which the sketches have been based, supplied company charts on terminology, as well as allowed me considerable time with the head of the factory. Takashi Maruyama, head of the Japan Lacquer Association, and a fine artist, who spent a great deal of time with me and who also introduced me to Mr. Ōuchi; Tadao Akuta, the Vice-Director of the Hatakayama Museum, for allowing me new photography of his famed Zeshin inrō storage box and for arranging through Riuji Hisama of the Otsuka Kogeisha Co. Ltd. for the photos used in entries 34 and 35; Jino Sadao of the Tokyo Museum of Science and Natural History and Sugiha Nobuhiku, Chief Curator of the Crafts Department, the National Museum of Modern Art, for the time and effort extended on my behalf.

In Wajima: Kazuo Yamagishi of the Wajima city government, who took me to the studio's of several

craftsmen where I was allowed to watch them work; Isaburo Kado, a noted artist from that same area, who accompanied us part of the time.

In Kyoto: To my teacher, Kyōhei Mizuuchi, a great artist, who has been guiding me through various stages of lacquering these past years and whose prize-winning piece (cat. no. 56) will always be remembered; Yoshio Shirai, who suppled special technical information on *nashi-ji* and contributed the sample board for the exhibition; and to my dear friend of many years Emiko Takeda, who escorted me and arranged for countless visits to various artists in the Kyoto area. I wish to express special thanks for your patience and tenacity.

In the United States: Many thanks to Charles A. Greenfield, who has been my teacher for eleven years and to whom I have a great debt; Ann Yonemura, whose catalogue was a source of information and whose enthusiasm was and is an inspriation; my long suffering secretary Annette Phillips, who struggled through countless typings; my assistant Naoko Yaegashi, who caught things no one else did; and my husband David, who perservered through it all. I am extremely grateful to Michael B. Glass whose incredible photography and fine sense of design, together with his associates, in particular Frances Zeman, technical consultant, Dori Kohlberg, typographer, and Marla Deutsch, artist and illustrator, has made this publication all Elaine Ehrenkranz hoped it would be.

Most importantly, to Samuel Miller, director of the Newark Museum, Valrae Reynolds, the curator of the Oriental Collection, and to all the people at the Museum who have helped to bring this exhibition to its final hours, I extend my deepest appreciation for this opportunity.

Finally, a special thanks again to Reiko Suzuki for her unlimited assistance and to all those who have contributed to this publication and who for various reasons, were not mentioned.

B.T.O.

Introduction

Japanese lacquer, with its heavy applications of pure gold on a precisely worked, elegantly finished surface, has long fascinated the world. The use of gold for decorative purposes has symbolized wealth and power in virtually every culture. Perhaps the ostentatious use of the metal reached its height in Japan during the sixteenth century, when a famous general had a portable teahouse covered in gold leaf and furnished it with accoutrements for the tea ceremony cast in the same radiant element. The purity and abundance of the sprinkled gold on gifts of Japanese lacquer to the court of China, stimulated the greedy Khans to attempt the invasion of Japan in A.D. 1274 and again in 1281. More recently, Westerners have been attracted to lacquer by its elegant designs and special qualities of rich color, brilliant luster, and high degree of craftsmanship.

The study of Japanese lacquer is not an entity unto itself. The technical evolution of this art form must be examined in light of the prevailing economic and social conditions of each period, and the pictorial imagery of lacquer decoration studied as a reflection of the country's history, literature, and cultural inheritance. Because most of the material devoted to the manufacture and history of Japanese lacquer is in the Japanese language, and largely inaccessible to Westerners, few non-Japanese understand the extraordinary skill, knowledge, patience, and time necessary for the most experienced artist to complete even one small object.

The basic difference between Japanese lacquer, most often referred to in this text as *urushi*, and lacquer as the West understands it is that the lacquer we are most familiar with *dries*, while *urushi hardens*. The former substance is a resinous material suspended in a solution such as alcohol, which dries through the evaporation of the solvent; Japanese lacquer is a nonresinous sap derived from the *Rhus verniciflua* tree, a member of the genus that includes poison ivy, poison oak, and poison sumac. Touching raw, viscous lacquer, or sometimes just inhaling its fumes, will often result in a toxic reaction that causes an external or internal rash (or both) for those who have not become desensitized. This unpleasant aspect of the medium makes it unpopular with many artisans and discourages those who would otherwise use it.

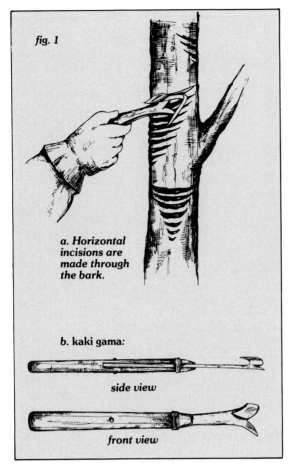

fig. 1

a. Horizontal incisions are made through the bark.

b. kaki gama:

side view

front view

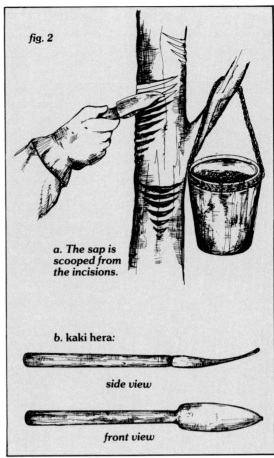

fig. 2

a. The sap is scooped from the incisions.

b. kaki hera:

side view

front view

Urushi is gathered by tapping the tree when it is about seven to ten years old, and in some areas when it is as young as five years. Deep horizontal incisions are made through the bark with a special scoring instrument called a *kaki gama* to reach the channel or core which contains the sap (figs. 1a and b). The sap oozes out very slowly and is scooped from the tree with a curved instrument called a *kaki hera* (figs. 2a and b). (It takes about twenty-four hours for enough of the material to accumulate for collection.) About every five days new shorter cuts are created below the original ones, in an outward sequence, resembling a series of inverted triangles (figs. 1 and 2). Raw lacquer is harvested several times a season from late spring to early fall, with the average tree producing only six to seven ounces (about thirty cc.) per season. Upon exposure to light and air, the fresh sap, translucent and grayish in color, thickens and darkens rapidly.

Urushi has unique physical and chemical properties. Although it liquifies in dry heat and coagulates in cold, it hardens best at a temperature ranging from 75° to 85° F. At about 108° F. it again becomes soft; then, if reheated to about 180° F., it hardens rather quickly. *Urushi* is erratic, but under controlled conditions a thin coat will usually dry to the touch in about six hours. The curing time is longer in the winter than in the summer and is the shortest in the rainy season. The sap is composed of ten to thirty-five percent water, small percentages of albumen and gum arabic, and sixty to eighty percent of a catechu substance called urushiol.[1] *Urushi* requires a humidity of approximately eighty percent, plus a temperature ranging from approximately 65° to 85° F. to harden thoroughly, since the chemical reaction between the urushiol and the enzyme laccase, found in the albumen, requires external moisture to solidify. To create a moist environment, a wet box, or drying cabinet, called a *furo* is utilized. The inside of the box is hung with wet cloths (or water is sprayed on its walls), and the lacquered objects

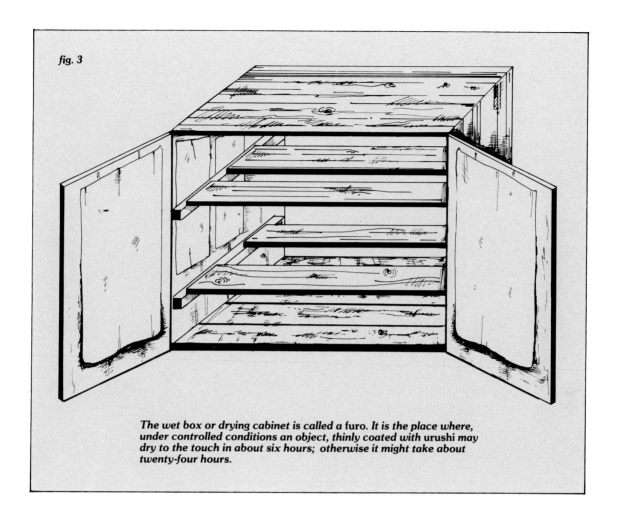

fig. 3

The wet box or drying cabinet is called a furo. It is the place where, under controlled conditions an object, thinly coated with urushi may dry to the touch in about six hours; otherwise it might take about twenty-four hours.

are then placed on shelves within it (fig. 3). The enclosed *furo* also keeps the dust off the moist, still sticky coating. The *urushi* begins a hardening process that will make it dry to the touch in about twenty-four hours, however, it will not become chemically inert, nor completely hard until some time later.

The grade of raw *urushi*, is predicated upon the type of soil in which the tree grew, the climatic conditions during its growth, its age, the season in which it was tapped, and the part of the tree from which the sap came. High-quality *urushi* is imported to Japan from China and a small amount comes from Korea, with Vietnam, Cambodia, and Burma providing a lesser quality. The best, and the most homogeneous in nature, is Japanese and is taken from the middle part of the main trunk of the tree. After the sap is gathered, the various grades are separated, hand-filtered in small amounts through special papers, and then put in airtight containers. The lower grades, some of which come from the upper part of the trunk and the branches as well as from the previously mentioned imported sources, are used as preparatory sealers and primers, while the higher qualities are used to finish the surface and its decoration.

Once *urushi* has hardened, it seals the surface to which it has been applied, making it completely resistant to *all* liquids and even to some acids. Its adhesive quality and its insolubility in water make the subtance an excellent binding agent. When it is mixed with sawdust and rice paste, the resulting compound is used for restoration processes; the mixture acts both as a cohesive agent and as a sealer. Cloths saturated with *urushi* and put in layers around a form have been used as a vehicle for sculpture of extraordinary durability, and hardened lacquer droppings have been carved into exquisite forms. When polished, *urushi* achieves a gloss of unparalleled sheen. Today about five hundred tons of lacquer are required yearly in Japan, with that country being able to provide only five percent of the total used.

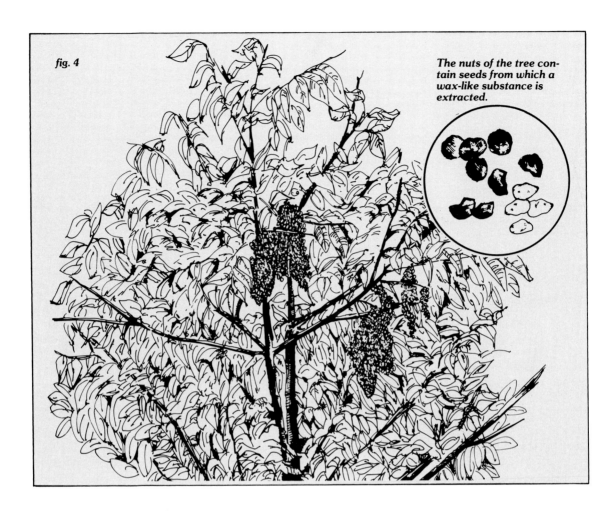

fig. 4

The nuts of the tree contain seeds from which a wax-like substance is extracted.

Nothing is wasted when the tree is tapped out. The nuts, harvested in the fall, contain a seed that provides a wax used in candles, lipstick, and some medicinal ointments (fig. 4). Trees that are cut down are dried, and the seasoned wood used for farming tools and house interiors. The color of the core of the tree is yellowish-green, and its grain is so attractive that it is made into alcove posts or sliced into pieces for parquet flooring.

Refining Urushi

The processes discussed here are based on present methodology, but are remarkably similar to that of earlier, premechanical times. After being taken from the tree, the sap is put in a large tub or pail and covered to protect it from light and dust. A thick milky film develops on the top, and the material darkens. Since a complete description of all types of lacquer processing would require more space than is available here, emphasis will be only on those most commonly used. The terms describing the different states of the fluid, which vary according to the area in Japan in which the lacquer is processed, will be those used in the Tokyo (Kantō) area.[2]

Bark particles and slivers of wood are removed from the sap by straining it through a cloth, sometimes linen, which though expensive is strong and tightly woven. The strained substance, tan in color and with a grayish film, is called tree lacquer (*ki urushi*), or sometimes *seishi urushi* (*seishi* means purified). At this point in the process *ki* and *seishi* are interchangeable terms.

The two main classifications of *urushi* depend on how it is further processed or refined at the *urushi ya*, which is not only the processing company but also stores, imports, and sells lacquer. The first and finest is called *ki shōmi urushi*, which refers only to Japanese middle-trunk lacquer gathered during

fig. 5

Light colored suki urushi vats are usually placed further back in a room than those of kuro urushi, as the former is used less often than the latter.

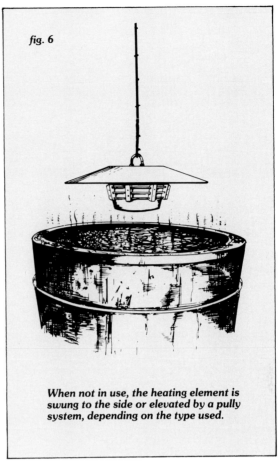

fig. 6

When not in use, the heating element is swung to the side or elevated by a pully system, depending on the type used.

June (the best time), July, and August and neither heated nor adulterated but mixed with cotton and spun-filtered for further cleaning. This, the very highest grade, is the only one used for the final clear coating in art lacquers. Unprocessed, top-grade *urushi*, imported from Mainland China, Taiwan, and Korea, still retains the appellation *ki urushi* at the processor, an indication of its foreign origin and its quality, which is inferior to that of *ki shōmi*. The second major classification is *seisei* or "cooked" lacquer. It includes *urushi* that has been processed by heating or by the addition of other materials, or by both.

"Cooked" *urushi* is further classified into two major categories: plain lacquer, to which light coloring material or oil or both may be added (*suki urushi*), and the dark, lower-quality lacquers, to which black (*kuro*), in the form of iron powder, filings, or oil, is added before cooking begins. Naturally plain and black *urushi* are put in separate vats (fig. 5).

Both categories of lacquer are first thoroughly blended with a mechanical mixer that replaces the stirring paddle of the old days. The length of this procedure depends upon whether or not oil is added: without oil, both types are stirred for thirty minutes; if oil is added, two to five hours are necessary to complete the mixing process.

In a procedure known as *kurome*, heat is then applied to remove the excess water in the sap and to allow uniformity of drying. The heat needed for the evaporation process is provided by coiled heating elements suspended above the tub; they replace the sun's heat used in former times (fig. 6). If oil has been added, three to four hours are required to homogenize the fluid; if no oil has been added, only forty to forty-five minutes are needed. After heating, only two to three percent of the water remains and the thick, syrupy, grayish brown liquid is of uniform consistency.

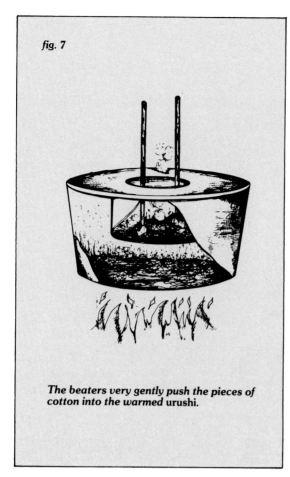

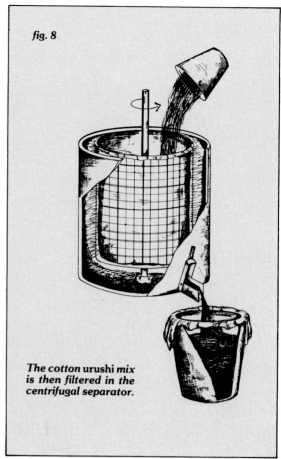

fig. 7

The beaters very gently push the pieces of cotton into the warmed urushi.

fig. 8

The cotton urushi *mix* is then filtered in the centrifugal separator.

All *urushi*, regardless of type, undergo the next step. Cotton is added very gradually by hand in small quantities to a shallow bowl of lacquer and is gently mixed in . The basin that contains the cotton-*urushi* mix rests on the lip of a deeper vat (*ukan*) containing hot water (fig. 7). While the hot water keeps the mixture warm, it is indirect heat and sustained at a set temperature: therefore, there is no chemical or physical change within the mix and the cotton attracts and picks up impurities, such as dust. The mix is then placed in a large centrifugal separator. A circular metal mesh screen (about two inches wide and covered on both sides with a cloth filter) is inserted into the vat and hugs the inner wall. Powered by electricity, rather than by hand as in former times, the separator spins, forcing the cotton-*urushi* mix through the cloth filter, hurling the refined and filtered substance against the inner wall of the vat, where it slides down and flows out an open spigot into a large pail, also lined with a cloth filter (fig. 8).

After this final filtering, the two main categories of "cooked" *urushi* — plain with or without oil, and black with or without oil — are put in storage tubs to await use either as they are or to be further processed by the addition of color or more oil.

Use of Different Grades

Only purified, unprocessed Japanese trunk lacquer, *ki shōmi*, is usually employed for the final clear finish of undecorated objects or as the vehicle for the uniquely Japanese decoration process called *maki-e* (literally, "sprinkled picture"). In this distinctive technique the design is first drawn on the surface in wet lacquer. Colored or metallic particles are sprinkled on the moist area, allowed to harden, and then, in some cases, polished (figs. 9a and b).

Processed, plain (*suki*) *urushi*, the next best grade, is used with or without oil, as the medium to which

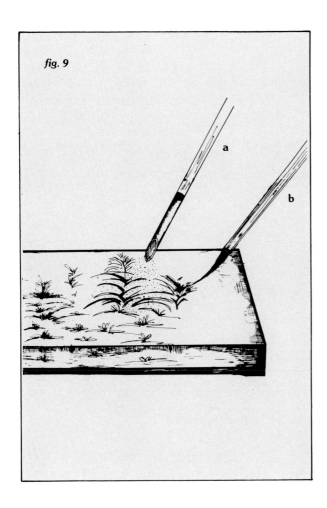

fig. 9

After a design has been layed down on a finished ground, wet lacquer is applied to the desired area with a rat's tail brush (b). Then a metallic powder or pigment is sprinkled on the moist surface (a). This decorative process is called maki-e or "sprinkled picture."

other substances are added to make up the surface coatings (*uwa nuri*). For example, red lacquer (*shu*), made by adding cinnibar coloring to plain oil *urushi*, is employed in the Chinese style of layering coat upon coat for carving (*tsui shu*) into a design. The addition of oil imparts a slight gloss to the unpolished surface. The term for this kind of processed, oiled red lacquer is *shu ai urushi*.

The medium most often used as a ground is known as *nashi ji* (pear-skin ground) — so named because small, irregular gold flakes are sprinkled and then polished in several layers that resemble a "pear skin's." A small amount of powdered gamboge (*shiō*) an orange to brown gum tree resin that is bright yellow in powder form, is mixed with plain oil-less *urushi* to impart a yellowish cast, thus deepening the tone of the gold flakes suspended within the several coatings. It must be remembered that when using plain oil-less *urushi*, polishing is required after every coat has dried.

Black *urushi*, depending on grade quality, is used mainly for undercoatings. (The middle *naka nuri* and under base *shita ji* sealing or coating procedures will be discussed later.) However, the very highest quality oil-less black *urushi* is needed for the complicated black waxy ground known as *ro iro*. The finest of lacquers attain their deep black color and luster by the addition of as many as five coats of this type of lacquer. A high-quality black finish called *nuri tate*, made of an oiled black lacquer, often supplies the final coatings on the undecorated insides of boxes.

Today about ninety-five percent of the *urushi* used in Japan is imported from China and other countries and is principally employed for middle and undercoatings. Chinese *urushi* is inferior to that derived from Japanese trees because its urushiol content is lower and therefore it does not harden well.

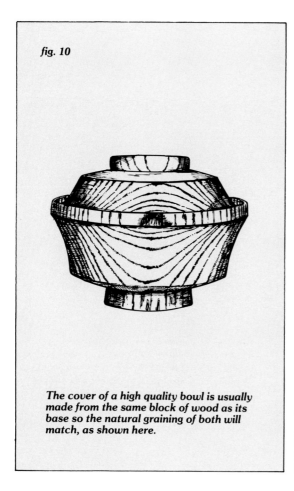

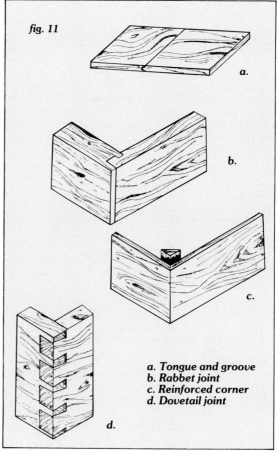

fig. 10

fig. 11

The cover of a high quality bowl is usually made from the same block of wood as its base so the natural graining of both will match, as shown here.

a. *Tongue and groove*
b. *Rabbet joint*
c. *Reinforced corner*
d. *Dovetail joint*

Constructing and Coating the Core

The construction of a piece of lacquer takes place in three stages: the building of the base, body, or core; the application of the various lacquer coatings used to seal and protect the object; and, finally, the decoration of the surface.[3] If not expertly prepared the core, or base, the foundation for the artistic expression, will crack or fissure, destroying the surface it supports. For example, many Meiji period (1868-1912) wares produced by the renowned Shibata Zeshin (1808-91) and his atelier have cracked and/or warped, as green wood was often used, and in some cases the joined surfaces have not been lined properly with fabric, if lined at all. It is unfortunate that his particular style of work was produced by artisans who succumbed to the overwhelming demand of the European market, and resorted to shortcuts, with little regard for the lasting qualities of the object.

Almost all boxes have a wood core (*kiji*). The various steps in the creation of the parts of a box are assigned to specialists, whose positions for the most part are still hereditary. The expert who makes the shapes for both covered and uncovered bowls, for example, works on the lathe. (Objects turned on the lathe are called *hiki mono*, literally, "pulled things.") He usually lives near water, since wood, until recently, was transported by boat. Pine (*matsu*) and cypress (*hinoki*) are considered the best wood for cores because they are white, nonresinous, and fairly free from knots. Other woods most often used are paulownia (*kiri*) and cherry (*sakura*). Zelkova (*keyaki*) is employed most often for bowls and other objects in which the graining is important (fig. 10). Woods are seasoned sometimes as long as thirty to fifty years before use; the succession of the craftsman's line was therefore important for the wood would be part of a craftsman's inheritance.

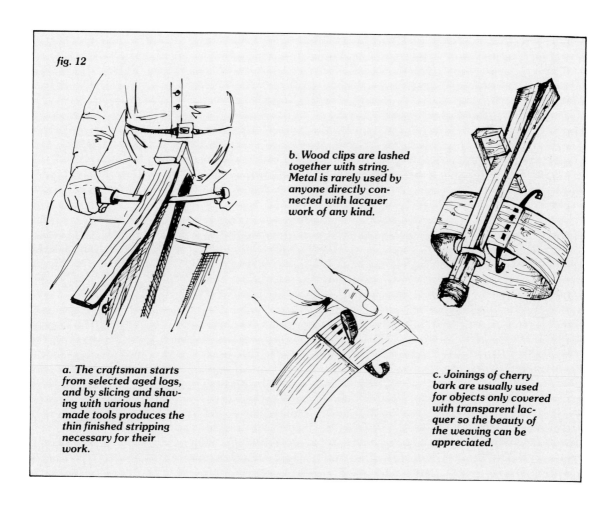

fig. 12

a. The craftsman starts from selected aged logs, and by slicing and shaving with various hand made tools produces the thin finished stripping necessary for their work.

b. Wood clips are lashed together with string. Metal is rarely used by anyone directly connected with lacquer work of any kind.

c. Joinings of cherry bark are usually used for objects only covered with transparent lacquer so the beauty of the weaving can be appreciated.

The cornering (*sashi*) is done by a specialist who cuts, miters, and butts the corners of all joined objects (*ita mono*). Whether curved or straightedged, corners require additional internal reinforcement with a filler for durability. Usually this substance is an adhesive called *kokuso*, composed of sawdust, rice paste, and black urushi. All joints are filled only from the inside during the early stages of manufacture. Until recently, the corners and the rectangular pieces of wood in a box of top quality were joined either by dovetailing or rabbeting (figs. 11b and d); the thin rectangular slats of the top and bottom were joined by the tongue-and-groove method (fig. 11a). These were expensive and time-consuming techniques, used today only by the best artists in the country. After the basic construction of the object had been completed, the *kokuso* mixture provided additional reinforcement. Today, boxes are usually joined as illustrated in figure 11c, by mitering, and then reinforcing only the corners.

Bent work (*mage mono*), such as the thin, rounded sides of trays, is the province of another specialist. The worker first cuts a large piece of seasoned wood along the grain, pulling away from the gnarls (fig. 12a). The rough-hewn, smaller straight-grained piece is then divided into thin strips, which are soaked in water for a day to make them pliable. The ends are shaved, one end thinner than the other. The piece is bent around a wooden form to make the curve, with the shaved ends overlapping each other. The ends are pasted and tied with a string or joined by clips (fig. 12b). Cherry bark is sometimes woven into the joining to reinforce it (fig. 12c).

The various types of sealings and undercoatings used on lacquer objects fall into three categories: the initial processes of covering the core with layers of lacquer compounds are known as *shita ji* (literally, "under ground"); the middle coatings, *naka nuri*; and the final coatings, termed *uwa nuri*.

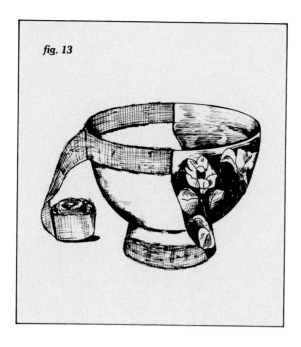

fig. 13

After the linen is applied, successive coats of mixtures are added mainly to the body of the article, until the fabric and its adjoining surfaces are of one level. Later, finishing coats of lacquer are added to the even surface which may then be decorated.

Only after all these processes have been finished is the surface ready for decoration. Recently, the first two steps have been combined and completed by the same shop — and not by the lacquer artist who decorates the object. The third is undertaken by the more persevering and meticulous lacquer designer, who wants to insure the success of his decorative work.

Coating the Core

Often priming is done by a single shop of four to six men who turn out hundreds of pieces a month. The head craftsman receives the box, or other object, from the joiner. He inspects it and then proceeds to cut and fill the outside part of the joints with the same adhesive filler paste used by the core maker. When it hardens, this filler strengthens and binds the joints but remains flexible enough to allow for the expansion and contraction of the wood. The edges are shaved and sanded, and the box is given a base coat of black, low-quality *urushi*. Linen is pasted with lacquer onto the entire inner and outer surfaces of the box, or the entire inner and outer surfaces of the box, or sometimes only onto the joined edges, depending on the quality of the product.[4] In the case of a bowl, the edges getting the most wear are covered (fig. 13). With a wide spatula, a thick mixture of rice paste, *urushi*, and a claylike substance (*ji no ko*) is applied to all surfaces. When this coat is dry, it is smoothed down with sandpaper or a whetstone. Next, a mixture of ground, coarse baked clay and *urushi* (*ippen ji nuri*), literally, "first ground coating," is used to cover the inside of the box. After this mixture dries, it is polished with charcoal and water. The same mixture is then applied to the outside of the box and polished. Another coating, a mixture of medium-grade baked clay and *urushi* called "second ground coating" (*nihen ji nuri*), goes on the inside and then on the outside (as above) and is polished in turn with charcoal and water. Then, a third and final ground coating (*sanben ji nuri*), consisting of the finest grade baked clay and *urushi*, is applied on both the inside and outside, and it is finally dried and polished. A drying period is always necessary after any applications of *urushi*, for only a dry surface can be worked further.

Middle and Final Coatings

Lower grades of black *urushi* (see page 17) provide for the middle coatings of the core. The lacquer is filtered again through special paper to further refine it. Then the object, such as a box, is coated first on the inside and placed in the *furo* to dry; then it is coated on the outside and dried again. Depending upon the season, the drying time is about eight hours. All surfaces are then polished with a whetstone. If the

fig. 14

a

b

a. Hollow tubes (tsutsu) come in different sizes with mesh openings of the varying widths necessary for the variety of shaped powders used in maki-e.

b. When the brushes for laying down broad masses of lacquer wear down, their wood sides are cut away in order to extend the length of the bristle.

surface is still not completely smooth a mixture known as *sabi urushi*, consisting of powdered pumice, *urushi*, and a little water, is applied. After this mixture dries, it is polished with charcoal and water or with a whetstone. The inside and outside are coated one more time with the mixture and then polished again with charcoal and water.

The final coats require a better quality black *urushi*, which is filtered first through three sheets of paper; then through five, and finally through seven. No impurities or dust should remain in the viscous fluid, which is then applied on both the inside and outside of the object and dried.

For large or mass-produced objects coated with *urushi*, there are four kinds of *furo*, which vary in their drying time — and sometimes the filtering and drying processes are automated. In an atmosphere of low humidity, the objects, set on racks, are turned every four minutes — up and down so that the *urushi* dries evenly. Then the pieces are moved to another drying chamber, exposed to high humidity, and moved every four minutes. After two hours — including the time in both *furo* — the lacquer has set. The objects are then placed in a chamber called an *age muro*, which has very low humidity. After about eight hours, the pieces are placed in a special drying chamber in which the humidity is very high. The entire drying process, takes approximately seventy-two hours. While *urushi* lasts indefinitely on the surface of an object — unless exposed to direct sunlight — a new substitute for it, cashew, an oil extracted from that nut's shell, will last only about three to five years.

Materials other than wood involve a variety of other finishing processes, not covered in this text, but a few will be mentioned in connection with the catalogue entries. Among the other substances most often used are strips of bamboo, which are woven into shapes and then coated with lacquer (*rantai*); and hide, usually that of a cow or wild pig, which is softened by soaking and wrapped around a mold until dry and then lacquered in a process known as *shippi*. In the dry-lacquer technique (*kan shitsu*), layers of fabric, such as linen, are wrapped around a form with intermediary coats of lacquer applied as the cohesive agent. After the internal mold is removed, the dried lacquered cloth retains its shape. Paper may also be used as a core: sheets of paper are saturated with lacquer and piled layer upon layer on top or inside a shaped mold, usually made of clay or wood as in *papier-maché*. If placed inside a mold the procedure is called *ikkan-bari*, literally "lacquered paper." If the lacquered paper is applied to the outside of a shaped core it is called form-molding, or *hari nuki*.

The final decoration of lacquer objects is completed by a specialist called a *maki-e shi*, literally, "sprinkled-picture person." Such men are highly trained and exceptionally skilled, and only after a long apprenticeship with a master may they strike out on their own. The lacquerer's tools and equipment are extremely expensive. One brush may cost as much as three hundred dollars; the hair preferred is that of a young Japanese woman (a man's hair is considered too stiff), and it must be strong and resilient. Encased in wood, brushes come in various widths; and as the ends fray from use, the sides are cut back (fig. 14b). The finest brushes, utilized for drawing thin lines, are made from the extraordinarily fine hairs of a rat's tail, which have a special springiness and strength not found in the hair of other animals (see fig. 9b).

Gold particles or powders come in many sizes, in different shades, and various shapes. They are sprinkled on a surface by means of a hollow tube (*tsutsu*), with one open end for putting in the granules, and the other end covered with a screen or stiff mesh (fig. 14a). The sizes of the openings vary according to the size of the granules desired. Silver, tin, and other metals, as well as shell and colored pigments, also come in various shapes and sizes and are sprinkled onto the surface to be decorated. Several types of charcoal and polishing stones, a *furo*, and a dust-free room are needed to produce lacquer pieces.

The lacquer artist, like a surgeon, must have his tools ready before he begins. First he selects or sketches his picture; then he decides on the background that best fits the composition. Most grounds are black to contrast with the gold commonly applied on top of them in a wide variety of techniques. Usually the artist sketches his ideas and draws the final design or picture on paper. After outlining the design with a chalky substance, he turns the drawing face down and, with a pallet or burnisher, transfers the art onto the prepared surface. Another method is to trace the drawing with a brush dipped in lacquer and then turn it over and press the thin wet lacquered lines onto the prepared surface. A light powder shaken over the wet lacquer lines makes the drawing stand out. Some artists work more spontaneously, drawing directly on the surface rather than using a transfer method incorporating any of the many techniques described later in this text. The artist builds his design carefully, always working from the ground up. Almost any effect achieved in painting or sculpture can be part of the lacquer artist's repertoire, but great time is required for mastery of the art and few persist.

Notes:

[1] Sometimes known as lac or urushi acid.

[2] The standard terminology of processes and terms have been supplied by the Fujii Urushi Kōgei Company of Tokyo whose president Mr. Hachirō Ōuchi, gave generously of his time and expertise and also supplied descriptive charts and diagrams that are the basis for certain statements made in this text.

[3] The techniques applied to the under construction and steps in coating the base vary in number in various parts of the country. Those discussed in this section are based on information gathered from the Wajima area.

[4] Most lacquerers usually reinforce only the joints with fabric, but Kyoto artisans still use what is termed "Kyoto style" core work, where all surfaces are covered on both sides with linen, a technique employed there since early times.

The Catalogue

Chronology

JAPAN

Jōmon Period	ca. 10,000 B.C. - ca. 300 B.C.
Yayoi Period	ca. 300 - 552 A.D.
Asuka Period	552 - 645
Nara Period	645 - 794
Heian Period	794 - 1185
Kamakura Period	1185 - 1333
Namboku-chō Period	1333 - 1392*
Muromachi Period	1392 - 1568
Momoyama Period	1568 - 1615
Edo Period	1615 - 1868
Meiji Period	1868 - 1912
Taishō Period	1912 - 1926
Shōwa Period	1926 -

* Also considered part of the Kamakura Period.

CHINA (periods referred to in text)

T'ang Dynasty	618 - 906 A.D.
Sung Dynasty	960 - 1279
Yüan Dynasty	1279 - 1368

The Evolution of Patronage, Style, and Technique

Decorated lacquer artifacts found in Japan date as far back as the first millennium B.C., or the late Jōmon period. However, it was not until after Buddhism was introduced into Japan in A.D. 552, with its need for iconographic images, that the use of lacquer became more widespread. Shinto, Japan's earliest and oldest religion, is pantheistic and requires few, if any, statuary or accoutrements. In Shinto, natural phenomena such as rocks, waterfalls, or streams, are sacred, and the spirits that dwells within them may be summoned "*in situ*," by a double handclap. Ritual, not imagery, is required.

The Asuka and Nara Periods

Japanese arts of these two periods directly reflected the taste, techniques, and designs prevalent in China because of the prolonged contact between Japan and the T'ang Court (618-906). By the first part of the eighth century, with the newly reformed codification of Japanese law, a department of lacquer known as the Office of the Guild of Lacquer Works, was established by the ruling government. Objects to be lacquered were sent to this official center. The increasing need for Buddhist temple furnishings caused the demand for lacquer to grow, and each household of a certain status was ordered to plant lacquer trees as certain taxes were to be collected in the form of about one pint of sap a year.[1] Patronage of the arts was completely centered around the imperial household, located in the capital city of Nara, and around the Buddhist temples it supposedly controlled.

During this period Buddhist statuary and liturgical implements, temple furnishings, and paraphernalia for worship, as well as secular items, particularly boxes, were created principally by the "dry-lacquer" method known as *kan shitsu*. In early Japanese Buddhist art there is a period of approximately 100 years that represents the beginning, maturation, and almost complete eclipse of

dry-lacquer statuary technique. In late Asuka sculpture it appears first to have been used for superficial decoration such as jewelry or hair ornaments in the form of a thick, malleable compound of powdered clay, punk, and lacquer. Then, almost in conjuction with the appearance of clay images, a very complicated style of sculpture using the "hollow dry-lacquer" technique called *dakkan shitsu* evolved. The relationship of these developments cannot be ignored, as clay was also first employed as the basis for producing some of the first hollow dry-lacquer sculpture. Although there are no sculptures of this technique from this period extant in China, it is probable that the method was adapted, along with the use of clay, from the T'ang Court.

A statue was created as follows: an image was first sculpted in clay and dried; then a mold of the clay was cast, as in casting a bronze — probably with two seams or by leaving the bottom open. The clay image was then destroyed by digging it out or setting it aside (if side seams were used). The dry hollow casting, or mold, was then coated with lacquer and bark as a stiffener and lined with cloth, usually hemp soaked in lacquer. After the inside, lined-cloth shape had hardened, the outside mold was broken away, leaving the new, dried-lacquer figure to be finished by polishing and decorating with color or gold leaf. The technique provided a light, life-sized image that was easily transportable

A simpler variation of this technique was the application of hemp directly to the modeled clay, with lacquer added as a binder; the process could be repeated several times for additional thickness. When the outer shell was thoroughly dry, the clay was removed from the interior through the bottom, and the surface finished. This method, however, was not as popular as the earlier, more complicated one, since it presented many technical problems. Possibly the hemp adhered to the clay in the drying process, and the shrinkage of the cloth against the immovable clay undoubtedly also caused problems.[2] Additional decoration, such as jewelry or costuming, might be added, with a mixture of lacquer and clay or sawdust. Sometimes a lattice or a wood armature was added to support the trunk, legs, or head. Three sculptures supported by the lattice method exists: two in the Hōryū-ji Temple and one in the Tōshōdai-ji Temple, both in Nara. The lattice temporarily replaced the wood armature, which sometimes distorted the image when completely dry. After the use of a wood armature was perfected, the lattice structure was no longer employed.

These complicated forms soon gave way to a method involving a carved wooden image to which a compound of powdered clay, punk, or powdered incense and *urushi* was applied in the finishing process. The Japanese term for this technique is *moku shin kan shitsu* or "wood-core lacquer." About this time (during the eighth century) theatrical masks for the dance-drama known as *Gigaku* were also created in the "dry-lacquer" technique.

Objects such as sutra boxes, portable shrines, and musical instruments were also decorated in one of several lacquer processes imported directly from China. The decorative procedures described herein are divided into those for the preparation of the ground, and those for the pictorial elements or surface designs. Introduced in this period was a ground of irregularly shaped, pure gold particles (*heijin*) that were made by rubbing gold with a file and sprinkling the rather coarse particles sparingly over a moist lacquer surface. Afterward, a coat of clear *urushi* was added, ground down, and then polished further until part of the filings were uncovered. The object was then ready to be decorated in a number of techniques.

The earliest, most often used decorative technique was mother-of-pearl inlay (*raden*). The shell was usually placed directly into the wood core by cutting through the ground and setting the shell flush with the wood's surface; to create what is termed "sheet" design, or *hyōmon*, the image or decorative pattern was cut from thin sheets of gold, silver, or both, and pasted on the finished surface. After several finishing coats of lacquer were applied, the surface above the metal design was polished or scraped away, exposing the pure color of the precious material; pigments in paste form were brushed onto the object in a technique known as *yūshoku*. The pigments were then covered with an oil that dried. However, since objects decorated in this manner chipped easily, the method soon became obsolete.

Gold and silver decoration was applied in three different techniques. In *kin gin-e*, gold and silver in powder form were mixed with glue, and the design was drawn on the surface with a brush. As with pigments, however, exfoliation was again a problem, and this method soon fell into disuse. In *makkinru*, the precursor of the burnished *maki-e* technique known as *togidashi*, coarse gold filings were sprinkled over the moist surface of the design, relacquered once, and polished until the design was revealed. Only one example of this method exists and reposes in the Imperial storehouse, known as the Shōsōin, in Nara. The third technique, *maki-e*, is that in which the design is drawn on the ground in lacquer. Gold or silver particles are sprinkled on the sticky lacquer, which then hardens, binding the powder to the surface. Thin lacquer is usually rubbed on lightly to fix the particles more securely to the base. This method became the most popular and enduring method for decoration, as it allowed greater fluidity of motion and a large variety of designs.

Examples of all these techniques, however rare, may be seen in Japan today. Certainly, the greatest achievements in lacquer during the Nara period (all located in Nara) are those masterpieces of Buddhist dry-lacquer sculptures created around 734 and found in the Golden Hall of the Fujiwara clan's compound at the Kōfuku-ji Temple; the guardian figures (about 742) of Tōdai-ji Temple; and the magnificent figure (about 763) of the Buddhist priest Ganjin (A.D. 687-736) in the Tōshōdai-ji Temple. Although these statues are over 1,200 years old, their resistance to the elements and the hardships of time is testimonial to the extreme durability of lacquer.

Notes:

[1] Equivalent to about ten days' wages. See Langdon Warner, *Japanese Sculpture of the Tempyō Period*, Cambridge, Mass., 1969, p. 56.

[2] *Ibid.*, pp. 87-139.

The Heian Period

In order to avoid the political influence of the Buddhist monasteries, the capital was moved about twenty-two miles from Nara and re-established as Heian-kyō in A.D. 794. In 838 the Japanese ceased sending official envoys to China, because the T'ang Court was becoming unstable and weak. This act led to a new independence in the development of Japanese art and culture, and lacquered works of art underwent a stylistic evolution reflecting a purer Japanese taste. The aristocratic Heian Court became renowned for its sensitivity, refinement, and love of nuance in the use of color and language. Poetry became of paramount importance, and two great literary masterpieces, both written by women, originated during this era.[1] The influence of the Heian aristocracy on all art forms, including lacquer, was profound and far-reaching.

The Guild of Lacquer Works, formed in the eighth century, was abolished, and a new official system, in which the various operations of the lacquer industry, such as foresting trees, and tapping for sap, as well as the training and supervising of artisans, came under one authority, the Imperial Bureau of Works. In addition, the Imperial family and the major temples had their own lacquer artists who were responsible for special ritual objects; some lesser nobility patronized their own artisans as well.

New shapes in boxes and objects developed, and new techniques evolved, as older ones were refined. Palanquins and carriages decorated with lacquer became popular. *Maki-e* appeared on sword scabbards and on saddles, while Buddhist statuary and ritual objects became more elaborately decorated. Religious figures were made mainly of wood with lacquer compounds added during the finishing process.

The "hand box" (*te-bako*), which had been introduced from China at an earlier date, became popular among the court women. From the few available facts, it has been theorized that the original box with a

fited inner tray held three smaller containers[2]: one for cosmetics; one for writing materials (the *suzuri-bako*); and one for incense, (the *kōgō*). However, the high-born Japanese married woman needed blackening materials, and thus the writing box (which then evolved as a separate unit) was removed and subsequently replaced with more numerous receptacles. By the late eleventh century, the six most common boxes stored within the *te-bako* were two small rectangular boxes for tooth black; a square box for a cosmetic such as white face powder; a large round box containing a mirror (*kagami-bako*); and two small, round boxes for incense.

These objects were decorated with both old and new techniques, of which the most common was "poured on ground" (*ikake ji*), in which gold or silver (or sometimes both) was sprinkled separately and heavily enough to resemble solid metal, although the filings used were still rather coarse; only one coat was necessary for the effect desired at the time. Later on this technique, utilizing very fine gold dust heavily applied, became known as *fun-dame*, and, subsequently, the more lustrous gold ground called *kin ji*.

A new color was achieved with the additon of a small amount of silver dust added to gold, creating a blue-gold powder (*aokin-fun*). Sprinkled on as a mix, it produced a delicacy and nuance of tone appealing to court taste. Another method of applying *aokin-fun* was to graduate the sprinkling (*maki-bokashi*) so that the powder ranged from thin to thick in different areas of the design.

As the purely Japanese style of lacquering called *maki-e* began to evolve, the "burnished" sprinkled picture technique called *togidashi maki-e* was among the earliest to develop. In this method the design is first drawn on the ground in lacquer, and then the metallic or pigmented powders are sprinkled over the moist lacquer lines of the composition. When the lacquer is dry, layers of black lacquer are added to coat the entire surface, thus building an infinitesimally small mound on the design. The surface is then polished down until only the very top of the original sprinkled design is exposed. Care must be taken in the final polishing so that the under design is not removed. During the Heian period this technique was used sparingly and in combination with others. Later, in the Edo period, two great artisans specialized in creating works of art wholly in this painstaking method.

The use of mother-of-pearl inlay was introduced in combination with *maki-e* rather than on plain lacquered wood as in earlier periods. In place of the lacquered hide and dry-lacquer shapes that had been used as the base or core for Buddhist sutra boxes in the Asuka and Nara periods, wood became the common base to which lacquer decoration was applied. Boxes of this period have gently swelling sides and softly curved tops. For the first time the lid and bottom edges are lined with a pewterlike metal (*byakurō*), in those places where they rest on each other, to protect against chipping or cracking, and perhaps to minimize warping.

Notes:

[1] They were the *Tale of Genji* (*Genji Monogatari*) by the Murasaki Shikibu, and the *Pillow Book of Sei Shōnagon*. Both women served the Empress.

[2] Hirokazu Arakawa "*Kōgō*," Pyramid, Tokyo, Nov. 1979, pp. 36-39.

The Kamakura Period

During the Heian period the court nobles, overly occupied with aesthetic pursuits, slowly isolated themselves from the political problems of the provinces. Without realizing the ramifications of this course of inaction and neglect, the court delegated an ever-growing amount of control and authority to the newly developing class of military enforcers, the samurai. Finally, under the leadership of their own military aristocracy, the two largest and most powerful of the samurai clans decided to wrest the leadership of the country away from imperial control. The Genji (Minamoto) and the Heike (Taira)

engaged in a final bitter conflict that ended in the defeat of the Taira in 1185, and, by the war's end, the head of the Minamato clan, Yoritomo (1147-1199), had formed what was essentially a military protectorate over the country. Then, in order to avoid political complications with the court, as well as to prevent its direct influence on his men, he moved the capital to Kamakura, where, by 1192, under sanctions of the imperial family, he was awarded the title shogun. This newly established shogunal system lasted approximately 650 years, until the Meiji Restoration in 1868, when the imperial family under the Emperor Meiji resumed full power, and the shogunal system was abolished.

Although the court in Kyoto continued its patronage of the lacquer arts, a gradual shift in style became evident. By the thirteenth century, as the taste of the ruling military class began to prevail, shapes became less fluid and more expressive of strength and vitality. In hand boxes, a definite 1:5 ratio was established between the height of the lid and the height of the body of the box. The metal side rings for the cord attachments were placed in a lower position. These changes resulted in a different sense of proportion, giving the box an appearance of strength and masculinity.

Silver powder, often used in previous periods, no longer continued in fashion, and gold became the predominant metallic powder for decorative purposes. With an increase in the refinement of gold powders, new techniques became possible. Two new grounds evolved: one used flattened particles of gold (hirame), sparingly sprinkled over moist lacquer, relacquered with clear urushi, and then polished. The other was a variation using irregular flakes of gold in a technique simulating the appearance of "pear-skin," called nashiji. The mottling of this ground was achieved when the sprinkled flaked gold was applied to a moist lacquered surface and then covered with several layers of transparent yellow-tinted lacquer called nashiji urushi (see p. 19), which was polished after each application.[1] The latter ground was so attractive that it replaced that of heijin.

For creating pictorial elements, added dimension was achieved through raising the foreground by layering with powders and lacquer rather than through the use of inlay. This concept brought about the evolution of two new methods: hira maki-e, literally "low sprinkled picture," usually referred to as "low relief," in which one layer of lacquer above the ground is sprinkled with gold and dried; then, a small amount of thin lacquer is applied only over the design to fix the particles to the ground and is then polished; and taka maki-e, literally, "high sprinkled picture," usually referred to as "high relief," in which more than one level is achieved through a lacquer-powder-polish-relacquer-powder-polish-relacquer method. The less expensive and least time-consuming way to achieve this effect was to use charcoal powder in an urushi mixture.[2] The further refinement of gold particles in this period enabled the artisan to create designs in which the different sizes of the grains added dimension and tonal variation. Sheet gold (kana-gai), as well as a thinner type of the same metal, cut into various shapes (kiri-gane), came into use for creating sparkling highlights, a technique also used in the decoration of paper and sculpture. Mother-of-pearl inlay as a major design element also became popular during this period.

A new kind of practical lacquer ware was developed by Buddhist monks from the Negoro Temple. Principally vessels for food and drink, these objects, shaped of wood, were usually covered first in black lacquer, then in a warm vermilion red. Use would wear down the outer color, and the soft black undertone would show through. There was a perfection of form and symmetry in these utensils, and it was enhanced only occasionally by the simplest pictorial design. Called the Negoro style, the shapes and techniques were continued until the temple was burned in 1585. By that time the monks had carried their knowledge and crafts to other areas of the country, such as Wajima in the north.

Notes:

[1] In the Edo period special nashiji powders were introduced. The flakes were made thinner so the edges would curve, giving the illusion of bulk and providing more surface for the reflections of light.

[2] Today the sabi urushi compound, consisting of powdered pumice, urushi, and water, is almost always used for making taka-amki-e.

The Muromachi Period

As a result of fighting between two branches of the imperial house for the right of succession, the city of Kamakura was destroyed by 1333. Subsequently, the capital was moved to the Muromachi area of Kyoto. Civil strife kept the country in a constant state of upheaval during this era, which is sometimes considered the medieval period in Japanese history. It was followed by the renaissance of the Momoyama period (1568-1615).

The Muromachi period was marked by renewed contact with China, and Japanese art again reflected Chinese influence. In lacquer, brushwork in the styles of Sung (960-1279) and Yuan (1279-1368) landscape painting were combined with the softer, curved-line effect of the Japanese painting style *yamato-e*. This amalgamation — along with a new interest in the simple teachings of Zen Buddhism, which appealed greatly to the military — is evident in the more somber coloring on lacquers of this period. Certainly the use of a solid black ground, without the relief and beauty of the sparkling glitter seen on objects of earlier periods, reflects the grave mood accompanying the continuous political unrest.

Among upper-class women the *te-bako* continued in popularity, as the ruling shoguns adapted aristocratic ways. Their influence on style, became evident however, when both the outer and inner containers underwent a change in proportion. While the ratio of the height of the outside box to the height of the lid diminished to 3:1 rather than the previous 5:1 — thereby making the box appear smaller and less massive — the inner smaller *kōgō* and tooth blackening boxes became slightly higher and heavier than those of the previous period. Although the outside box was now lower it still maintained a soft, curved, arch-shaped lid.

Under the indulgent Shogun Ashikaga Yoshimasa (ruled 1449-1474), lacquers in the Higashiyama style (named for the location of his palace) flourished. Kōami Michinaga (1410-1478), the first lacquer master who can be linked with specific works, was active during this period. Utilizing designs by fashionable contemporary painters, such as Tosa Mitsunobu (1434-1525), Nō'ami (1397-1471), and Sō'ami (died 1525), Kō'ami and another *maki-e* master, Igarashi Shinsai (active in the mid-fifteenth century), started the two earliest schools of lacquer under the direct patronage of the shoguns. The Kō'ami school continued in a direct line of descent, master to master, under reigning shoguns until the nineteenth century. Traditionally, their lacquer designs had been inspired by master painters of the times, especially those of the Kanō school, whose style was originally based on Chinese painting techniques.[1] The Igarashi line survived only until the end of the seventeenth century. It is to the first Igarashi that most of the Higashiyama-style lacquers are credited.[2]

Notes:

[1] The Kanō school of painters, started in the fifteenth century by Kanō Masanobu (1434-1530), were the official painters to the court of the shoguns.

[2] Dohō Chūzaburō (died 1678) and his son Dohō Kizaburō (died 1697?) were famous members of the Igarashi school of lacquer. They moved north to the province of Kanazawa, in the middle of the seventeenth century.

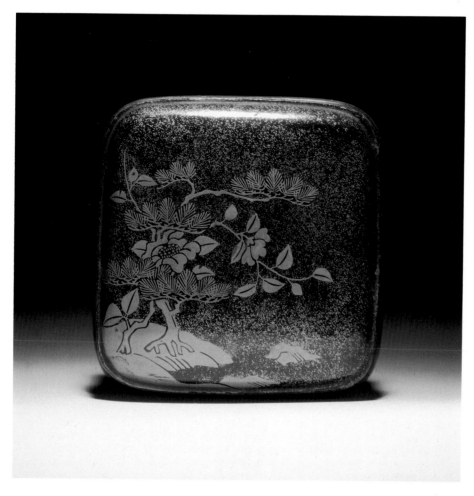

Dimensions: L. 2½ in. (6.4 cm.)
W. 2½ in. (6.4 cm.)
H. 1¼ in. (3.2 cm.)
Sixteenth century.

1. Incense Container (*kōgō*)

Perhaps the most peculiar aspect of the late Muromachi style is the flattening of the pictorial elements, with little or no use of techniques that would create the illusion of depth. The flat, two-dimensional image on the cover of this box demonstrates little regard for perspective and is typical of the designs of this period. The influence of Chinese-style painting is evident in the calligraphic strokes of the trees, roots, and rock formations, whereas the softly curved shapes of the landscape are more in the Japanese style of brushwork.

The composition evokes a quiet, somber evening, when forms blend together in a failing light. The poetic overtones are intensified by the sparing use of a lightly sprinkled flaked gold, which, against a predominantly black background, suggests an evening sky with sparkling stars. The branches of the pine are intertwined so that their needles form a frame for the fresh bloom. The foreground, which is composed of heavily sprinkled gold in the *ikake ji* manner, is well drawn, and the final design work is expertly applied in the burnishing, *togidashi* technique.

The shape of this box indicates that it was originally used for face powder. Its gently domed top and softly curved sides edged with a pewterlike metal are characteristic of boxes of the Muromachi period.

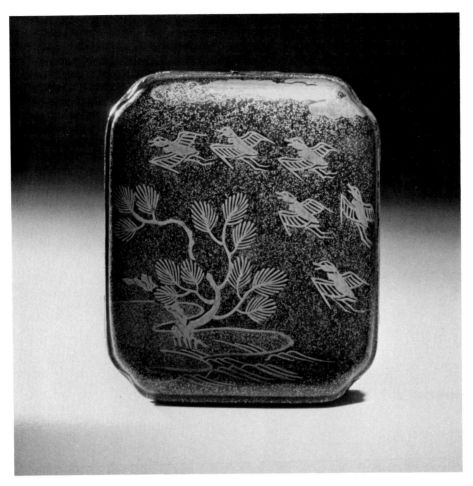

Dimensions: L. 2¾ in. (7.0 cm.)
W. 2⅜ in. (6.0 cm.)
H. 1⅝ in. (4.1 cm.)
Style of Sixteenth century.

2. Incense Container (*kōgō*)

Inverted corners (*irizumi*) were introduced in the Muromachi period and popularized in the design of both small and large boxes. Somewhat bulkier than the previous example, this container bears a more complicated composition. The scene on the lid is bordered at the top with a cloud formation, while waves gently lap at the shoreline at the bottom. Plovers flying over pine trees fill the sky. The playful birds in flight are set against a heavily sprinkled gold "pear-skin" ground technique that suggests a bright, sunny day. The pictorial element is in the same burnished technique, as that of the prevoius example, but the composition is not as somber. The activity of the birds creates a feeling of movement that raises the spirits. Filling the entire space with the design, carrying it over onto the sides as well as the top surface of the lid, was prevalent toward the end of the Muromachi period. As in the previous example, both top and bottom edges are lined in a pewterlike material.

The Momoyama Period

After a century of almost constant civil war the country was in dire need of stabilization. At the start of this era there were approximately two hundred separate provinces varying in size and wealth, with each reigning lord, or *daimyō*, having absolute power over his own territory. Three great warriors rose to dominate the politics of the country, each achieving a major step toward its complete unification.

The first of the trio was the iron-fisted, strong-willed *daimyō* Oda Nobunaga (1535-1582). Ruthlessly, he began gathering up the reins of the country and proceeded to burn down the temple compounds of the large, extraordinarily militant Buddhist forces who were defying him. The patronage of the arts, which in the previous period had been in the hands of these religious forces, ceased. Militancy during Nobunaga's fairly short era allowed little time for new developments in art. He was assassinated by one of his own generals, and the mantle of power fell to Toyotomi Hideyoshi (1536-1598), Japan's greatest soldier-statesman.

Hideyoshi's strength and determination led to military, but not political, unification of the country. He had a passion for gold and began the tradition of giving beautifully lacquered objects as presentation pieces and gifts in exchange for services rendered. It was his love of the new and exotic that provided the impetus for the further evolution of the lacquer arts. Although the first Portuguese merchants and Christian missionaries entered Japan as early as 1543, it was not until Hideyoshi's reign that the influence of foreigners, called *namban* or "southern barbarians," became prevalent. Images of these exotic creatures were introduced into the paintings, screens, and lacquers of the period.

After Hideyoshi's death from natural causes, Tokugawa Ieyasu (1542-1616) the *daimyō* of an extensive eastern province, was declared shogun in 1603, and finally, when Hideyoshi's son died in 1615, the Tokugawa reign officially began. The seat of government was established at his castle town of Edo (now Tokyo).

Basically, three styles of lacquer were predominant during the Momoyama period: the traditional Kyoto type as exemplified by the Igarashi school; the unique Kōdai-ji style lacquers, named for the temple in the Higashiyama section of Kyoto and probably created by the Koami master Kyūjirō Chōan (1569-1610)[1]; and those rarer lacquers known as *namban nuri*, displaying mostly Portuguese and occasionally Dutch figures or decorated in a mother-of-pearl inlay technique found most often on trunks made for the European export market. The Momoyama period was comparatively brief, but its direct stylistic influence may be seen in lacquers up to the middle of the seventeenth century.

The ground usually employed for all these styles was either plain black lacquer or *nashi ji*. The pictorial elements exhibited new techniques: *maki-hanashi*, when no further application of lacquer is added on the surface of the design; *e-nashi ji*, in which the "pear-skin" sprinkled gold ground technique was introduced into the pictorial elements; and *hari-gaki*, or *hikkaki*, in which the design was scratched with a needle or other thin device so that the ground showed through.[2]

Notes:

[1] These elegant and highly styled objects were given as gifts by Hideyoshi's wife in memory of her husband. Heavily decorated in gold, they reflect the rich and colorful life Hideyoshi favored. It was only during the Edo period that these lacquers were given the formal identity of "Kōdai-ji style."

[2] The more traditional method, whereby a design such as the veining of a leaf is left in reserve and the fleshy part built-up around the empty space (*kaki wari*), was the more prevalent method used for creating a low relief effect.

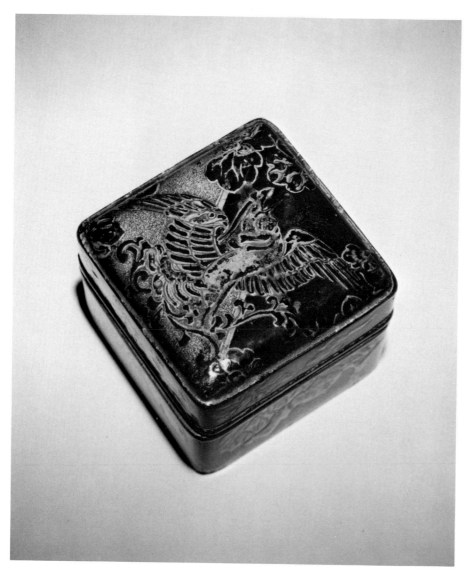

Dimensions: L. 3⅛ in. (7.9 cm.)
W. 3⅛ in. (7.9 cm.)
H. 2¼ in. (5.7 cm.)
Seventeenth century

3. Incense Container (*kōgō*)

One type of Kōdai-ji style lacquer is identified by a geometric linear design resembling pine bark, stylized in lozenge shapes called *matsukawa-bishi*. This use of a jagged line as a compositional device for the division of space appeared first in the Muromachi period.[1] However, its further development, whereby the composition of the ground is split in half by a "lightning-bolt" graphic (*katami-gawari*), is indicative of Momoyama artistry.

The cover of the box shown here displays the phoenix bird (Japanese : *hō-ō*) in typical combination with leaves of the paulownia tree (*kiri*). In Chinese folklore, the phoenix is one of the four supernatural beasts associated with the quadrants of heaven[2], and was considered the "emperor of all birds." Its shape was adapted unchanged into Japanese mythology. The bird, whose form is characterized by its

crested head and full plumage, is reputed to live in the paulownia. Both inspired creativity: the bird because it has an imaginative shape, and the flowering tree because it is a symbol of nobility and was originally an emblem of the emperor of Japan. In the sixteenth century he granted its use to Hideyoshi, who in turn adopted the leaf as his family crest. Until the Meiji Restoration, the combination of this bird and the tree on lacquer usually indicated an object so decorated belonged to a branch of the reigning shogun's family.

A zigzag line subdivides the background of the lid and sides of the composition into two grounds, comprised of a plain black field juxtaposed to one of sprinkled gold "pear-skin." The phoenix on the surface of the lid was well drawn, and the calligraphic strokes of the underdrawing provide a subtle contrast to the surface finish.

The underpainting made of a mixture of red ochre and plain oil-less *urushi*, was first drawn on the ground. While the design was still wet, gold powder was sprinkled on it. The artist deliberately allowed a tiny red edge to remain which results in adding contrast to the design. Also, with use, the surface has worn down, exposing even more of the red. This accent of color provides an enhancing subtle undertone reminiscent of *negoro* lacquers.

The placement of the phoenix on a diagonal composition allows the elaboration of a full wingspread. The bird's body is raised in black *taka maki-e*, and a sprinkled gold outline adding both dimension and contrast, is evident between the interstices of the plumage. His tongue and lower beak show a faint outline in vermilion. Cut pieces of silver and gold have been applied to the throat, breast, and lower body of the phoenix and to the leaves of the tree in a technique utilizing "pasted patches" (*kime tsuke*) which was first introduced during this period.

The shape of the box is slightly bulkier than most typical Momoyama style incense containers, but its contour retains the arched lid popular in the seventeenth century. The naivete of the composition indicates that its creator was probably out of the direct influence of the Kōami masters and may have been an artist living on the outskirts of Kyoto. Its size suggests use in a home shrine where incense is offered to the Buddha rather than as part of a game ensemble (see page 67, re: incense game). The two edges of the receptacle are lined in a pewterlike material, and the bottom section (as well as those of cat. nos. 1 and 2) has a built-up inner rim that keeps the lid secure.

Notes:

[1] See Jō Okada , et al. *Nihon no Shitsugei.* Vol II, #89, #90. A set of matching writing box and table.

[2] The other three are the dragon, white tiger and tortoise; see C. A. S. Williams, *Outlines of Chinese Symbolism and Art Motifs.* Dover Publications, Inc., 1976, pp. 323, 367.

4. Cosmetic Storage Box (*te-bako*)

This box, with its high-arched, overlapping lid, was probably used for the storage of women's cosmetics or combs. It appears somewhat bulkier than most hand boxes of this type, but its general shape and style, including the internal fitted tray, are indicative of the category. The stylized design on the top of the lid — elongated panicles of paulownia flowers and leaves in a field of connecting leaves and arabesques — is typical Kōdai-ji patterning. This particular rendition is a version of the crest used by the Toyotomi (Hideyoshi) family during the sixteenth century and is an aid in dating the object.[1]

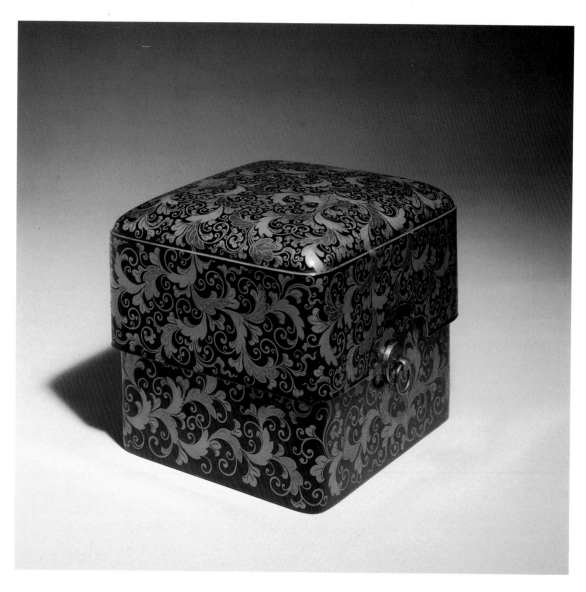

Dimensions: L. 7½ in. (19.1 cm.)
W. 6½ in. (16.5 cm.)
H. 6⅜ in. (16.2 cm.)
Seventeenth century.

This artist has incorporated an unusual variation in design technique, where upon the pictorial image has been expressed somewhat rhythmically. The scroll or arabesque patterning on the bottom half of the box allows more of the solid black ground to show through than the next level of leafy foliage, found on the sides of the lid. Thus, the tightening of the pictorial imagery allows less ground to show through. The pattern on the top surface of the lid is even more tightly composed, and somewhat more compact, because of the addition of the paulownia design to that surface. Therefore, the cadence of the pattern, from bottom to top may be expressed as a slow, medium, and fast rhythmic repeat.

As in many Kōdai-ji style lacquers, the dark black of the ground provides a dramatic contrast with the interweaving of the gold pictorial elements. On this example the leaves of the arabesque design as well as the paulownia foliage on the lid are of sprinkled gold, and the "pictorial pear-skin ground" technique called e-nashi ji. On the basis of its style and design, this box can be placed in the mainstream of Kyoto Kōdai-ji style lacquers, and it probably dates from the first quarter of the seventeenth century.

Note:

[1] For a similar example see Kyoto National Museum, *Kōdai-ji Maki-e*, Kyoto, 1971, p. 16, #18 (*kara-bitsu*) "chest with legs."

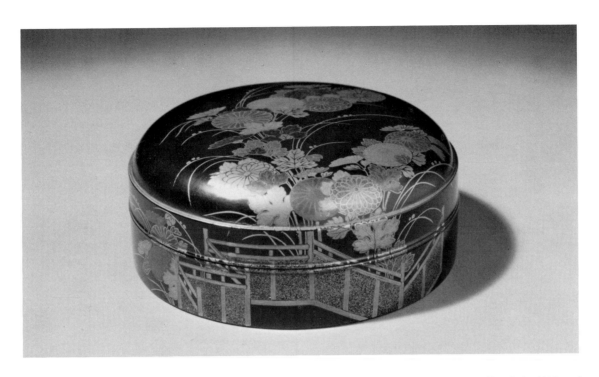

Dimensions: Dia. 5½ in. (14.0 cm.)
Ht. 2¼ in. (5.7 cm.)
Seventeenth century.

5. Mirror Box (*kagami-bako*)

Autumn grasses and flowers, including variations on chrysanthemums in bloom, were favorite subjects of Kōdai-ji style lacquers. On this mirror box, flowers emerge from a fencelike enclosure that circumscribes the sides in an elegant design. Sprays of pampas grasses highlighted with dewdrops draw the eye around the lower level of the composition. The design on the cover of the box, however, in which the chrysanthemums seem to literally burst into full maturity, presents a startling and sudden change in perspective. The projection of the full, comparatively oversized group of flowers and grasses on the upper surface of the lid utilizes a close frontal viewpoint and a flatness in execution, that echo Muromachi two-dimensionality. The complex composition, in which the fence rises along the sides in a zigzag pattern with complete disregard for realism and the mixture of visual proportions are characteristic of lacquer designs of the Momoyama period, especially in works known to have been produced by the Kōami masters.[1]

The plain black ground provides a dramatic, unimpaired tonal quality from which the designs stand out in low relief. Here, in typical Kōdai-ji styling, both blossoms and leaves incorporate the *e-nashi ji* technique, with its orangy color. To further emphasize the leaf pattern, veining and general outlining are usually applied in a variation on the low-relief technique called *keuchi*.

The chrysanthemum blossoms and their leaves are made of fine gold and silver powders and of flaked gold. The black lines that define the shapes within the gold pictures are actually left in reserve. In this case, the surface of the strewn powders has not been given a final protective coat, but has been left uncoated, in the typical Momoyama technique called "merely sprinkled" (*maki-hanashi*); thus the silver dust has oxidized considerably. The weave of the fabric used to line the entire box is visible through the lacquer coating on the inner surface of the lid. The new, vigorous movement found in the themes introduced in Momoyama lacquers reflects the emerging vitality of the country and a dramatic change from the somber, more static designs of the previous period.

Note:

[1] For a similar composition see Kyoto National Museum. *Kōdai-ji Maki-e*, Kyoto, 1971. p. 34, #35.

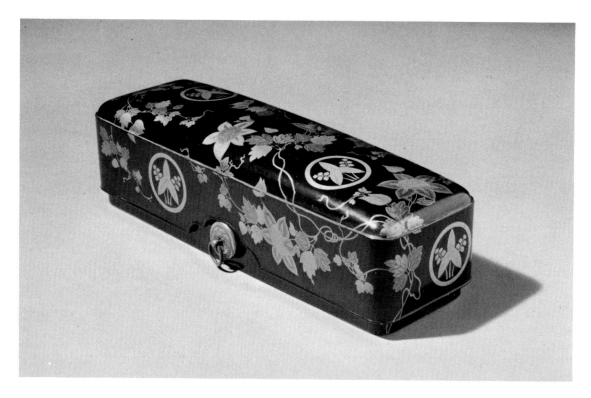

Dimensions: L. 10⅛ in. (25.7 cm.)
W. 3½ in. (8.9 cm.)
H. 2¾ in. (7.0 cm.)
Seventeenth century.

6. Document Box (*fu-bako*)

Winding tendrils of the flowering clematis, in various stages of bloom, decorate the surfaces of this box. The twisted stems of the vine and the mature leaves curve gently along the contours of the arched top and straight, flat sides of the cover. Its overlapping lid is kept in place by two cords, each attached to a ring, and the ends can be tied in a bow to secure the top firmly to its base. A box of this shape customarily held letters or rolled documents and was used for either storage or as a courier's message container. The emblem prominently displayed on the design, is a family crest based on a form of water plantain. This particular blazon, set within a golden circle, was originally used by the Mizuno family and appeared on such family possessions as kimonos and lacquers. Since the twelfth century this design has also been celebrated as the *shogunsō*, or "victory plant," and in complex variations its use increased in popularity until the end of the Tokugawa period.

The underpainting of the box shows great calligraphic skill. The brushwork is that of a trained painter, with the pressure of each stroke visible from inception to end. Other evidence of supreme artistry is the swift, sure, continuous movement needed to complete the curving strokes of the intertwining vines. The deep, shiny jet-black ground acts as a dramatic setting in which the surface designs of vines and flowers are worked in *e-nash ji*, and plain gold, in low relief.

Part of the pleasure of this box is hidden by the lid and visible on the lower half only when the box is open. There slender tendrils of swirling vines with perfectly formed leaves, decorated in vivid *e-nashi ji* and finely powdered gold, greet the eye. Only the owner or the recipient of the contents of the box would view this subtle artistry. The entire surface, executed in typical Momoyama techniques, has a glossy finish achieved through a final coat of lacquer.

The Edo Period

In Japan the term "Renaissance" may best be applied to the first half of the Edo period. As in Europe, Japan's revival in art and literature came about as a direct result of a radical change in the social and economic climate.

With the advent of the Tokugawa shogunate, strict laws, accompanied by an isolationist policy, were successfully enforced. The social structure was frozen into four classes, and transition between them forbidden except by special permission. The four categories, based on the Confucian concept of productivity within a society were in order of merit; samurai (warrior), farmer, artisan, and merchant. The samurai class had almost life-and-death control over the the rest of the people; yet, ironically, it was their refusal to cope with certain economic policies that ultimately resulted in a major shift of wealth, eventually bringing the despised unproductive merchants into a position of power and patronage. Intermarriage was outlawed, and all upper-class marriages required permission from the shogun.

In order to prevent the raising of money for rebellion, the government required the *daimyō* of the provinces to maintain two households, the primary one within the capital at Edo (Tokyo) and the other in their home province. The wives and children of these provincial rulers were literally hostages as they awaited the return of their husbands for varying periods of time, from six months to two years, depending on their home provinces' distance from the capital. The need to finance the large entourages necessary for such continuous travel stripped these aristocrats of funds, while the merchants who supplied the goods necessary for such movements gained wealth and power. Simultaneously, the samurai class found themselves without military pursuits and often reliant upon government stipends.[1] By 1638 the country was isolated from external influence, and all trade with foreigners was restricted to a small island called Deshima, off the port of Nagasaki.

The samurai class, having no wars to fight, became interested in the arts and literature, while at the same time new art forms, inspired by the emerging middle class quickly developed. If Momoyama reflected the subtle elegance of the aristocracy, the Edo period brought forth a new patron, bursting with vitality and hungry for bright opulence.

In 1603 the castle town of Ieyasu became the capital of the country, and Edo began to flourish as a major artistic center. The government invited many established lacquerers from Kyoto while also patronizing new families of artisans whose subsequent generations were retained under the patriarchal hereditary systems. These artists introduced new shapes and forms in lacquer. Koma Kyūi (died 1663) and Kajikawa Hikobei began their lines of succession during the seventeenth century. Yamamoto Shunshō, also of Kyoto, whose line continued for many generations became known as a perfectionist in the burnished lacquer technique called *togidashi*. Shiomi Masanari (1697-ca. 1722), also of Kyoto, became a specialist in this technique as well and started his own school, but he worked in a different style.

The history of lacquer as a focus for artistic statement rather than as a decorative device, could be said to begin with Hon'ami Kōetsu (1558-1637). Kōetsu broke from the so-called classical style of the Momoyama period and was the first to combine gold lacquer and a pewterlike metal in a new shape for writing boxes. Especially notable was the contour of the lid, which was made to resemble the swell of a mountain. He also moved the inkstone from the center to the left side of the box and made it larger, a more practical application. Almost one hundred years later, Ogata Kōrin (1658-1716) followed the same decorative style, but his forms were more classic and the inkstone of the writing box was moved back to the center.

Kōetsu did not generally sign his work (but his distinctive style is easily recognized); therefore existing lacquer works bearing his or Kōrin's signature, are highly questionable. There is no documentary proof that either or both actually did the lacquer work themselves or, instead, supplied the designs and concepts. As a result, there are few extant authenticated pieces.

The experimentation during the Edo period resulted in a refinement of old methods along with many innovative combinations, which produced more variety in design techniques than during any of the previous periods. The passion of the rising middle class for lacquer gave rise to new shapes, gorgeously decorated, and it is during this period that the multitiered medicine container called the *inrō* became the focus of a movement that crossed all social boundaries. It became the most elegant form of personal attire not made of cloth.

Note:

[1] These stipends, paid in rice, had to be converted to spendable funds. This resulted in the beginning of a rice exchange, innovated by and controlled through the merchants, who naturally reaped great profits.

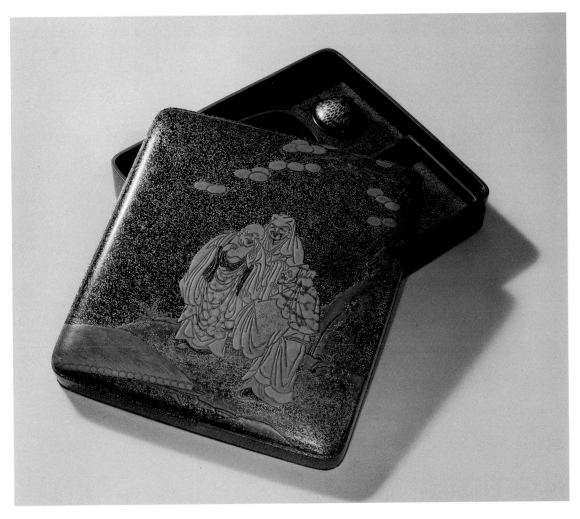

Dimensions: L. 9⅜ in. (23.8 cm.)
W. 8½ in. (21.6 cm.)
H. 2⅛ in. (5.4 cm.)
Seventeenth century.

7. Inkstone Box (*suzuri-bako*)

There is a famous allegory in which the Chinese Buddhist theologian and priest Hui-yüan (334-416), makes a vow never to leave the perimeters of his retreat and cross the Tiger Ravine.[1] One evening, after an enjoyable gathering, two of his friends, a Confucian poet and a famous Taoist sage, join him in a stroll. Deeply immersed in conversation, the group crosses a bridge over the river that acted as Hui-yüan's boundary. Suddenly the three stop. Realizing the vow had been broken, they burst into the spontaneous laughter that accompanies man's insight into his own folly. The scene of the three laughing sages appears on the cover of this writing box, an indication that its owner must have been familiar with this classic Chinese tale.[2] The theme has been interpreted in many mediums, but this rendition may have been directly influenced by a fifteenth-century ink painting.[3]

Stylistically, the lacquer composition displays the soft contours of traditional Japanese painting. The robes of all three figures fall away from the bodies in naturalistic folds. The textures as well as the designs of the fabrics have been carefully delineated to stand in relief, and their patterning has special significance. For example, the figure of the Buddhist Hui-yüan displays the Japanese symbol of chrysanthemums on his Indian-style monk's garment, while the two other figures wear the more typical Chinese-style robes, undertrousers, headdresses, and soft slippers. Pine branches arching above the group give emphasis to the background, and the flowing water at the foot of the hill below them forms an almost circular frame around the group.

The ground of the composition is of scattered gold flakes. The pictorial images are mainly of sprinkled gold on a raised surface (*taka maki-e*), in the fine-powdered heavily sprinkled gold called *fun-dame*. Surface treatments of the designs in relief are also of varying levels covered in gold. Pieces of coarse sprinkled blue-green shell (*ao-gai*) are embedded in Buddha's robe and decorate the trousers of one of the other figures, acting as a strong color and textural break from the otherwise monochromatic costuming. Additionally, small flakes of shell are scattered sparingly throughout the foreground and protrude above the surface of the tree trunk. These highlights, along with patches of small thin-cut gold squares, provide the contrast of sparkling texture. Since the fine powdered gold on the garments appears as a matte finish, the surface coloring seems to recede against the more highly polished highlights supplied by these applications of the pure metal.

Inside the lid a scene of great turbulence is revealed . Against an orangy *nashi ji* ground, clouds drift across a serene moon, contrasting dramatically with the thunderous upheaval of waves against a small islet of rocks with a broken tree. Two birds are perched on the main section of the uprooted trunk, while one hovers in flight near them. The smooth surface of the moon, a cutout of silver foil, catches the eye, causing it to move around the different components of the composition. There is no doubt that the strong contrast in tone — set by the joyful scene on the outside of the box lid set against the turmoil portrayed on the inside — is intentional. The sense of calm in the face of great upheaval portrays a state of mind: the three birds, symbolizing the three men on the lid — above the chaos — suggest calm in the face of adversity. The surface composition is in low and high raised gold relief, with scatterings of various small pieces of the shiny metal added for highlights.

The broad formation of the inkstone and the size of the brush tray usually reflect the influence of Kōetsu, who, as noted, placed the stone on the left side of the box rather than in the center. However, occasional examples of inkstone boxes dated to the Muromachi period also display this untypical formation. Here, the softly carved deep stone is considerably thicker than usual, lending a practical stability to the formation of the bottom of the box.

Notes:

[1] Some translations of the story call the boundary "Tiger Creek," which would be more relevant here.

[2] Traditionally this group, as shown here, are known as "The Three Laughers" and represent the Three Creeds: /Sākyamuni (567 B.C.-487 B.C.), who represents Buddhism; Confucius (551/2 B.C.-478/9 B.C.) Confucianism; and Lao Tze (3rd century B.C.), Taoism.

[3] A photograph of this painting, from the Asano Collection of Tokyo, may be found in the catalogue titled *Japanese Ink Paintings*, edited by Yoshiaki Shimizu and Carolyn Wheelwright, The Art Museum, Princeton University, 1976, p. 30.

8. Inkstone box (*suzuri-bako*)

The Rimpa tradition, based on a totally Japanese style, was first introduced in the late sixteenth century by the connoisseur-calligrapher Hon'ami Kōetsu and the calligrapher-painter Tawaraya Sōtatsu (late sixteenth-early seventeenth century), both of Kyoto. However, the term "Rimpa" was derived from the name of its major and most renowned practitioner, Ogata Kōrin (1658-1716). *Rin* came from Kōrin, *pa* means "school", thus "Kōrin's school." This misnomer occurred because, until recently, little was known about Kōetsu and even less about Sōtatsu. Although recent reevaluation of the school now places even greater importance on Sōtatsu's contribution, for the lacquer scholar it is Kōetsu's innovative style that set the precedent.

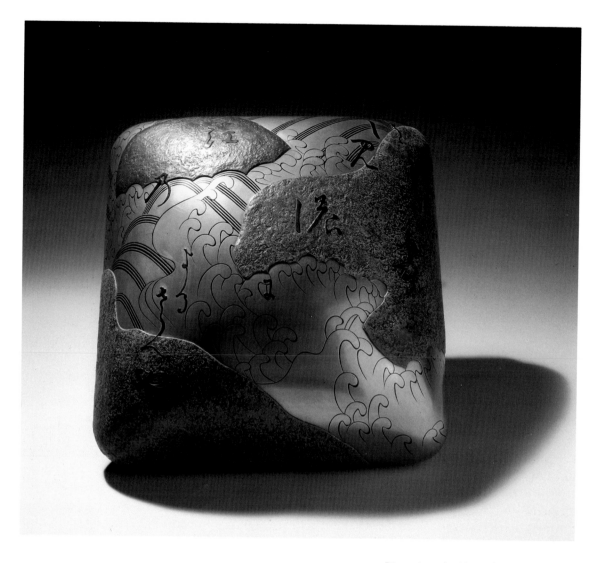

Dimensions: L. 10½ in. (26.7 cm.)
W. 9⅝ in. (24.4 cm.)
H. 4½ in. (11.4 cm.)
Style of Eighteenth century
(early 19th century facsimile)

Sometime during his career (the dates are not known), Kōetsu introduced a new high-domed shape to the lid of the writing box. He juxtapositioned broad areas of sprinkled gold lacquer to masses of lead or pewterlike material, with raised characters of writing imbedded on the lid's surface, and moved the inkstone from the center to the left side of the box, allowing the ink to be closer to the work area[1]. This style was supposedly never repeated, except, by Kōrin.[2]

Ogata Kōrin's life is well documented, especially his development as a painter; but little, on the other hand, is available concerning his artistry as a lacquerer. As with Kōetsu, it has been hypothesized that Kōrin did not actually make his own lacquers, but oversaw their manufacture and, of course, supplied the designs. Drawn to Kōetsu's style in lacquer, Kōrin followed the tradition with variations of his own. In the early nineteenth century the great painter Sakai Hōitsu (1716-1828) revived the Rimpa spirit.[3] The box shown here is a product of this early nineteenth-century revival. It is a copy, of Kōrin's copy, of a Kōetsu original, which unfortunately, has been lost. Accordingly it seems possible that the original Kōetsu box was pawned by Kōrin in 1693.[4] Otherwise there are no records that date the existance of Kōetsu's earlier example except the inscription found on the outside storage box that houses the Kōrin copy.[5]

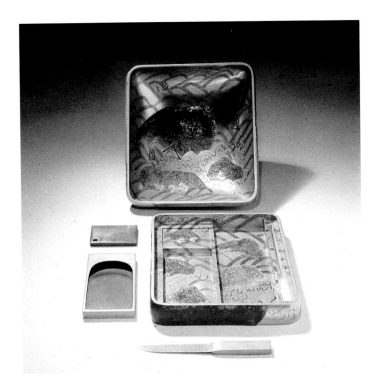

Inside View

This *suzuri-bako* is extraordinarily heavy because of the large amounts of metal applied to all its surfaces. The distinctive shape of the lid raises the question of whether wood or another material was utilized for the core within. Certainly, the addition of so much metal places considerable stress on the shape. Never before or probably since, has the substructure been so complicated. There are three possibilities as to the type of material utilized in its underneath construction. The first is that its domed shape is a result of a molded *kan shitsu* "dry-lacquer" technique; the second, that it is hide, first molded into a form and then used as a support to which "dry lacquer" was added; the third, and most probable, is that the basic structure is of wood, in four sculpted sections, joined tongue and groove to form the desired shape, covered with cloth on both sides for reinforcement, and filled with a lacquer compound, which also acted as an adhesive for the metal inlays. There is a definite change in the angle forming the high sloping sides as they continue up from the four rounded edges. After the middle coating process, it seems likely that thick coats of *kokuso* were used to build the body, (a tiny chip on the inner wall of the bottom shows some kind of compound under the sprinkled gold lacquering). Also, the metal inlays would have to be secured to the understructure completely. Probably the inner sections of metal are half again as thick as those projecting above the surface.

Kōrin was also a famed textile designer, and his technical training in that field is evident in the wave patterning visible on all the surfaces of this box. Upon close examination it becomes evident that a stencil, such as is used in fabric design work, was first applied section by section with an ochre lacquer mix to the finished black surface of this box. After the design was semidry, gold powders were then sprinkled on it, a method that would account for the even quality of line.

The workmanship of this facsimile can be appreciated most in the formation of the Chinese characters and the Japanese syllabary (called *kana*) that make up the poem, and are inserted into the composition in polished metal. Although the *kana* and Chinese characters on this box appear to be in the same area and general style of those on Kōrin's example, there is enough variation in the spontaneous flow of the calligraphy to indicate the artisan exercised some individuality in his interpretation.

The writing on the cover reads:
Suminoe no
— yoru —
continues on the under side of the lid:
yoru sae ya.
yume no kayoi ji
hitome
and is completed on the inside of the bottom section:
yokuramu.
The orginal poem reads:

Suminoe no	With the waves rolling in
kishi ni yoru nami	on the shores of the inlet at Sumi
yoru sae ya	even in the evening
yume no kayoi ji	at the meeting place of my dreams
hitome yokuramu[6]	will she flee from others' eyes[7]

Written by Fujiwara Toshiyuki (880-907), this *waka* is originally from the *Kokin Waka Shū* ("Ancient and Modern Poems"), an anthology of 1,100 poems compiled in the early tenth century. It should be noted however that the script on the cover omits the calligraphy for the words *kishi*, meaning "bank" or "shore," and *nami*, literally, "waves." Obviously the artist wanted the masses of metal formed into rocks (acting as the bank or shore) and the wave patterning, to act as pictograms thus replacing words with imagery.

In the late nineteenth century, there was another revival of Kōrin's works in both painting and lacquer for the European export market. One reason for dating this box to the early-nineteenth revival category is the artists' attempt to change enough parts of the design and metalwork to demonstrate independence of thought. Late nineteenth century copyists were chiefly interested in producing deliberate forgeries for the ignorant foreign market. They would have been less likely to undertake the kind of painstaking work necessary to create this particular box. To the best of this writer's knowledge, this example of a true revival piece is the only one of its kind in the United States.

Although the documentation on the outside box (*tomo-bako*) of Kōrin's piece in the Seikadō Collection identifies it "as a copy of Kōetsu," it seems possible that further study on this subject is necessary. There is no doubt that the calligraphic style of the written metal characters is that of Kōetsu; the question is whether the rest of the design is Kōetsu's or did it, perhaps, simply provide an inspiration for Kōrin.

Notes:

[1] The only surviving writing boxes utilizing the high-domed lid and attributed directly to Kōetsu are the two known as *Funabashi* ("Boat Bridge") at the Tokyo National Museum and "Man Carrying Brushwood" at the Atami Museum. The *Funabashi* box has high incrustations of script similar to those seen on the example shown here.

[2] It seems possible that Kōetsu's box maker had a secret formula for creating a box whose structure could withstand heavy applications of metal. Certainly later copies were few in number, and some of the technology was probably lost. Recent attempts at simulating the old appearance of the metal inlays have failed.

[3] In 1815 Hōitsu published the famed *Kōrin Hyakuzu* (one hundred sketches by Kōrin). A supplementary volume followed in 1826. Other similar publications reviewing Kōrin's works were also published during the first quarter of the 19th century, known also as the "Kōrin Revival" period.

[4] Howard Link and Tōru Shimbo. *Exquisite Visions: Rinʼpa Paintings from Japan,* Honolulu Academy of Arts, 1980, p. 139.

[5] Kōrin's example of this box is a "Registered Important Cultural Property" in Japan and found in the Seikadō Collection in Tokyo. It is pictured in Yūzo Yamane, *Sōtatsu to Kōrin,* Nihon no Bijutsu, Vol. 18, p. 123, #64.

[6] *Nihon Koten Bungaku Taikei.* "Kokin Waka Shū," #559, Vol. 12, Iwanami Shoten, Tokyo, 1958, p. 214.

[7] Translated by Sharon Nakazato.

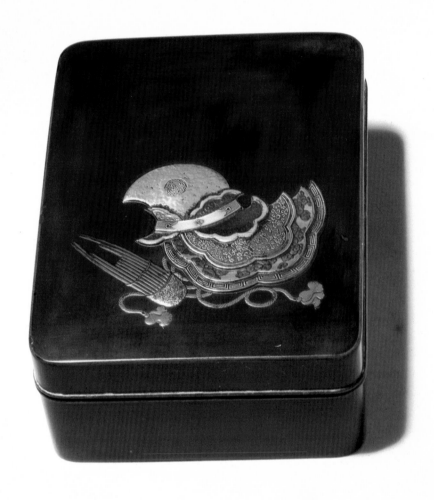

Dimensions: L. 4½ in. (11.4 cm.)
W. 3⅜ in. (8.6 cm.)
H. 1½ in. (3.8 cm.)
Eighteenth century.

9. Incense Box (*kō-bako*)[1]

Poet, painter, potter, sculptor, and master of lacquer works, the creator of this box, Ogawa Haryū (1663-1747), later known by his art name, Ritsuō, was a true Renaissance man. He was born in Kyoto and was the son of a samurai family.[2] The advent of peace left the family dependent upon a government stipend, and it is known that he left home and wandered slowly east until he arrived in Edo at the age of twenty-three or twenty-four. There he met Takarai Kikaku (1661-1707) and Hattori Ransetsu (1654-1707), disciples of the leading contemporary poet Matsuo Bashō (1644-1694). The three young men became lifelong friends and shared living quarters in the back of a sandal shop in the Nihonbashi section of Edo. It is said that Ritsuō never forgot the poverty of those times, though all of his works of art are full of bright color and joyful images.

From poetry, he went on to drawing, painting, sculpture, and lacquer. He was trained as a painter in the Kanō style of painting by a disciple of the famed Hanabusa Itchō (1652-1724), later he and the master became friends. There is very little documentation concerning his training as a lacquerer,

although it has been said that Ritsuō was a student of Ogata Kōrin and his brother Kenzan (1663-1743). Another source, however, states that he learned lacquer from a Chinese master, named Shūsei, when that master visited Japan in the Genroku and Kyōho periods (1688-1734).[3]

Sadly, Haryū's friends both died in the same year: Kikaku at forty-six and Ransetsu at fifty-three. By that time the three had become renowned poets, and Ritsuō's memorial writings in their honor became famous throughout Japan. At fifty years of age, he met the *daimyō* of Tsugaru, the northernmost province of the island of Honshū, who invited the highborn, educated artist-lacquerer to come and work for him. That Tsugaru *urushi* was then of the finest quality must have been an added inducement for the artist to accept the offer. About this time, Haryū adopted the art name Ritsuō, meaning "broken straw hat," perhaps as a reminder to himself of his earlier, leaner times. Under the patronage of the provincial aristocratic household, his lacquer art flourished.

Ritsuō's uniquely styled works demonstrate an interest in Chinese studies, and he delighted in creating imitations of ink sticks in the compartmentalized, multitiered lacquered seal/medicine carriers known as *inrō*.[4] However, his distinctive hallmark was the use of appliqué in a variety of techniques and materials especially the incorporation of glazed pottery inlays. He used various art names, which he signed in either lacquer or ceramic; and the most common being a particular shade of green glazed pottery embossed in the characters for the art name he used in seal form, *kan*.

Historians have often referred to Ritsuō as a student of the potter Kenzan, but that seems unlikely. Close examination of their works shows no similarities in style, technique, or application. Kenzan excelled in a very free and open ink-painting technique and was, perhaps, more interested in the calligraphic image of his surface design than in the color intensity of his glazes. Ritsuō, unlike Kenzan, was a brilliant colorist and, regardless of the medium in which he worked, always considered the dramatic use of complementary tones of paramount importance. What does seem probable is that Ritsuō studied with the famous potter Nonomura Ninsei. (There are no available data concerning Ninsei's birthdate, but he is thought to have died between 1688 and 1695.[5]) Ninsei's works demonstrate a purity of tone and intensity in glaze combined with a vibrancy of design, different from the calligraphic effect so prevalent in Kenzan's work. Exquisite sculptured faience inlays are usually found in Ritsuō's lacquer work, except in his ink cake lacquers. Each appliqué of glazed pottery is an artistic achievement from the hand of a superb potter. It seems probable that there was a relationship between Ninsei and Ritsuō, but unfortunately there is no documentation available to this date that substantiates this theory.

Bugaku, a musical dance drama, was imported from China into Japan in the seventh century. This sophisticated form of court entertainment must have fascinated Ritsuō and his clients, for the costumes and other accoutrements used in its performance decorate many of his lacquered objects.[6] The headgear shown here, worn by most performers, is shaped like the stylized silhouette of a bird and is called a *tori-kabuto*. Elegantly decorated and usually lined in scarlet silk, it has appeared in art as a symbol of the entire Bugaku dance form.

The wind instrument know as a *shō* is part of the musical accompaniment in Bugaku and is also employed in other stately or sacred music. It is made of seventeen bamboo reeds of various lengths bound together by a circular band and blown through one opening. The sound it makes resembles that of a chord on a reed instrument.

Both these objects appear on the lid of this small box, which is finished in exquisite detail. The hat is of gold and black lacquer, with mother-of-pearl, inlaid pewter, and multicolored glazed ceramic inlay. The double-banded instrument is of gold and red lacquers in low and high relief, highlighted with metal inlay. The tasselled string that ties under the chin of the dancer in order to secure the hat, is in high relief red lacquer. The black lacquer ground has "caramelized" with time, and the resultant gradations in tone and color add a sense of age to the piece.[7] The adroit positioning of the compositon with its technically complicated components, could have been achieved only by a great master.

In keeping with the quiet dignity of the cover, the inside of the container is undecorated except for a light even sprinkling of *nashi ji*. The edges on the box are lined in a pewterlike material and the artist's mid-life signature, Ritsuō, is accompanied with a red glazed faience seal that reads *Kan*.

Notes:

[1] During the early part of the Edo period small rectangular boxes like the one seen here came into use. It functioned either for sweetmeats or as part of an incense game set. Whether a box is a *kō-bako*, meaning, literally, "incense box," or a *ko-bako* —meaning "small box," is difficult to determine. Probably this piece was utilized as an incense container.

[2] According to recent information provided by Imamura Kenzō, head of the eleventh-generation house of Ogawa, the residence called *Nijō jinja* (now a national shrine) in Kyoto was founded by Ogawa Tosanokami in the sixteenth century. The building was originally a "Rice (Bank) Exchange," then a pharmacy, and a little later a hotel for *daimyō*. Accordingly, Haryū (not Haritsu, as previously used) was born in this house. He had two brothers, and, being young, restless, and possibly independent in nature, left his home to wander. If this information is correct, then his early study in Kyoto and his acquaintance with Kōrin, Kenzan, and Ninsei, also of Kyoto, are more valid. A sign posted at the shrine gives the historic information about the building, but Ritsuō's early history is unknown, possibly because of his departure (in disgrace?) from his family.

[3] Naohiko Masaki "Haryū Zaiku no Hanashi" (Talking about Haryū's Works), *Tokyo Bijutsu Gakkō Kyōyūkai.*, Vol 9, Tokyo-Bijutsu Gakko, April 1930, pp. 1-2.

[4] See Ann Yonemura, *Japanese Lacquer*, Freer Gallery of Art, Washington, D.C., 1979, pp. 76-85, for original research on this subject.

[5] There are various conflicting opinions as to Nonomura Ninsei's true dates, but the most recent source is Masahiko Kawahara, "Ninsei," *Nippon Toji Zenshu* #27, Tokyo, 1976, p. 11.

[6] Similar interpretations of the theme may be found in the collections of Charles A. Greenfield and the Metropolitan Museum of Art.

[7] The black coloring of *urushi* is achieved by the addition of iron filings. With time there is a natural chemical change within the final coatings, resulting in a mottling or "caramelized" effect. Usually the degree of caramelization is an indication of the age of the lacquered object.

10. Inkstone Box (*suzuri-bako*)

The owl is seldom seen in Japanese art because it was considered by the Chinese (whose repeated influence is reflected in many aspects of the Japanese culture) to be an unfilial bird (supposedly devouring its parent) and a harbinger of death. It seems probable that the creature's nocturnal habits were responsible for its unhappy associations with night demons. In the late seventeenth and early eighteenth century the bird began to appear on lacquer objects, such as this inkstone box, perhaps originally introduced by the artist Ritsuō as he recalled the days of his youthful wandering.

On the lid of this box an owl sits with its back to the viewer. Perching on the branch of a tree, it is seemingly gazing at the moon. The composition sets a lyrical, if somewhat poignant mood, reminiscent of a famous poem created by the artist and his friend Kikaku.

Aki kaze ya
kasa ni yadokaru
ama ga shita
matsu o sanjo ni
tasogareshi tsuki.

Feeling the autumn wind
under my woven hat,
only this moment do I see
the moon rising
over the pine tree.[1]

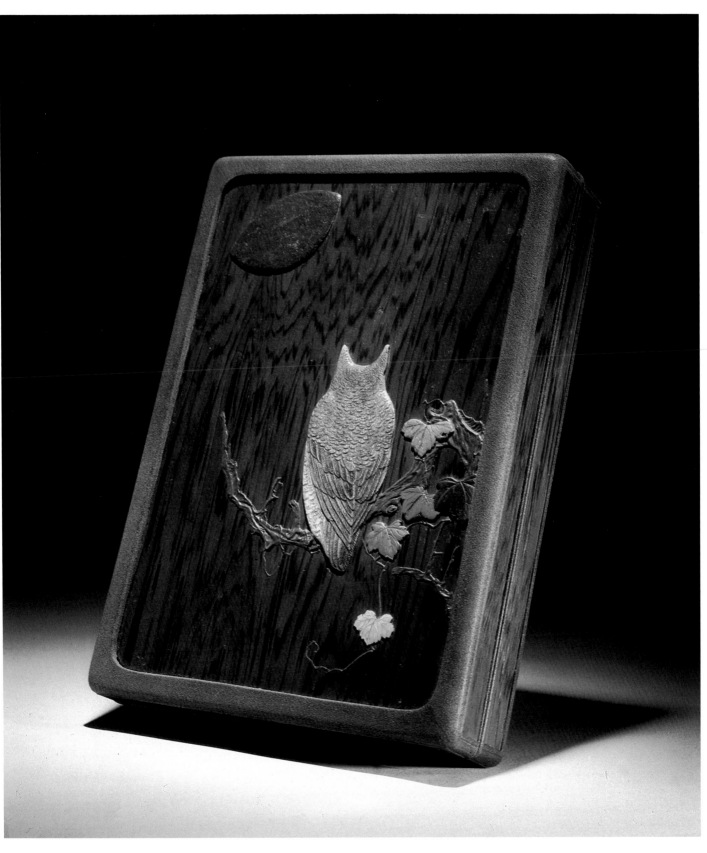

Dimensions: L. 8½ in. (21.6 cm.)
W. 6⅜ in. (16.2 cm.)
H. 1¾ in. (4.4 cm.)
Eighteenth century.

51

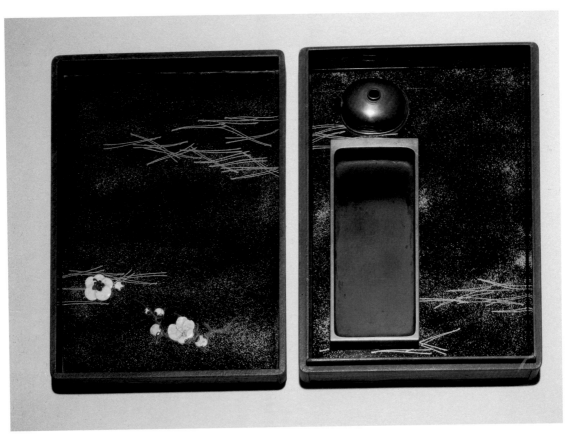

Inside View

The lid and sides of the box are completely surrounded in what at first appears to be a metal enclosure, an eminently practical detail that would protect the edges of the lid.[2] Close examination, however, proves that the muted gray substance, grainy in texture, is actually lacquer imitating the alloy know as *shi bu ichi*, which has been combined with powdered pumice.[3] Its soft, light color provides a contrast to the dark, naturally textured wood of the adjacent ground. Five leaf-shaped inlays composed of carved red lacquer, gold lacquer, mother-of-pearl, and black lacquer simulating the appearance of *shakudō*, decorate the right side of the lid.[4] The tree branch on which the owl perches is brown *urushi*, textured and colored to resemble bark. By providing a soft, glowing highlight, the twisted vine of pure sprinkled gold contrasts subtly with the deep brown of the ground and the tree.

The moon, which first appears to be an appliqué of a leadlike material, recalls Kōrin's metal inlay work, but this area is again, of lacquer. The owl's body, delicately feathered, is an inlay of ceramic; all the bird's feathers are carefully delineated to form a mass that blends into the total composition yet provides a textural contrast. Ritsuō was known for his multiple inlay and was the first master of this style.

On the inside of the cover is a variation of the sprinkled gold "pear-skin" ground technique called "cloud" or "*mura*" *nashi ji*. It provides an uneven sparkling backdrop for the slender, elongated pine needles that appear in gold low relief. Glazed ceramic inlays in the shape of cherry blossoms have been carefully set into the lower part of the composition. The delicate stamens of the flowers are in that particular shade of green often seen in the potter Ninsei's works, as well as in the glaze applied to Oribe-style pottery. As this shade appears in the majority of Ritsuō's work (with the exception of his ink-cake shaped *inrō*), as well as on the pottery signature seals he applied to his later lacquers, it has become an aid in identifying the work of the master.

Signature Seal

The tasteful and harmonious placement of the delicate young buds alongside the soft open petals of the mature flowers, all of which are scattered in perfect balance, is a tribute to Ritsuō's mastery of design. Again the inkstone has been positioned on the far left, with space on the right for the brushes. The master's ceramic-embossed, green-glazed seal *Kan* appears under the inkstone and is set into the bottom of the box and protected by a reserve in the underside of the stone.

Notes:

[1] Translated by Naoko Yaegashi.

[2] For another variation by the artist of this same theme (showing the owl full faced), including the use of an enclosure, see "A Lacquer Box," *Kokka #228*, The Kokka Publishing Company, Tokyo, May 1909, pp. 359-362.

[3] An alloy usually made of three parts copper to one part silver which when "pickled" in a solution turns a soft gray. It is then scraped off and in its powdered form sprinkled on the moist *urushi*. Its appearance may also be simulated by silver powder and charcoal.

[4] An alloy of copper and gold which when "pickled" in a solution turns a shiny black. Its appearance, however, may be simulated by black lacquer.

11. Container for Sweets (*kashi-bako*)

Mochizuki Hanzan, who worked during the mid-eighteenth century, was a pupil or follower of Ritsuō, but he developed a virtuosity of style and movement that made him a master in his own right. Little is known about him, but he was undoubtedly educated and skilled in many arts since his works show a knowledge of literature, court entertainment, and tea ceremony. Containers for sweets, such as the example shown here, are an integral part of the ceremony utensils; the taste of the sweet is balanced with the somewhat bitter taste of the green tea. [1]

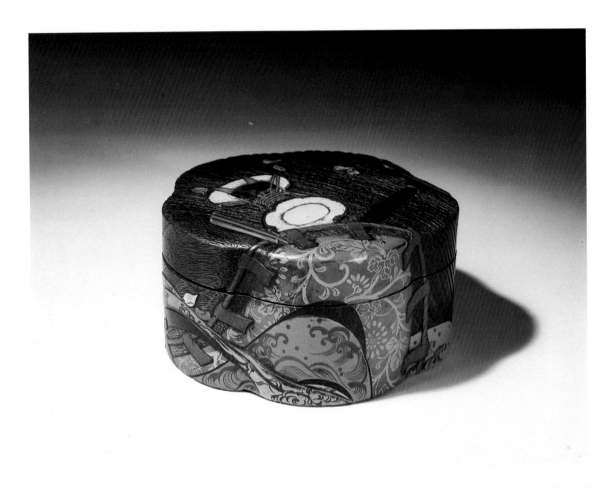

Dimensions: Diameter 5⅛ in. (13.0 cm.)
Height 2⅝ in. (6.7 cm.)
Eighteenth century.

Like the incense box of cat. no. 9, this container has a cover design centering around court entertainment, but while the former design is quietly elegant, this one reflects unrestrained youthfulness and a vitality of movement. The lobulated form in paulownia wood is an unusual shape for a container for sweets. The natural graining of the wood has been incorporated into the compostion so that its surface variegation simulates the calligraphic strokes that represent a swirling wind. The drum used in formal music, the fan, and the divided curtain shown here are all components associated with the dance. The fabric of the curtain, attached to both holders and cord, billows and swirls as if disturbed by a sudden fierce wind. Falling leaves are tossed upward, and the drum and fan, also caught in the same strong draft, are blown askew, suggesting the disruption of a performance.

The darkened stained wood acts as a dramatic backdrop for the green and salmon-colored lacquered curtain, whose high-relief surface is superficially decorated in gold, silver, and black designs. The inlaid leaves are of mother-of-pearl, many of them partially covered with red lacquer for contrast. The cord to which the curtain is attached and the curtain's tabs are finished in gray and brown lacquers. Pottery inlay is the indispensable characteristic of a fine Hanzan creation, as of the works of Ritsuō. In this example it is seen in the two ceramic yellow-glazed inlays constituting the two sides of the drum. The red lacquer cords that hold the drumhead tight supply a colorful contrast to the quiet, smooth surface adjoining it. The box is signed on the bottom with an inlaid seal of ceramic, embossed with two characters reading *Hanzan*. Red lacquer has been rubbed into the spaces between the raised lines of the signature, simulating the red paste left in the recessed areas of a handheld personal seal.

Note:
[1] For a description of tea ceremony utensils see Ryōichi Fujioka, *Tea Ceremony Utensils*, translated and adapted by Louise Allison Cort, New York/Tokyo, Weatherhill 1973.

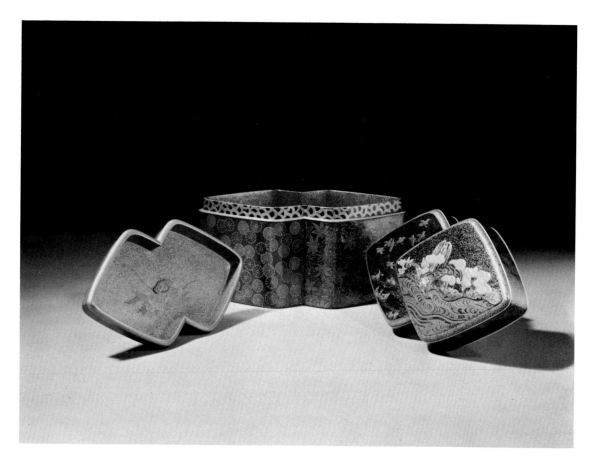

Dimensions: L. 4½ in. (11.4 cm.)
W. 8¾ in. (22.2 cm.)
D. 4½ in. (11.4 cm.)
Eighteenth century.

12. Incense Box (*kō-bako*)

The four seasons are an important element in Japanese aesthetics and many art forms incorporate symbolism reflecting seasonal changes. The four sides of this box bear designs symbolic of spring and fall. Cherry blossoms and bamboo grasses on one side suggest the former, while maple leaves and chrysanthemums recall the latter. These motifs are applied in a subtly grayed hue combined with a brighter gold tone, in that one-level burnished technique called *togidashi*. The double-lozenge shape creates an overlapping quadratic form for the lid, providing an unusual surface for its composition.[1] Of the two landscapes on the lid, the right half has a more three-dimensional construction. It is further divided on its horizontal plane by an irregular raised ledge, representing a shoreline. Part of the effect was accomplished by the box maker, who layered the top when he made the box. Thus the area is raised, in part, by the wood of the lid. Further elevation of the shoreline, however, was created by the addition of either *sabi urushi* (a mixture of lacquer, powdered pumice and water) or, powdered charcoal. The dense substance was applied to the desired areas, and when semidry was contoured to form specific shapes. When completely dry, the surface was sanded smooth and was then ready for the application of finishing techniques. The two landscapes on the lid echo the seasonal themes decorating the sides and reflect the atmosphere of day and night by providing dark and light-colored grounds.

The ground under the swirling river, created of sprinkled gold on the right panel, and the edge of the shore, have been highlighted by the addition of thin rectangular pieces of gold in various sizes. These slightly thicker slivers of shiny metal create a bright reflection on the water in an effect, reminiscent of a sunny day. The left side of the lid is dominated by a black ground, only sparingly sprinkled with fine particles of gold; this ground creates the illusion of night. Plovers in gold low relief fly across the sky,

while below them water plantains growing in patches line the shallows. Again the cut-gold highlights on this area provide a sparse and subtle contrast.

The tray inside the box is suspended by a high inner lip, whose outside ridge is decorated with a textile pattern in gold low relief. In the middle of the tray is an inlay in the form of a green-stained ivory grasshopper, with long, elegantly curved antennae of sprinkled gold, set off by a magnificent ground of heavily sprinkled *nashi ji*. The textured orange color of the ground of the tray compliments the coloring of the insect and adds a touch of life to the otherwise quiet composition.

Note:

[1] Another example of this shape may be seen in Tokyo National Museum, *Tokubetsuten*, 1977, p. 165, #195.

13. Incense Container (*kōgō*)

The shape, size, and quietly rich quality of this tiny, flat rectangular box would indicate that it was probably made to fit inside a cosmetic storage box as part of a wedding set.[1] Such sets sometimes took as long as five years to make and were a necessary part of the aristocratic bride's trousseau. All components usually had the prospective groom's *mon*, or family crest, accompanied in some manner by the bride's blazon. This box represents the finest quality possible and was probably made by the family's own lacquer maker, whose only project for a set period of time would have been the creation of the necessary number of pieces, which would sometimes be as many as seventeen separate articles.

The decoration on the lid incorporates a double-crest design in a repeat pattern. The outer section is of stylized wisteria in a form that represents the emblem of the Andō family of Iwakidaira. The inner section has the stylized pattern of bamboo grasses, covered with snow on a round reserve, that served as the family crest of the Tateno family.

Inside the box both the top and bottom are decorated with a profusion of fall grasses, including bush clover, pampas grasses, and ague weed. When the lid of the box is removed and placed to the left of the bottom half, with its inner surface face up, the interior designs appear as mirror images of each other. The outside of the bottom half of the box is as elegantly decorated as the lid. The ground, of the finest

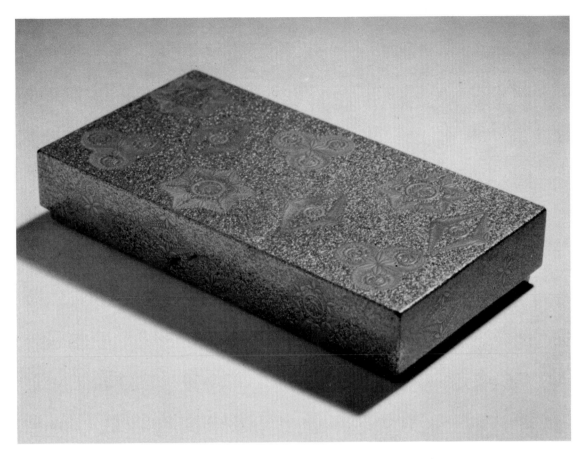

Dimensions: L. 3⅜ in. (8.7 cm.)
W. 1¾ in. (4.4 cm.)
H. ⅝ in. (1.6 cm.)
Eighteenth century.

nashi ji, is so thickly applied, it appears as a tiny sea of gold. A mixture of the highest quality of silver and gold, applied in both low and high relief, in varying consistencies was used in the pictorial imagery. The quality of the work is exceptional, lending it an air of quiet elegance.

Note:

[1] For an example of a lacquer wedding set see Jō Okada et al *Nihon no Shitsugei*, Vol. IV, pp. 18, 19.

14. Portable Picnic Set (*sage jū bentō*)

Cherry-blossom viewing was and still is the most important event of the Japanese spring, and a welcome excuse for a picnic. A particularly poignant event is the loss of petals from the heavily laden trees in a shower of delicate color and velvety texture. To the samurai (especially of earlier periods) this time had a special significance: the loss of the petals of the double-blossom cherry tree symbolized the wish that they, like the flowers, might lose their lives in the bloom of youth rather than in old age.

In a typical portable picnic set, like this one, food and utensils are usually stored or placed in the lidded, five-nested container (*jū-bako*). Drink was served from the two pewterlike sake bottles that sit on the lid of a small, flattened fitted container, whose surface has two cutouts for the sake bottles to rest in. Inside this smaller rectangular-shaped box are five lacquer dishes, elegantly decorated to match the rest of the ensemble. In addition, a deep, uncovered container for storage and a flat, footed square tray for serving fit into their own compartments. Each part of this unit is designed to fit exactly into the richly decorated

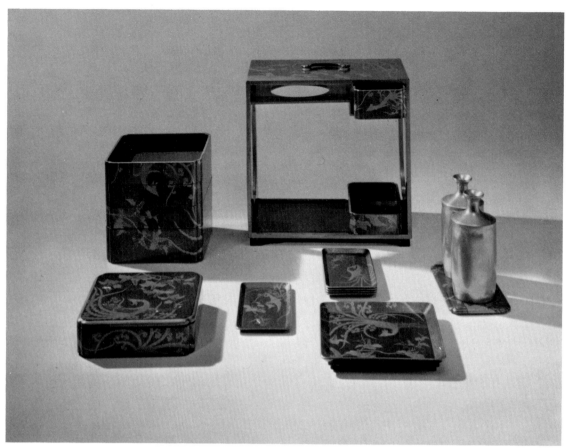

Inside View

frame. The meaning of the cutout in the shape of a covered jar, which makes up the sides of the carrying case, is unknown but is seen often in early picnic sets of high quality.

Judging from the lacquer design, it is highly probable that a member of the nobility owned this set. The small metal pegs that secure the handle are in the shape of a sixteen-petal chrysanthemum; this flower and the phoenix in flight among the branches of a blooming paulownia tree were motifs reserved for the use of the imperial or Tokugawa court until the Meiji Restoration. The colorful background of the compositon and its extraordinarily fine detailing indicates that the ensemble was probably made in Kyoto by a member of the Kōami family. These artists preferred *nashi ji* grounds in contrast to those of the Igarashi school, which displayed more unadorned, solid-colored space.

The deep orange of the *nashi ji* contrasts in texture and tone with the masses of gold that form the long plumage and spread wings of the phoenix. Branches and leaves with flowers and berries of the mature tree supply the vertical element of the composition. All the gold low relief work is done in a powder so finely grained that its surface cannot be polished, but only lacquered. Thin *ao-gai* shell supplies color in the plumage and wings of the bird, as well as for the leaves of the tree. The gorgeous blue, purple, and pink of its coloration is intensified in direct light, and one can imagine that shifting sunlight on these surfaces would create sparkling jewel-like reflections. In cross light it becomes apparent that the subtle feather markings that define the bird's body and plumage, as well as the veining and edges of all the leaves, have been outlined in the thin, delicate gold low relief technique known as *keuchi*. This ensemble epitomizes the quiet elegance and refinement of its owners and is reminiscent in feeling of the Momoyama period, when *Kōdai-ji* style lacquer surfaces were decorated in a similar but less flamboyant manner.

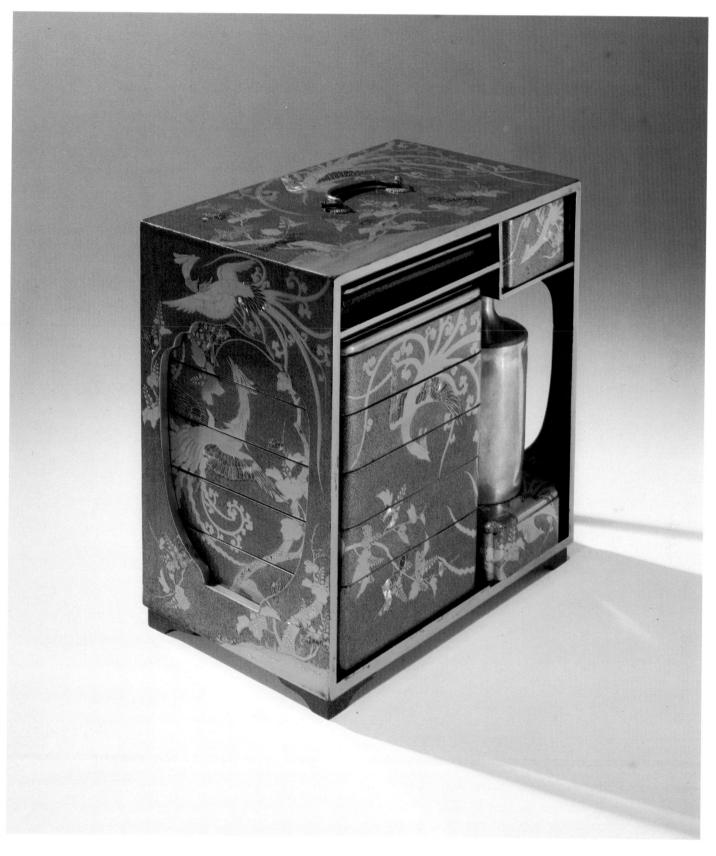

Dimensions: H. 11 in. (27.9 cm.)
W. 11¼ in. (28.6 cm.)
D. 6⅝ in. (16.8 cm.)
Eighteenth century.

15. Portable Cabinet (*sage-dansu*)

It seems appropriate that a cabinet used for the storage of poems, books and paper, including a fitted writing drawer, should bear a design combining a Chinese-style landscape with Japanese lyrical and poetic overtones. The composition of the temple compound suggests the *Ishiyama dera* Temple outside Kyoto. Famous in history, legend, and literature, that romantic and renowned place was where the Murasaki Shikibu wrote the literary masterpiece, *The Tale of Genji*, in the tenth century. One of the eight famous views of Ōmi, this temple is located on the Seta River, which originates from Lake Biwa. With Mount Hiei in the distance, the temple, its compound, and surrounding views are similar to those represented on the various panels of this box, as they might have been observed from the opposite side of the river.

The top panel shows three cranes, two by the water's edge and one in flight looking down on a landscape of a country village surrounding the temple. The hazy, distant half-moon with drifting clouds against the black ground suggests early evening. The pagoda section of the temple is separated from the other buildings by a low mountainous mass. The angularity of the composition with its partial disregard of proportion and variation in line quality, is an attempt to utilize the direct free style of ink painting. Two tiny figures dressed as pilgrims are shown in the foreground, in an allusion to the typical Japanese philosophical concept of man's inescapable smallness against the overwhelming power of nature.

The scene on the front panel is again a landscape, focusing on such greenery as water plantains, a swaying wisteria, and other trees in full foliage. The angle of descent of the three cranes in the upper left corner draws the eye diagonally downward, making the cluster of buildings from which the finial of the temple emerges the focal point of the design. A small village nestles near a pavilion. Rocks jut up in the sharp strokes of a traditional Chinese painting; however, the huts, curving land masses, and wave formations are characteristic of the softer style of Japanese painting (*yamato-e*).

If the box is rotated from right to left, the pictorial images read as a scroll. The left side panel shows a low shoreline punctuated by a large pine tree. Pilgrims and a scholar on horseback with his young assistant behind him are shown crossing a bridge. Other pilgrims wind their way up the side of the mountain and approach the entrance gate to the temple grounds. Brush carriers bringing wood for cooking or heating rest their heavy burdens. The linear emphasis of the composition focuses on the long climb necessary to reach the temple. The general feeling is of activity, and the direction of the movement leads the viewer to the next panel, which is the back of the box.

Here, flying geese, semi-bare trees and the presence of plum blossoms and ducks indicate the season of very early spring. Fishing nets are drying against a tranquil shore. In this view the levels of the pagoda can be seen along with other buildings within the compound. Another small pavilion is only partially visible behind a high mound, two lone figures stand near a side entrance offering again, a subtle yet purposeful commentary. Darkened clouds traveling across the sky, in the upper corner, create a somber mood.

The last panel alludes to the approach of winter in the strength of the high jutting, sheer rocks to which the small pine trees cling. One large, truncated pine is of a size and angle impossible to be natural, yet this exercise in artistic license adds symmetry to the entire composition, providing a frame for the pavilion underneath. The star on the roof of the pavilion and the inclusion of a particular type of short-branched pine suggest that this building might be used for court entertainment. Boats rest along the shore with fishing nets drying on poles. A darkened sky heralds the approach of blustery weather in a reprise of the previous panel.

The techniques used in this complicated artistic rendition are simple and basic. The artist has chosen the classic black high-gloss ground known as *ro iro* to provide the necessary dramatic contrast for the greatest appreciation of the range of gold used. The only variation of hue occurs with the occasional, atmospheric use of silver powder with the gold. The techniques of *togidashi*, *hira*, and *taka maki-e*,

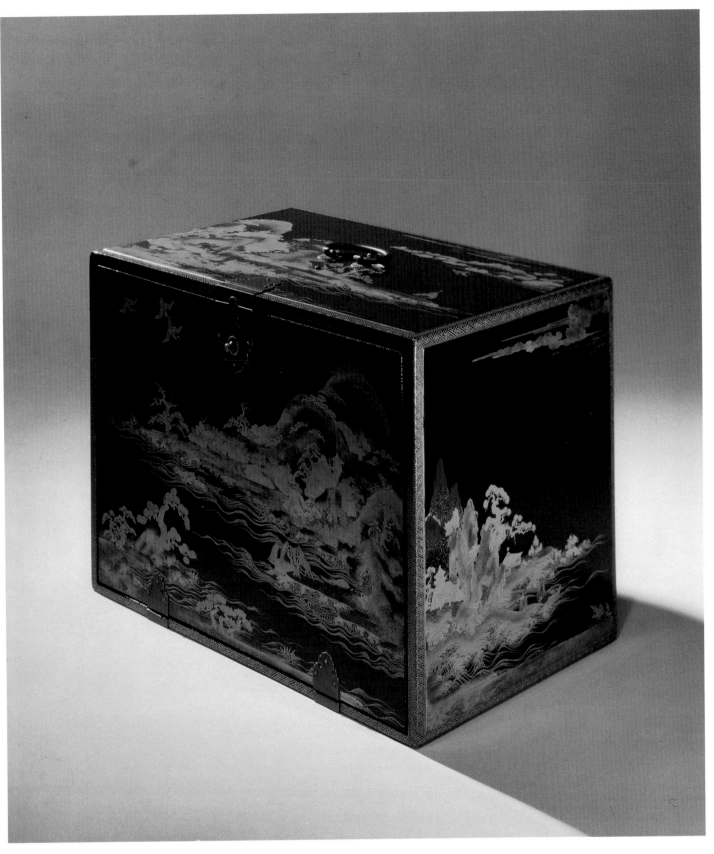

Dimensions: L. 12¼ in. (31.1 cm.)
W. 17 in. (43.2 cm.)
H. 10¼ in. (26.0 cm.)
Eighteenth century.

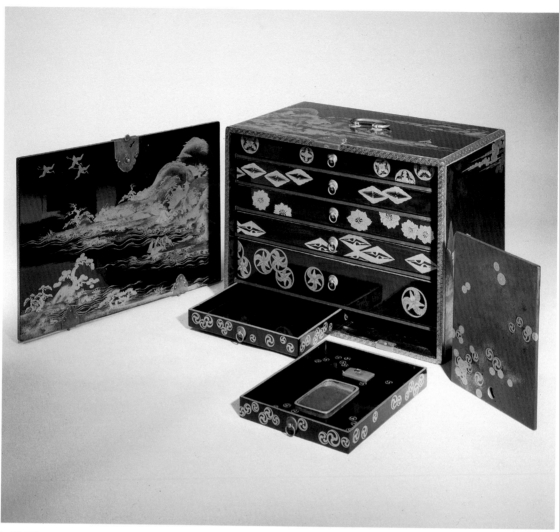

Inside View

have all been incorporated into a harmonious blend; the emphasis is on the painterly quality rather than on obvious technical virtuosity.

The interior drawers are of different depths and a variety of family crests decorate all four sides of each drawer. That the three usually unseen components of a drawer are decorated is evidence of the lacquerer's thoroughness as well as of the owner's wealth and position. The bottom lower right-hand drawer contains an inkstone box whose cover is finished in a fine, muted powdered silver, and adorned with golden patterns in the shape of three commas. This design may represent the owner's crest or it may be a Buddhist symbol matching the symbolic key-fret design embellishing all the outside corners of the box.

The freedom of brush movement apparent in the complex design of the composition, coupled with the obvious extraordinary technical skill, indicate that the creator of this box was a lacquer master of great renown. It is one of the finest examples in this collection.

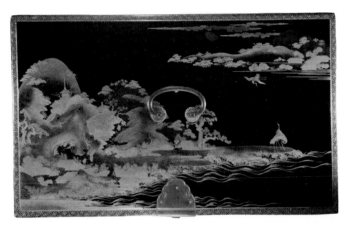

Top View

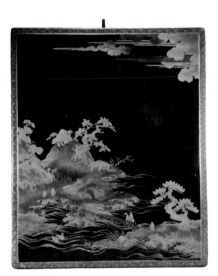

Left Side View

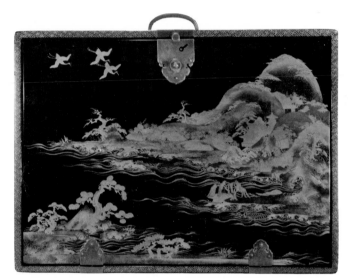

Front View

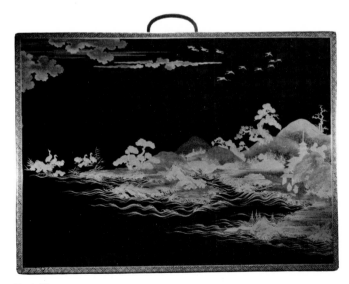

Back View

Right Side View

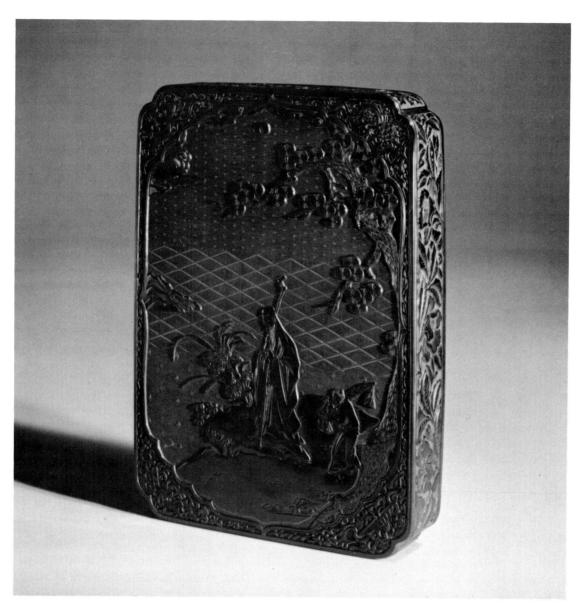

Dimensions: L. 10¾ in. (27.3 cm.)
W. 8⅛ in. (20.6 cm.)
H. 1⅞ in. (4.8 cm.)
Eighteenth century.

16. Inkstone box (*suzuri-bako*)

This two-color box with its inverted corners, has in each of the upper quadrants a mixture of symbols of Chinese origin. The gourd and traveler's hat are the accoutrements of a traveling scholar, while the stone chimes and a pair of rhinoceros horns derive from the Chinese "eight precious things." Set within a large, rectangular reserve, which is the central part of the composition, are two figures: a Chinese scholar and his attendant, shown carrying a long musical instrument wrapped in cloth. They both stand under a large pine tree by the rocky edge of a body of water. In the background a full moon and drifting clouds suggest a night setting, and the chrysanthemums and pampas grasses in the foreground allude to the season of autumn. The Chinese method of intricately carved lacquer (*chō shitsu*) used here is a distinct and difficult technique often employing between fifty to one hundred layers of red (*shu*) or black (*koku*) lacquer which may also be combined, as in this example.

Here, layers of red lacquer were first applied, followed by coats of lacquer. Each application had to be thoroughly dried and polished before the process continued. It was necessary for the lacquerer to know

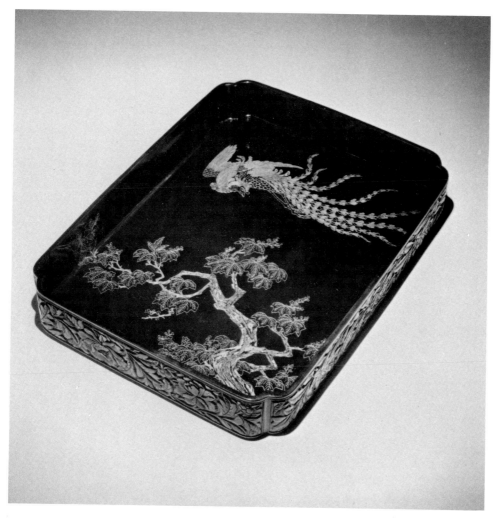

Inside View

exactly how far to cut down through the lower levels of both red and black to produce the graduated coloration seen here. After first carving through and removing the hardened black material where it was not needed, the artist carefully divided his remaining red background into three distinctive areas to provide depth and textural contrast. The lower third, cut into small S-shaped pieces, represents water; the middle ground of lozenge shapes imparts the impression of land; and the upper third, suggests twinkling stars and moving currents of air.

The inside of the lid bears the outline of a phoenix flying over a paulownia tree. This style of work is achieved by an engraving technique know as *chinkin-bori*. Originally brought from China in the Kamakura period it was revitalized, especially in the northwestern area know as Wajima, during the eighteenth century. The technique involves the careful incising of a design in thin shallow grooves into a black lacquer ground. Clear lacquer is then brushed into the grooves and the excess carefully removed with cotton. Finally gold foil or powder is sprinkled or forced into the design. The excess powder is removed by wiping immediately, and the lacquer allowed to harden.

This box, which is extremely heavy, displays the versatility of a very difficult technique in a two-color combination. The box owes its weight to the many coats of lacquer required for finishing its outer surfaces. The traditional Chinese method of carving is usually to cut straight down, emphasizing the depth of the lacquer material as well as the grace and technical precision of the artist. A Japanese variation of this multilayer technique, whereby the distinct coloration of each layer may be seen clearly because the carving is on the slant, is studied in cat. no. 56.

Dimensions: L. 3⅞ in. (9.8 cm.)
W. 3¼ in. (8.3 cm.)
H. 1⅛ in. (2.9 cm.)
Eighteenth century.

17. Incense Container (*kōgō*)

The samurai families of the Edo period lived in a time of enforced peace, with only their history to remind them of past glories. Storytellers told and retold to avid listeners such classics as *The Tale of Hōgen* and *The Tale of the Heike*. These exciting and romantic stories recalled to retired warriors the drama of past challenges and heroic deeds.

The artisan who created this box, undoubtedly as a special order for a member of the samurai class, evidently researched his subject well. The knobbed helmet shown here is typical of the style worn by military chieftains at the end of the Heian period (794-1185) and this example probably represents the helmet worn by the famous late Heian period leader, Minamoto Yoriyoshi (998-1075).

Headgear of this type was shaped as a simple low bowl with a hole in the back for the samurai's queue. After the bowl was lacquered on the outside, eight to twelve metal plates (later twelve to twenty-eight) were attached around the crown and riveted. The inside of the bowl and the outside attached peak were lined with leather. The neck guard usually consisted of five rows of metal or stiff leather, occasionally, as in this case, laced with red silk. Four laminated bands from the back were fused in front to form one piece that curved to frame either side of the face. These cheek protectors were leather-covered and sometimes decorated with the owner's crest. Heavy silk cords were laced through three rings attached

to the inside of the helmet, then secured under the chin, In the late eleventh century hornlike projections modeled on the antlers used in earlier times, were added as decoration and created a more fearful appearance.

A unique part of this box is the formation of the central area of the helmet. The lacquerer shaved or carved away part of the inner wood surface of the lid to provide more dimension for the construction of the composition. After the surface ground of *nashi ji* was prepared, additional irregular flakes of flattened gold were then sparingly applied. This subtle extravagance imparted a textural contrast to the background and a special touch of elegance. The helmet itself is of various colored pigments sprinkled skillfully in low and high relief techniques. The artist was careful to maintain clarity of tone and sharp, precise detailing. "Horns" of thin, finely wrought bronze are set onto the surface.

The cheekpieces are decorated with inlaid mother-of-pearl, covered with gold powders in the lacy patterning of chrysanthemums. The design and workmanship of the box are of superior quality, and complicated, difficult techniques are used; there is a subtlety in the presentation of the composition. The box exudes a feeling of strength without a hint of ostentation.

18. Portable Cabinet for Incense Ceremony (*kō-dansu*)

Incense (*kō*) has been burned in the temples of Japanese Buddhists as part of their ritual since the introduction of the religion in the sixth century. The fragrance served as an offering to Buddha as well as an aid in quieting the mind. In the Heian period there came into use large specially constructed burners over which clothing and hair were draped in order to permeate them with fragrance. During the same period a game developed that centered around the identification of different blends of incense comprised of powdered fragrant wood, musk, and honey.

In the Kamakura period samurai imbued their helmets with strong incense before battle. During the following Muromachi era the ritual known as *kōdō*, or the "way of incense,"became formalized, and rules of etiquette were followed by the aristocrats who practiced it. Finally from the seventeenth to the eighteenth century the game (*kō awase*) reached the height of its popularity. Its two major schools had adherents among the imperial family, the samurai class, and some of the wealthier townsmen. Unfortunately, today most of the components that made up the elegantly lacquered incense ceremony sets have become separated from each other.

This small portable chest is a storage cabinet for elements used in the game. Its three drawers of varying sizes would have contained utensils, papers, extra mica (on which the incense was heated), and the extraordinarily precious whole pieces of fragrant woods from which one would cut a fragment for a game. This piece would then be cut down or slivered as part of the ritual during the actual game. This cabinet is in the typical shape for a *kō-dansu*, and its tightly fitted drawers still retain a delicate odor. The decoration on its surfaces is that of *Nunobiki* ("Pool of Fabric"), and a recurring romantic theme often utilized in literary discourse. Its name is derived from the similarity in appearance between the water falling from a great height over white stones, and the long threads seen in the weave of a fabric. The top and front panel of the box are treated as a continuous composition, with the falls being partially obscured by cherry trees and their blossoms. The lyrical imagery is carried further by single petals gently falling in front of the descending water, while arcs of spume break over rocks and curl back into smaller waves.

The technical achievement of being able to communicate a strong feeling of motion within the *maki-e* format is extraordinarily difficult. Using only gold, silver, and a combination of both, in low and high relief, the artist has created an illusion of majesty and force through tedious time-consuming techniques. The land area on either side of the waterfall is composed of tiny particles of flattened gold. Each flake has been singly applied, rather than sprinkled from a tube, to form a mass of texture. Additional highlights in the form of pieces of gold leaf have been added to the gold-powdered high relief forming the trees and their branches. Each blossom is also individually and accurately rendered in high relief, and the extraordinarily thin-lined stamens of the cherry blossoms add a delicate balance within the design. The angular rocks and stones rising in high *taka maki-e* are emphasized by the addition of thin geometrically shaped pieces of cut gold. The resulting, shiny effect suggests sunshine reflected upon the rocks and water and exudes a feeling of warmth and life.

Dimensions: L. 9½ in. (24.1 cm.)
W. 6 in. (15.2 cm.)
H. 7¼ in. (18.4 cm.)
Eighteenth century.

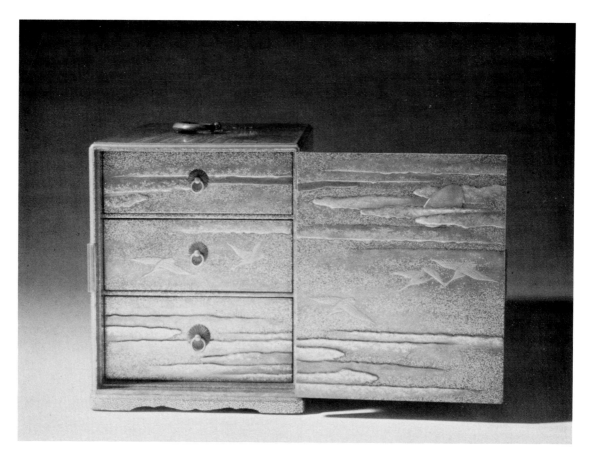

Inside View

The other sides of the box show fully mature trees in bloom with branches extending over turbulent foaming water and jagged rocks, areas that seem to form the sides of the waterfall. Short pines further decorate the shoreline. The curved edge around the bottom of the box is decorated with large, irregularly shaped gold flakes called *oki-hirame*. The outside metal hinges of the door and handle are embossed with the shape of cherry blossoms, a continuation of the central theme. Two Japanese characters (standing for *Nunobiki*) wrought in elegant calligraphic forms of silver are applied to the surface of the falls as further identification of the scene.

The artist has treated the inside of the door and the fronts of the three graduated-size drawers as one scene. Pictured are a silver moon, partially obscured by drifting clouds, and a flock of geese in flight. This particular scene might have inspired the owner of the box to call to mind a famous poem:

Shirakumo no
hane uchikawashi
tobu kari no
kazu sae miyuru
aki no yo no tsuki.

Moon on an autumn night:
one can see the very number
of wild geese
flying in close-winged ranks
against white clouds.[1]

70

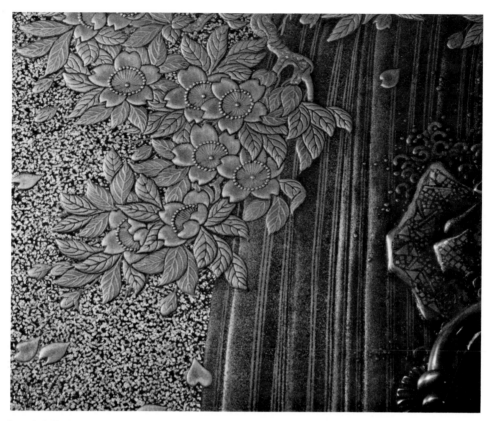

Detail of Workmanship

The background technique involves a thin layer of sprinkled gold, which has been covered intermittently with tiny, flat, irregularly shaped flakes and cut pieces of the pure metal. The drifting clouds in high and low relief technique are also embellished with geometrically shaped pieces of gold in a mosaic patterning, which catches and reflects light while brightening the edges of the clouds.

The extensive amount of time and expense invested by both artisan and patron to have this box made suggests that the box was made as a special order for an aristocrat. The rosette mounts in sixteen-petal chrysanthemum form that secure the bowl-shaped handle to the top of the chest, along with the extraordinary detailing of workmanship and the quality of material used, further corroborate this theory.

Note:

[1] Jin'ichi Konishi, "The Genesis of the Kokinshū Style," translated by Helen C. McCullough, *Harvard Journal of Asiatic Studies*, Vol. 38, #1, Harvard-Yenching Institute, Cambridge, 1978, p. 83.

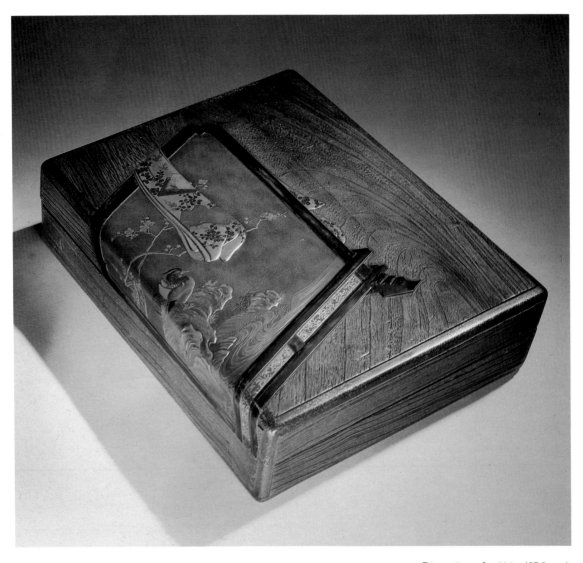

Dimensions: L. 11 in. (27.9 cm.)
W. 9 in. (22.9 cm.)
H. 3 in. (7.6 cm.)
Eighteenth century.
Signed: *Kajikawa* and bottle seal.

19. Stationery Box (*ryōshi-bako*)

A family of lacquerers working directly under the sponsorship of the shogun was founded by Kajikawa Hikobei (exact dates unknown) in the middle of the seventeenth century. He and his pupil Kyūjiro were followed by many students who later, in turn, branched off from this direct line.[1] Works of this family are noted for having large areas of such heavily sprinkled gold that their surfaces resemble metal inlay. This aspect of the Kajikawa style is especially evident in a rather unusual format, in the example shown here.

On the lid of this box is a windscreen placed on the diagonal, occupying most of its surface space and continuing down on the left to the lowest edge of the bottom half. (A windscreen is usually placed inside the front entrance or in hallways. It keeps out the cold winds of winter when the shoji-style sliding doors are open, and also serves as a decorative entrance panel. It is often covered on both sides with paper, upon which poetry or small paintings are mounted or pasted.) On the surface of the screen a manderin duck and its mate, symbolizing conjugal fidelity, rest below a blossoming plum tree. The male seems to be gazing out over moving water. The delicate branches of the tree extend diagonally

across the composition, and its small flowers and buds balance the heavy mound of the richly decorated kimono shown draped over the top edge of the screen. Traditionally the sleeve or sleeves of such a garment flung seemingly carelessly over a surface alludes to the theme called *tagasode* or "Whose Sleeves?" This symbol evokes the presence of a courtesan, and here the vermillion edging of the sleeves inner lining is further suggestive of intimacy.

The muted silver surface of the screen was achieved by first applying gold to the ground then adding a thin layer of silver powder; the combination furnishes a subtle blending of refined color. The smooth finish of this gray backdrop produces a contrasting of surface that allows the exquisite detailing of the low and high color relief work to be appreciated. The outer frame of the screen is of lacquer finish simulating rosewood, *shitan nuri*.The positioning of the Kajikawa signature accompanied by the traditional red bottle-shaped seal on the windscreen, suggests the brush painting format. It is difficult to say which member of the line created this box, as identical signatures and seals were used by almost all branches for about two hundred years. However, it is known that toward the late eighteenth century there was a move by the government to control the amount of gold used on lacquer, consequently there was a marked increase in the use of silver and plain colors. The incorporation of such metals as silver and tin into gold powders adulterated the gold, but resulted in tonal variations not customarily seen before this period.

Note:

[1] The Kajikawa's became most noted for their *inrō*.

20. Incense Container (*kōgō*)

The earliest recorded mechanical clocks in Japan were presented in the seventeenth century by a Christian missionary to Tokugawa Ieyasu and the governor of Nagasaki. The shogun placed his in the tower at Fushimi Castle, and thereafter this type of clock became known as a "lantern" or "tower" clock (*yagura-dokei*). The ancient Chinese signs of the zodiac had been used in Japan since the sixth century for indicating compass points as well as for telling time, and these same zodiacal animal images were applied to the faces of the clocks. During the seventeenth and eighteenth centuries concepts inspired by astronomy were incorporated into clocks, resulting in the development of complicted and unusual time mechanisms. These timepieces reflected the Sino-Japanese interpretations of star systems. Examples of such mechanical objects appear in prints from as early as 1681. Symbols representing the twelve animals of the sexagenarian zodiac, which is based on a cycle of sixty years, stayed in use until 1873, when the European calendar and method of telling time were adapted.

By 1638 the Tokugawa shogunate forbade foreign contacts and restricted all trade to a small island called Deshima in the harbor of Nagasaki. Only the Dutch and Chinese were allowed there. Foreign studies were forbidden until the last quarter of the eighteenth century, when the first Japanese-Dutch dictionary was published. A school for Dutch studies opened in 1789, making some measure of foreign knowledge acceptable under the law. It seems probable that this small incense container dates from that time. Its construction and its use of Western and Chinese astrological symbolism mark the owner as a learned man who had access to Western books on astrology. The lid is made to resemble a rare astronomical clock that was based on the Indian Buddhist conceptualization of the earth being in the form of an upside down tray rather than a globe.[1]

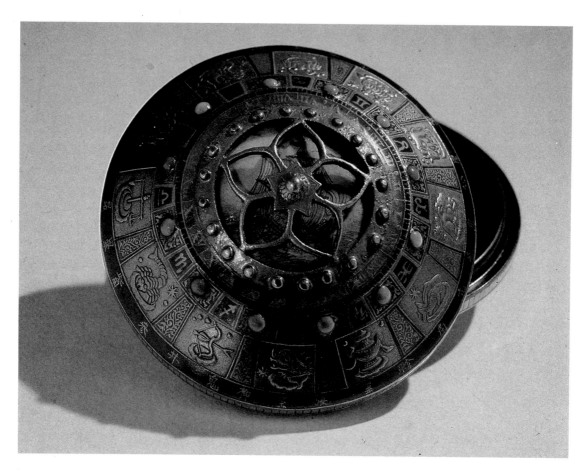

Dimensions: Dia. 2¼ in. (5.7 cm.)
H. ⅞ in. (2.2 cm.)
Eighteenth century.

In the center of the top part of the raised section of the lid, which represents the vault of heaven, an inlay reserve of pale yellow-stained ivory is etched in black with an illustration of a Dutch ship. Above this circle of ivory is an ornamental nut, usually employed as an elaborate attachment to a dial. The sloping sides have increasingly large concentric circles composed as follows: a ring of twenty inlaid metal studs embedded in brown lacquer; a band of green lacquer divided into twelve sections and marked with the Roman numerals I-XXIV (a dial mark separates every two motifs); a narrow band of red lacquer divided into twelve thirty-degree sections, corresponding to the twelve signs of the zodiac, with markings in low relief gold every five degrees[2]: twelve inlaid coral studs, alternating with green and red square-shaped reserves (on the red reserves are gold-embossed Greek symbols of the Western zodiac); a concentric band, consisting of gold lacquer reserves embossed in high relief technique, alternating with green lacquer squares on which are the twelve dial symbols of the European zodiac; a final ring in red lacquer on the slanted outer edge of the rim, with twenty-eight Chinese characters written in gold, representing the twenty-eight constellations of the heavens. Finally, the thin, flat sides of both lid and bottom are covered with rectangular pieces of cut gold.

This unique example was undoubtedly made to order, possibly for an erudite and adventurous Japanese scholar. The Dutch ship on the ivory inlay suggests that the owner or maker had seen such vessels either in Nagasaki or on prints from that area, which had become popular during the last quarter of the eighteenth century.

Notes:

[1] This shape, known by its Sanskrit name of "Sumeru," is shown in N. H. D. Mody, *Japanese Clocks*, London, Kegan Paul, French, Trubner & Co. 1932, pp. 111-112.

[2] The end of each thirty-degree section becomes zero degrees, and measurements begin again. The total represents the relationship between planets measured by the 360 degrees of a circle.

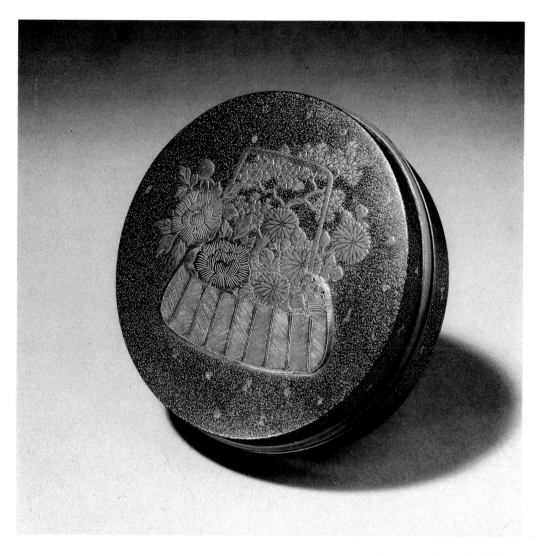

Dimensions: Dia. 3¼ in. (8.3 cm.)
H. ¾ in. (1.9 cm.)
Eighteenth century.

21. Incense Container (*kōgō*)

A basket of flowers set against a *nashiji* ground decorates the lid of this round incense container. This floral presentation is an emblem of Lin Tshi-ho, one of the Chinese Taoist immortals who is also considered the patron saint of flower merchants. Here Chinese and Japanese symbolism has been combined for compositional effect.

The basket contains peonies, chrysanthemums and a sprig of blossoms from a cherry tree, in gold high and low relief techniques. The handle of the basket is of lacquer, and its outline is of inlaid twisted gold wire. The woven appearance of basketry is simulated by thin, straight pieces of wire embedded in a compound made of *sabi-urushi*, then covered with a dark brown coating. The artisan completed the decoration of the flowers after this work was finished, for part of the blossoms hang over the edge of the basket. For color and textural contrast, large, irregular pieces of flattened gold have been embedded into the ground.

The edges of the box are lined with a pewterlike metal, and the inner lip of its bottom half has been constructed substantially thicker than usual to give a more secure base for the lid. At what point in time small *kōgō* were made in rounded form has not yet been determined, but most seem to have originated during the eighteenth century when a growing market demanded innovative shapes.

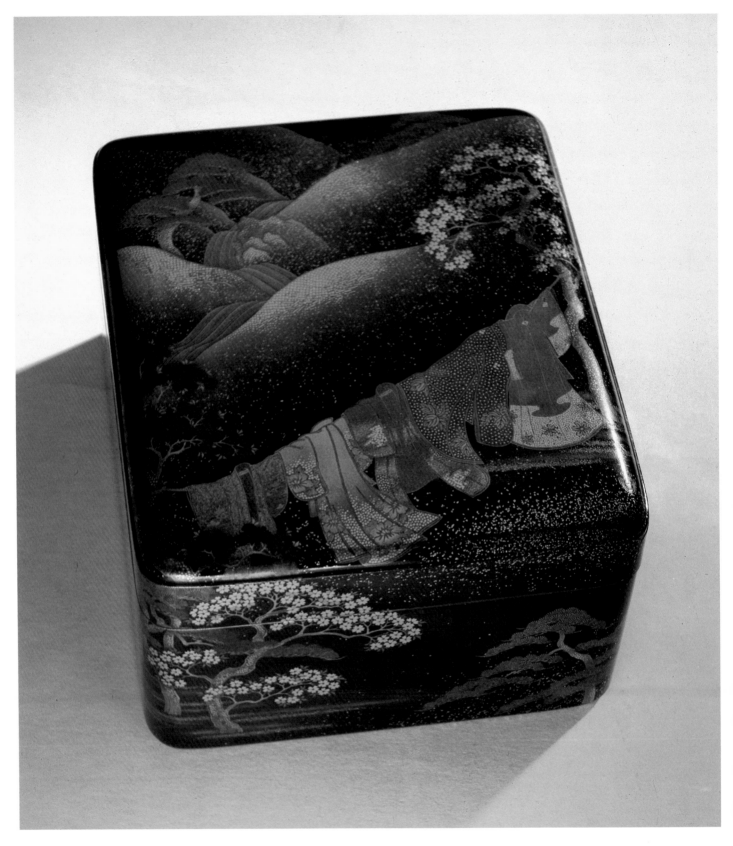

Late eighteenth/early nineteenth century
Signed: *Shunshō*

Dimensions: L. 5¼ in. (13.3 cm.)
W. 4½ in. (11.4 cm.)
H. 2⅜ in. (6.7 cm.)

22. Incense Box (kō-bako)

Yamamoto Shunshō (1610-1682) a member of an old samurai family from Kyoto, was a scholar of Chinese classics and a student of poetry and painting. He founded a school of lacquerwork that specialized in the technique known as "burnished" maki-e (togidashi). After his death his followers adopted the master's first name for their school. In the eighteenth century the school moved to Nagoya, where it ended with the eleventh generation in the last half of the nineteenth century.

The combined beauty of high, rolling hills, rushing waters, and blossoming wild cherry trees made Mount Yoshino in Nara prefecture particularly popular in the spring. Famous painters captured the grandeur of this area on paper, while lacquer artists such as one of the later Shunshō, who produced the box illustrated here, used this landscape to epitomize the freshness of the new season on a bright, sunny day.[1]

The construction of this box is fairly flat and its sides straight, features that are typical of the style of the late Edo period. The composition has a dramatic black background, against which flashes of color and gold depict distant hills. Cascades of rushing water flow through the hills, starting from the top background on the lid and leading to its foreground. Counterbalancing this curving movement is the linearity of a clothesline strung on a slight diagonal between two cherry trees. Hung on the line are several kimonos that seem to sway in a blossom-scented wind. The combination of such personal articles of clothing with fragrant flowers is again, as in cat. no. 19, an allusion to the theme of "Whose Sleeves?" a favored subject in older literary references as well as in early screen paintings.

Set into the ground of the lid, as well as on the decor of hills and rushing water, are square and rectangular pieces of thin cut gold in a mosaic pattern. The gnarled tree on the right side of the compostion has shiny blossoms with petals of pure gold, while one of the garments below has pieces of thin shell embedded into its surface. Placed diagonally, the designs on the sides of the box display boulevards of pine and cherry trees whose blossoms are again of cut gold leaf or powdered silver. A deep inner tray rests on the riser of the bottom section of the box. This short inside support is decorated with colorful flowers and scroll work in togidashi; the petals of the flowers are of alternating red, gold, and silver maki-e. The inside edges of the tray which bear a lozenge pattern surrounding centers of green shell, are of sprinkled silver and gold powders. Peonies and butterflies, again symbolizing spring, appear in a repeat pattern.

Another example of Mount Yoshino, with practically the same composition as shown here but a different combination of techniques on a two-tiered box, has been published by the Freer Gallery of Art.[2] It has been ascribed to Dōgyoku, an artist whose name is unknown at this time. Possibly the two artists copied from the same workbook, or else, since the scene has had poetic associations for a considerable time, the particular vantage point shown was recognized by all.

Notes:

[1] See "Flowering Cherries at Yoshinoyama" by Watanabe Shikō (1683-1755), The Great Japan Exhibition, Royal Academy of Arts, London, 1981, p. 71.

[2] See Ann Yonemura, Japanese Lacquer, Freer Gallery of Art, Washington, D.C., 1979, Entry 14, p. 30.

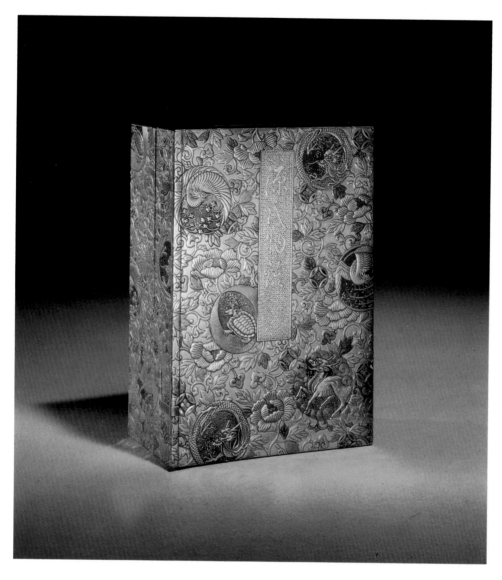

Dimensions: L. 4⅜ in. (11.2 cm.)
W. 3⅛ in. (7.9 cm.)
H. 1⅝ in. (4.1 cm.)
Nineteenth century.

23. Incense Box (kō-bako)

Perhaps the most influential literary subject to appear in Japanese art was the Heian classic *The Tale of Genji. (Genji Monogatari)* Written in the late tenth or early eleventh century by the aristocratic poetess Murasaki Shikibu (also see cat. no. 15), the story relates the birth, life, and loves of Prince Genji. Murasaki was a distant relative of the sixty-sixth emperor of Japan, Ichijō (987-1011) and was in the service of his wife, Akiko. The name Murasaki Shikibu was merely a sobriquet: Murasaki means "purple" in Japanese and is also the color of *fuji* (wisteria), the first half of her illustrious family name, Fujiwara; Shikibu refers to an office held by her father.[1] Little else is known about her except that she was married "to a distant kinsman."[2] She left to posterity a unique epic of court life during the gracious if somewhat *effete* Heian era. It was a time when poetry stirred great passions and lack of poetic sensibility was a sign of the uncultured and ignorant; when gradations of tone within a color brought a rush of emotion; when weeping heroes were *de rigueur*. It was also the period when incense was first introduced to heighten the elegance of the aristocrat's clothing, its sweet fragrance providing an even greater stimulant for the poetic mind.

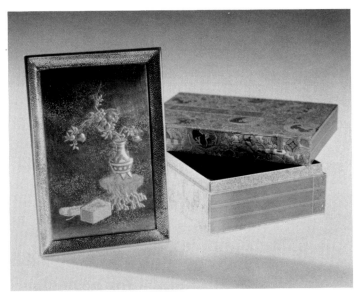

Inside View

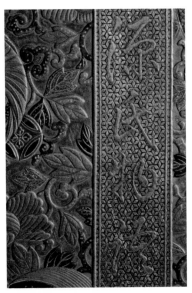

Detail of Workmanship

The Edo period saw a revival of Heian themes in lacquer boxes — especially those made for the newly popularized incense game. In the game, which was conducted with ceremonial ritual, a scent was wafted in front of a participant to test his or her skill in identifying it. Adroitness at this game was a sign of breeding and sensitivity as well as an indication of the wealth necessary to own its elegant accoutrements. Classified into seven fragrances, the various woods used in the traditional incense game were extremely rare and extraordinarily expensive, since most of them were imported from Southeast Asia.

The richly embossed surfaces of this box are covered with a texturing that simulates gold brocade and its shape resembles a book holder with characteristic closures. The elegant cover has two open sides, which are decorated to imitate the contours of five inner volumes. The title, *Genji Monogatari*, appears on the surface of the lid in flowing Chinese characters. The intricate style of fabric imitated in the patterning derives from a type of brocaded silk in use from the Heian to the Kamakura periods. Bright medallions enclose designs of "the four spiritually endowed creatures" from Chinese mythology. These four — the dragon, unicorn (*kirin*), tortoise (*minogame*), and phoenix — are scattered among a field of fully blossoming peonies, whose leaves form an arabesque design. In these medallions green shell was first laid down under the area of the reserves and then the figures added in gold high and low relief techniques, allowing small areas of the colorful shell to catch and reflect blue and green hues. This subtle use of a natural material lends the only color contrast to an otherwise all gold container.

The shallow tray within is of the finest workmanship. Its edges are covered with large flakes of gold carefully applied to fit as a mosaic, within an orange-toned lacquer base. The inner surface of the tray is decorated with a Chinese-style vase that rests on a table resembling a tree trunk, with its naturalistic roots forming the legs. Small branches bearing ripe persimmons (symbols of fall) are placed gracefully in a vase, while an open handscroll and volumes of books rest on the adjoining ground. The scene is executed with great delicacy and the contents of the composition tastefully composed, with attention paid to every detail. The rest of the work is in muted tones of colored lacquers and gold in high and low relief techniques. The quality of this box is extraordinary and even the outside surface of the bottom is as elaborately detailed on the lid.

Notes:

[1] See Murasaki Shikibu, *The Tale of Genji*, translated with an introduction by Edward G. Seidensticker, Alfred A. Knopf, New York, 1976, pp. vii-viii.

[2] Ibid., p. viii.

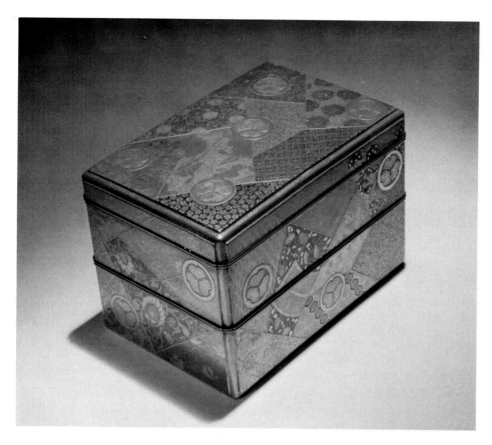

Dimensions: L. 4⅞ in. (12.4 cm.)
W. 3¼ in. (8.3 cm.)
H. 3¼ in. (8.3 cm.)
Nineteenth century.

24. Tiered Incense Container (kō jū-bako)

The popularity of the incense game reached its zenith in the eighteenth century, although changes in its accessories continued throughout the following century. Even today the game is played both in its original ceremonial fashion and in a new shortened form.

Two-tiered boxes such as this often housed the utensils for the game, usually in the bottom level, with incense in the top. The basic decoration here is of patterned fabrics, juxtaposed in a large, unevenly shaped mosaic. The highly reflective surfaces, ranging from gold-toned lacquers to various graded hues of pure gold powder, suggest the subtle differences in the fragrances of the incense within. In the patterning of one length of fabric there is a design (repeated on both sides) resembling the special headgear called a coronet, worn only by the male aristocrat and popularized during the Heian era. Also in that same bolt of fabric are illustrations of a bamboo curtain waving in the breeze combined with stylized sprigs of the paulownia tree. Again all these objects allude to the *The Tale of Genji* (see cat. no. 23). On the exterior of this box is the additional design element of the trefoil-shaped blazon known as the *aoi mon*, here contained within a circle of thick gold. This crest was restricted to the use of members of the Tokugawa family until 1868.

The quality of this box is outstanding. All the edges and corners are recessed, allowing the sides to appear as separate raised panels. The overall patternings are of gold in low and high relief, applied onto a variety of grounds ranging from the deep shiny black *ro iro* to the orange-toned, gold-flecked *nashi ji*. The textile patterns are in a low-layered technique, also in various tones of gold. The gradations of color achieved by mixing silver powders in different proportions to gold may be seen in the greenish-blue, pale yellow, and deep rich yellow of the finished surfaces. In addition, the brilliant pure metal, cut in the shape of flower petals, has been added to give further textural contrast. All the interior edges of the various layers are lined with silver to protect the edges from chipping.

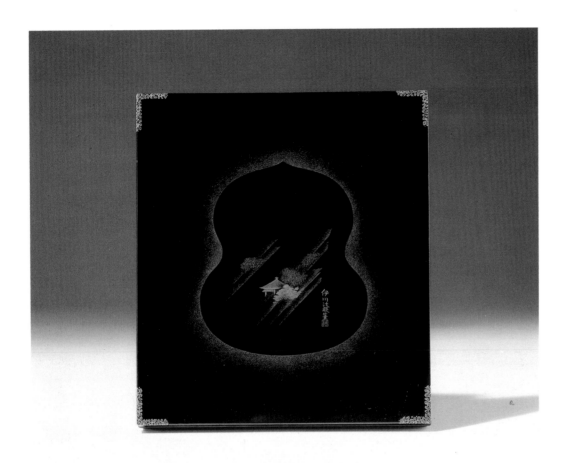

Dimensions: L. 6½ in. (16.5 cm.)
W. 5⅞ in. (14.9 cm.)
H. ⅞ in. (2.2 cm.)
Nineteenth century.
Signed: *Kōmin saku* (made)

25. Inkstone Box (*suzuri-bako*)

Nakamura Kōmin (1808-1870), the creator of this small writing box, was trained under Ōhara Yōyūsai (1772-1845) of Edo and was deemed a classicist in his own time. While masters of the nineteenth century were using heavy gold and ornate decoration, this artist retained older, more refined themes executed in subtle artistry. The design on the cover of this box shows Kōmin's ability to express lyric movement with extraordinary technical skill. The shiny black ground of the gourd-shaped enclosure is decorated in the abbreviated strokes of a landscape brush painting. The lacquer artist has succeeded in duplicating both the mood and the strokes of the original rendition which was painted in ink on paper. The scene is of a distant hut surrounded by maple trees, one completely leafless, glimpsed through sheets of rain. The signature, from the original painting, reads *Hōgen Isen* [1775-1828] *hitsu* (drew), accompanied by the seal *Tō*.[1] This painter was renowned for the free and sketchy manner of his work as well as for his technique of adding gold dust to his ink, an effect easily duplicated in *maki-e*. The edges of the gourd-shaped reserve that surrounds the design appear illuminated as though a light shone behind the outline. The entire surface of the lid is in the burnished technique of *togidashi*, with only the outer corners of the box in a low relief, sprinkled-gold design.

Decorating the ground of the inside cover, also in *togidashi* technique, is a design simulating a type of elegant handmade paper used during the Heian period. The thirty-one syllable poem (*waka*), written in gold characters in low relief reads:

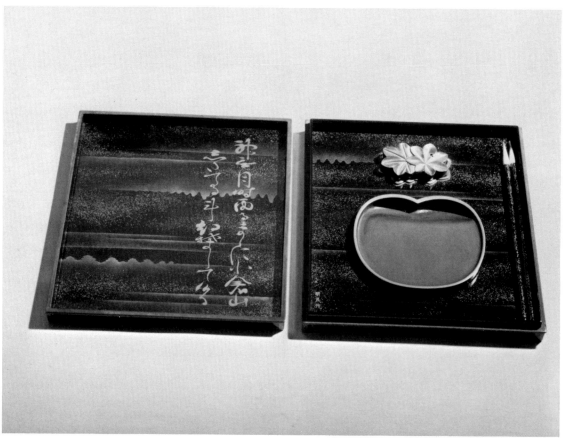

Inside View

Kanna zuki	October:
shigururu mama ni	as showers keep falling
ogurayama	on Mount Ogura
shitateru bakari	even under-foliage glows —
momiji shite keri	the leaves have turned color![2]

The poem refers to the scene on the top surface of the lid, which depicts Mount Ogura, a hill near the village of Saga in the province of Yamashiro, where the literary master, Fujiiwara Teika (1162-1241) completed the famous *Hyaku-nin Isshu* ("One Hundred Poems by One Hundred Poets"). Inside, the water dropper in the shape of a maple leaf echoes the theme of fall seen on the cover. The artists signature, *Kōmin saku* (made) appears near the inside section. The subdued classic tone of this compostion must have been a special order by a refined client seeking a quietly decorated writing material box suitable perhaps, for use in a tea ceremony room.

Notes:

[1] Issen is one sobriquet used by Kanō Naganobu, also know as Eishin. An official painter to the shogun's court, he was awarded the title of *hōgen* in 1802. In 1816 he took the name Issen when he was elevated to the rank of *hōin*.

Since the Nara period honorary ecclesiastical ranks were awarded first to priests, then to Buddhist sculptors, and finally to painters, carvers of Noh masks, and mirror makers. In the Edo period the honor was extended to other artisans like lacquerers and netsuke carvers. The three ranks in descending order were *hōin* ("seal of the law"), *hōgen* ("eye of the law"), and *hokkyō* ("bridge of the law").

[2] Calligraphy read and translated by Hiroaki Satō, assisted by Kyoko Selden. Usually *waka* are extrapolations or allusions to earlier examples. According to Satō, however, this poem is a direct misquote of one originally written by Minamoto no Morotaka (dates unknown) and found in the *Kin'yō shū* ("Gold-leaf Anthology") compiled in the twelfth century; its only change is the location of the scene. In all probability the nineteenth century change was intentional, perhaps an exercise of artistic license.

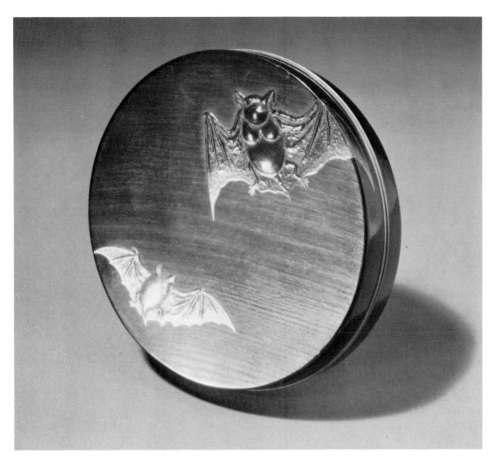

Dimensions: Dia. 3 in. (7.6 cm.)
H. ¾ in. (1.9 cm.)
Nineteenth century.
Signed: *Hokkyō Komin saku* (made)
and seal: *Senji*

26. Incense Container (*kōgō*)

This round incense container is another example of Kōmin's interest in older, more classic subject matter. Although the style of the interpretation is undoubtedly nineteenth-century Japanese, the subject of bats reflects earlier Chinese symbolism. At a time when little Chinese influence was evident in lacquer art, it was certainly an unusual choice and one decidedly made for the home market. Westerners have never cared for these creatures because of their associations with the dark. To the Oriental, however, the bat is emblematic of longevity and wealth; its pronunciation in Chinese is euphonically similar to the character for "happiness," and it is therefore a symbol of good luck.

The artist has used zelkova wood for the core and, by deliberately applying only a thin layering of lacquer to its raw surface, has allowed the natural wavy grain to show through and become part of the composition. Thus the flying mammals appear to be riding the waves of an air current. The figures of the bats are made either by application of a high relief material called *sabi-urushi* or by the more expensive and traditional method of layering lacquer upon lacquer to the desired height. The body of one creature is in black, toned gradually to gold (as though the bat were flying out of the darkness toward the light), while the other mammal, in gold, stands out vividly against the night black of the ground. The concise detail of the skin texture of these creatures has been accurately rendered, with meticulous care. The rims of the box are lined with pewterlike material.

On the inside of the lid, in colored *togidashi maki-e*, is the figure of a standing crane. To the right of the bird is the artist's signature: *Hokkyō Kōmin saku* ("made"), with a red seal. The title of *hokkyō* was an honorary appellation discontinued in 1873 (see footnote 1 of previous entry). It was bestowed by the court in recognition of exceptional skill in the arts.

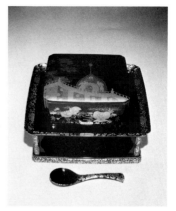

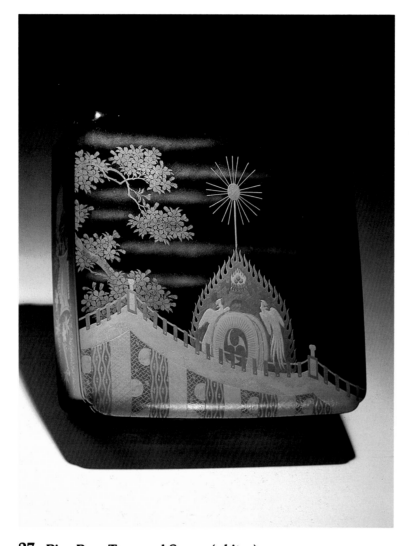

Tray:
Dimensions: L. 12 in. (30.5 cm.)
W. 12 in. (30.5 cm.)
H. 4¼ in. (10.8 cm.)
Nineteenth century.

Box:
Dimensions: L. 8⅜ in. (21.3 cm.)
W. 8⅜ in. (21.3 cm.)
H. 3¼ in. (8.3 cm.)
Nineteenth century.

27. Rice Box. Tray, and Spoon (*ohitsu*)

Formal rice servers such as the one shown here were and still are used only on festive occasions to hold rice mixed with red beans. This box is exceptional in its elegant embellishment. The theme decorating its surfaces is that of objects associated with the courtly form of dance known as Bugaku. Influenced by dance forms of China, Korea, and India, it came under court patronage in the seventh century. During the Heian period Bugaku reached the height of its popularity as it was integrated into official court life. Buddhist paintings that include celestial musicians show the same musical instruments as depicted here. Paramount to this entertainment is the *dadaiko*, a large drum that is enclosed by a decorative frame with a disc finial. This drum forms the principal decoration on the cover of the rice box.

The rendition of the musical instrument is in typical but stylized form. Flamelike projections following the outline of the mount or frame of the drum symbolize the fire of purification, as derived from the influence of Indian Vedic ritual found in early Buddhist iconography. At the apex of the mount are depicted three jewel-like objects, themselves surrounded by flames, resting on a lotus pedestal. These three jewels represent the Buddha, the *Dharma* (Buddhist law), and the *Sangha* (the Buddhist community). A pair of phoenixes further decorate either side of the frame.[1] The drum itself has a three-comma (*magatama*) symbol on its center. Worked into the dramatic deep black background of the lid is a delicate full-blossomed cherry tree in *togidashi* technique. Finely powdered gold, sprinkled to resemble low, drifting clouds, adds a quiet atmosphere to the setting. The lower part of the composition shines out in thick masses of pure powdered gold, in low relief. A curtain, which also divides the two

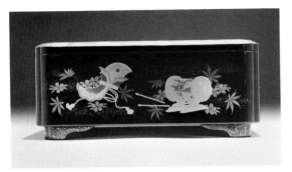
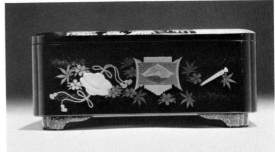
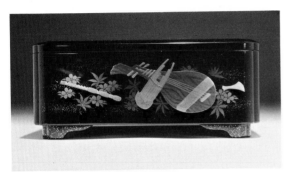
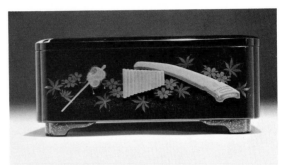

elements of the design, suggests the typical enclosure customarily used for outside entertainment. The fabric is elegantly textured in both low and high relief, gold on gold. The top border of the curtain and the tabs on its pinions contain a stylized motif that is either the crest of the Kuroda family — or an extrapolation based on it — which became popular for the beauty of its design.

The sides of the box, beginning with the front panel and moving left, display an array of articles, primarily those particular percussion and wind instruments incorporated in court music. The deep black shiny ground that continues on all sides also alternates with designs of cherry blossoms and drifting maple leaves in delicate *togidashi*. These contrast in their softer quality with the bright golden texture of the instruments displayed on all four sides.[2] Circling the box in low relief and pictured in full detail are: the double-headed drum (*tsutsumi*); a dance helmet in typical form (*tori kabuto*); a short double-reed woodwind called the *hichiriki*; a rare, seldom seen multireed tuning instrument decorated with a phoenix, called a *dosho* or panpipes; a set of cymbals; a *biwa* with a plectrum; the seventeen-reed *kan-shō*; the flutelike *shakuhachi*; the thirteen-stringed *gakuso*, predecessor of the modern *koto*, a ten-reed instrument; and finally the hand-held, double-headed object with attached beaters known as a rattle drum.

The inside of the lid, also in black *ro-iro*, is decorated with a large circular reserve. Within this circle, full branches laden with maple leaves reach out into space. Embedded under its final high-gloss finish are sparingly applied flattened gold particles called *hirame*. Throughout the composition of this box the artist has purposely employed the principal of dual, or alternating textures to add extra dimension to his work.

The double-tiered serving tray under the rice container is decorated with peony arabesques in low relief on a *ro iro* ground. The design and superb quality of the tray allow it to be used for the presentation of any object.

Notes:

[1] Customarily two large drums were used in Bugaku. One is decorated (as here) with a pair of phoenixes, the other with two dragons. They represent dancers known as those from the Right and the Left. However some forms of Bugaku performed today no longer utilize a pair of these larger drums.

[2] The appearance of two dragons and two phoenixes expresses the Chinese Taoist philosophy of duality wherein forces are divided into such pairs as yin and yang, female and male, soft and hard — a principle also expressed in the textural composition of this box.

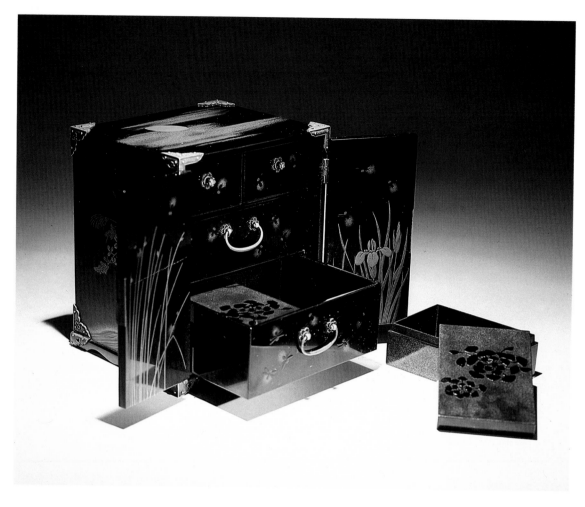

Dimensions: L. 4⅝ in. (11.7 cm.)
W. 5¾ in. (14.6 cm.)
H. 6½ in. (16.5 cm.)
Nineteenth century.

28. Small Chest (kō-dansu)

The outside wooden storage box in which this small, two-doored chest is kept has the characters *Tamagawa maki-e* written on its cover. This is a reference to the Tama River, which in the seventeenth century brought water by way of an aqueduct into Edo. Today the river enters Tokyo Bay near Haneda Airport.

This small cabinet was made for the storage of incense and its accessories. Its top is decorated with the scene of a hazy, moonlit sky. On a black ground in the *togidashi* technique a silver moon is surrounded by fleecy clouds created by delicately strewn gold powders. The composition suggests a quiet, windless night.

The front panel completes the landscape by depicting a river, its bank edged with bush clover and pampas grasses in gold and silver-gold *hira maki-e*, with minute pieces of cut gold added sparingly as highlights. Fall is the heralded season. Winged insects in glossy black lacquer and a reflection of the silvery moon seem to shimmer in the flowing gold and black of the moving current. Both left and right side panels continue the theme of moving waters and lush shores decorated with the fall flowers of patrina, bush clover, and grasses, in the same lacquer techniques of low and high relief as on the front. The back of the chest has a black ground, graduated in tone to a softly muted speckled gray, and decorated with fall grasses and bell flowers.

The new season of spring is introduced when the two-paneled doors on the front are opened to reveal a night scene of fireflies, either in sparkling flight against a black sky or clinging to blades of tall grasses. The tiny winged insects of bright red and black lacquer with inlays of shell are surrounded by an aura of light created by the most delicate sprinkling of fine gold powders. The metal pulls of the three inside drawers are shaped like cherry blossoms, carrying out the theme of the inner landscape. The right bottom drawer contains two small fitted inner boxes, which probably held mica chips or other small items used in the burning of incense. These elegant, rectangular-shaped matched containers were decorated with a stencil in a stylized peony design of shiny black lacquer in low relief on a smoky black ground.

All the corner joints on the outside of the chest are reinforced with studded metal corners designed to match the hinges and front catch of the doors. The dual nature of the artist's composition — whereby the top panel of a moonlit night doubles as part of a second composition involving a seasonal change — gives special interest to this piece.

29. Document Box (fu-bako)

The lid and sides of this *fu-bako* are decorated with simulated title pages from a variety of Noh chant or song books (*yōkyoku*), plays, with matching pictographs on their covers to help further identify the theme. Examination of the various illustrations will start with the outline of the book that overlaps the top edge of the lid and continues down the short back side.

On that cover page (although one of the characters is partially obscured) is the name *Tōboku*, on a silver reserve, in gold low relief. The illustration of plum blossoms in gold *taka maki-e* on a bright *nashiji* ground refers to the first scene of that play, in which a priest is seen gazing in meditation at plum blossoms near the Tōboku Temple.

The next cover beneath it, of a solid matte gold ground, shows an old couple standing under a large pine tree by the seashore. The title in low gold relief reads: *Takasago*. This is a particularly popular play about a priest who, on a lovely spring day, encounters an old couple who claim they are the spirits of the pines that line Takasago Bay.

On a *nashiji* ground decorated in a fret design, the next title appears in low relief gold letters on a silver rectangular-shaped reserve: *Sekidera Komachi*. The fret design is a Buddhist symbol and refers to the scene in that play in which an old woman relates the story of her life to a priest of the Seki Temple.

The next title page, from the triad of books on the lower half, is designed on a slant to the right and is decorated with irises and a plank bridge. The bright orange of the *nashiji* ground contrasts effectively with the flowers and textured wood of solid sprinkled gold superimposed on its surface. The title *Kakitsubata*, also in gold *maki-e*, is an allusion to that famed landmark, "the eight-planked bridge" (*Yatsuhashi*) from *The Tales of Ise*, a theme that Ogata Kōrin made famous in several of his paintings. In the Noh play, a young girl reveals that she is the spirit of the iris, known in Japanese as *kakitsubata*.

The cover on the left depicts an evening scene, showing the yellow fall flower known as patrina (*ominaeshi*), as well as pampas grasses and a brush fence adjacent to a *torii* (the Shinto architectural symbol signifying the entrance to sacred ground). Exquisitely detailed in high and low gold relief on a streaked gold and black burnished surface, the design creates a feeling of quiet and peace. The title of *Nonomiya* (rather than the correct *Ominaeshi*) has been mistakenly applied to this scene, instead of to another scene on the box, on its hidden lower half. *Ominaeshi* is a story about Ono-no-Yorikaze's wife, who died near the Iwashimizu Hachiman shrine (thus the symbolic *torii*). According to that story,

Dimensions: L. 9⅛ in. (23.2 cm.)
W. 4 in. (10.2 cm.)
H. 2 in. (5.1 cm.)
Nineteenth century.

patrina (*ominaeshi*) grew from her grave in great profusion, leading Yorikaze into believing they were her spirit; in her memory he dedicated many songs to them.

Nonomiya relates the story of Prince Genji's mistress, the Lady Rokujō, who haunted the plains in anguish after a quarrel with Genji's wife over the position of her carriage at a festival. Since only the title *Nonomiya* was applied to the lower half of the surface of the box — and no pictorial design provided further identification of the theme — it is easy to see how this unusual error came about.

The last title page on the upper surface is partially obscured and is shown draped over the top to the [short side] in front. Only one Japanese character, *sakura* meaning "cherry blossom" is evident, yet in combination with the illustrated scene it immediately recalls the famed play called *Saigyō-zakura* ("Saigyō's Cherry Blossoms"). In the play the recluse Saigyō's peace is shattered when unwelcome visitors come to view the blooming cherry tree near his hermitage. When Saigyō blames the tree for attracting strangers to his retreat, the spirit of the tree dances its denial. The decoration of the cover is a gold ground with cherry blossoms in low and high gold and silver relief.

The apparent error in labeling the scenes that occurred here is certainly unusual. In all probability the atelier worker never attended the Noh and therefore was not aware a mistake had been made, either in the initial drawings for the design or in its execution.

The Meiji, Taishō, and Shōwa Periods

With the abolition of the class system, the dissolution of the shogunate, and the restitution of the Emperor to power in 1868, innumerable samurai soon became destitute with the elimination of their government stipends. In desperation, lacquers were destroyed to extract their gold content, and because of the ensuing economic chaos, patronage of the art form declined. An attempt to set standards, such as establishing the minimum amount of gold to be contained in an alloy, was finally introduced by the first academic establishment instituted for that purpose. Formed under government sponsorship in 1889, the Tokyo Fine Art School, now known as the Tokyo University of Art, became the leader in setting forth principles and order for all craftsmen and artists, during this time.

"Meiji," when used as a descriptive term in art, suggests a style that usually reflects not only the newly imported Western technology and its associated art forms, but also, the incorporation of Western perspective. With the importation of chemical pigments, colors such as white, blue, orange, purple, and indigo, added a new range not possible before in lacquer works. However, since *maki-e* is a most conservative technique, mainly because of the physical limitations of the medium, little direct Western influence became obvious during this time frame, except for those objects that incorporated the new pigments. Sharp and concise detailing in the execution of a design is not necessarily an indication of Western influence during this period, but instead might reflect styles incorporating the principles of the Maruyama and Nagasaki schools of Japanese painting, which had been introduced in the middle part of the eighteenth century.

The criteria by which one usually determines the period of an artist's works depends on many factors. For example, Nakamura Kōmin (1801-1870) lived almost all of his life before the end of the Edo era in 1868 and is considered "pre-Meiji"; on the other hand, Shibata Zeshin (1807-1891) (see cat. nos. 25, 26) lived for sixty-one years before the advent of Meiji, but records show his greatest popularity as after 1868. Therefore he has been previously classified as a Meiji artist. Because of such conflicts of opinion, this text will not categorize works by the periods name, but will continue to classify them according to century.

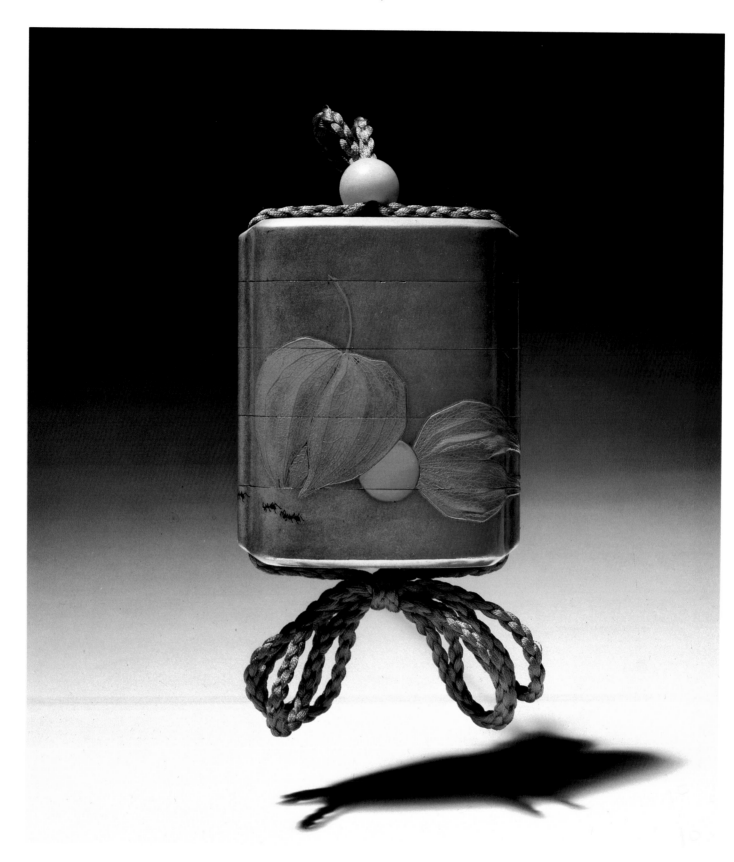

Dimensions: L. 3 in. (7.6 cm.)
W. 2½ in. (6.4 cm.)
H. 1 in. (2.5 cm.)
Nineteenth century.
Signed: *Zeshin*

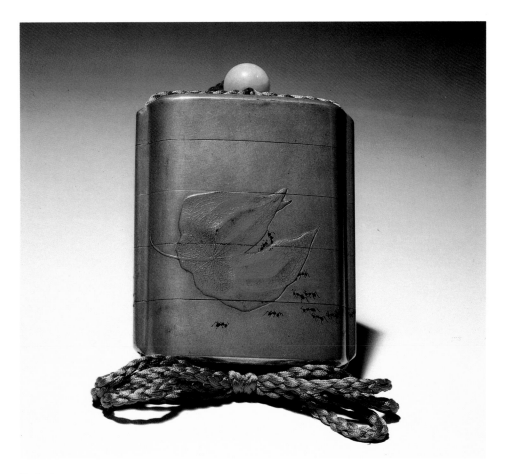

Back view

30. Tiered Medicine Container (*inrō*)

Shibata Zeshin (1807-1891) was born in 1807, the son of Chōbei Ichigorō, who had married into a family with only one child, a daughter, and had adopted as his own, her family name of Shibata. Ichigorō was a sculptor who specialized in the beautiful trasom carvings known as *rama*. His son's given name was Kametarō II, but shortly after his birth it was changed to Junzō. At the age of ten he apprenticed to the famed lacquer artisan Koma Kansai II (1766-1835) and when fifteen began studying the Maruyama style of painting, which emphasized accurate studies of nature.[1] In 1830 Junzō was sent by his family to Kyoto, where he studied the Shijō style of painting, history, philosophy, *waka*, and literature.

During this early period he also traveled extensively, but his health broke down and he returned to Edo in 1832, when he adopted the sobriquet Zeshin as well as the alternate, Tanzen.[2] He finally settled in the busy and well-populated section of Edo known as Asakusa, where he remained until his death. His home was called Tairyūkyo, the name that often appears on his seals. In 1835 Koma Kansai II died, and Zeshin, next in his teacher's line, became one of the last of the Koma, incorporating the name in seal form on lacquer painting, but rarely, if at all, on objects.

Zeshin's works became known to the West when they appeared in the World Exposition of Vienna in 1873, the Philadelphia Centennial Exposition in 1876, and again in Paris in 1883. Documents indicate that he perfected his early lacquer painting on paper technique by adapting the principles of *togidashi maki-e*, however, later on, he was able to handle the medium in the same direct manner as he did brush

painting. From the 1870s until his death in 1891, he was the most prolific artisan of fine lacquer in Japan. He undoubtedly had an atelier, for thousands of small lacquer trays, simply decorated dishes and larger objects of questionable quality bearing his signature appeared on the market during his lifetime. In 1890 the emperor awarded him the title of Court Artist, and in the same year Zeshin established the Japan Lacquer Association.

The master is known to have had four major followers. Two were his sons, Kametarō III (also known as Reisai born in 1850) and Shinjiro, (known as Shinsai the son of the second wife). A third was his pupil Shōji Chikushin, who accompanied him frequently on his travels but whose works of art are very few in number. By far his most renowned student was Ikeda Taishin (1825-1903). Taishin, Zeshin's oldest and most faithful student, adopted as his own the many shapes and the distinct style employed by the master.

The tiered, multicompartmented container known as an *inrō*, which first appeared in the late sixteenth century, became the focus of a major artistic movement during the Edo Period. Attached to a *netsuke* so it could be hung from the obi, the *inrō*, which usually held medicinal herbs in pellet and or powder form, was most often lavishly decorated in lacquer. Zeshin often worked in this difficult, small-scaled format, and the masterpiece shown here is an excellent example of a singular style concentrating on the concise, close-up detailing of one subject against an undecorated ground.

Three flowers in the shape of jack-o'-lantern's in brilliant vermillion on a soft oxidized silver ground, accompanied by tiny ants in a procession, are the subjects of this four-case *inrō*. The incredibly delicate veining characteristic of the actual plant covers the outer part of the fully mature flowers, pictured in two versions on either side of the piece.

In Japan children love this lantern-shaped flower as a plaything. Within its delicate outer walls resides a soft red pod filled with seeds. This seed pod is carefully detached from the stem within the top of the flower, and through this single opening the jelly with its seeds may be extracted. The children then inflate the empty skin by blowing into it and use it to make funny noises.

On the front side of the *inrō* are two flowers, with a pod lying on the ground beside one of them. The lacquer surfaces of both flowers are decorated with the most delicate gold *maki-e* work imaginable. Shading in low relief ranges from brilliant gold to a soft grayish yellow, blending into the darkened scarlet skin of the shell in a variety of tones. The round pod is in brilliant red *taka maki-e*, polished to a high shine.

In the lower left corner are tiny ants of black lacquer, exquisite in their detailing. Carrying the action of the composition from right to left, their procession leads the eye around the curve of the side channel (which houses the cord) to the image on the reverse. There, a myriad of ants are shown crawling on an open flower, attacking the ripe pod in order to reach its soft viscous semisweet food. The shiny jet-black insects and the surface of the scarlet pod surrounded by varying hues of gold and red, sets up a visually stimulating as well as distinctively styled contrast. The muted gray of the silver ground completes a rare and unusually subtle combination of colors, indicative of the master's extraordinary creativity. This *inrō* bears the signature Zeshin in gold *hira maki-e* on one side.

Notes:

[1] The Koma school of lacquerers had been patronized by the shogun since 1636.

[2] Zeshin is the Japanese reading of the name of an eccentric painter found in *Sōshi*, this master's favorite Chinese classic. Tanzen, also from the same story, means "restful nature." See Martin Fault's essay and footnotes in Howard A. Link, *The Art of Shibata Zeshin*, Honolulu Academy of Arts, 1979 (Robert G. Sawers), p. 28, fn. 19.

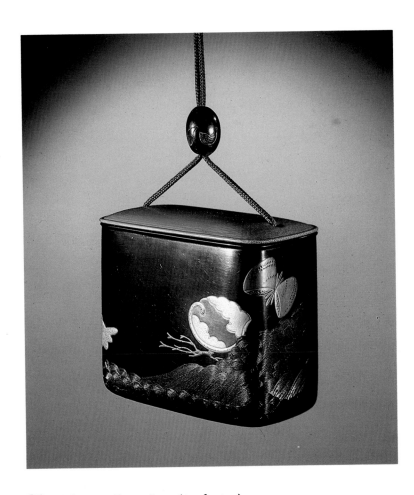

Dimensions: L. 2⅞ in. (7.3 cm.)
W. 1⅜ in. (3.5 cm.)
H. 2⅜ in. (6.0 cm.)
Nineteenth century.
Signed: Zeshin

31. Tobacco Container (*tonkotsu*)

The shape of this decorated container, with its graduated sloping sides and gently rounded corners and edges, must have been designed exclusively for or by Zeshin, since no examples of this shape exist without his signature or in a style other than his.[1] The sides are decorated with a black *ro iro* ground bearing the artist's famous "combed-wave" pattern, formally known as "blue-wave coating" (*seigai-ha nuri*). Supposedly originated by Seigai Kanshichi (circa 1680-1705) in the last quarter of the seventeenth century as a special order for a famous merchant of the time, the technique was thought to have been lost until Zeshin rediscovered and popularized it, in the nineteenth century. One method he used in its recreation was to combine black lacquer and beancurd (which act as a stiffener) in a mixture called *shibo urushi* and to apply it as a ground. At exactly the right stage of drying, the master created the comb pattern surface by applying a sawtooth-shaped tool, made from the grooved skull plate of a baleen whale, to the semi-viscous material surface in wavelike movements. After the mixture had dried, its surface was polished to an even level.[2] Only an accomplished artist can use this technique successfully, for *shibo urushi* often forms tiny lumps at the edges of the wave pattern as the comb is turned to complete the curve.

Inlay of shell provides blue/green color and additional texture to the design of shells and aquatic plants in gold high relief. The lid of natural bamboo (a substance that only Zeshin usually used most often in juxtaposition to black lacquer), gives the feeling of delicacy characteristic of the master's unique talent. This piece is signed *Zeshin* in an incised signature on one side.

Notes:

[1] For other examples, see Howard Link, *Shibata Zeshin*, p. 124, entry #62-64. Illus. pp. 136 and 138.

[2] This method was described to the author by the "National Living Treasure" Matsuda Gonroku, whose teacher learned it from Zeshin.

Detail of Workmanship

32. Inkstone Box (*suzuri-bako*)

In 1832 Zeshin settled in Tairyūkyō in Asakusa, near the bank of the Kanda River in an area now located in the Asakusa-bashi section of Daitō-ku, Tokyo. One of the most famous temples in the area is the Asakusa Kannon dera, maintained by the Tendai Buddhist sect. Two large guardian figures called *Niō* flank either side of the main gateway. Hindu in origin, these giant figures were absorbed early into the Buddhist pantheon. Their purpose is to defend the faith and keep evil spirits from entering the temple compound. During the seventh century Buddhist iconography and Shinto theology began to intermingle, with the result that certain Shinto characterizations appear in Buddhist imagery. The *Niō* became the Shinto representation or guardian diety for the sandalmaker. Even today the two giant figures at this temple have over sized symbolic sandals attached to the small individual gate houses that surround them.

On the cover and sides of this inkstone box Zeshin has captured the essence of these guardians in a singular colorful composition. The oblique angle of the design is as unique as is the presentation of the subject. Only one hand and a small part of a torso scarf allude to the presence of a figure. Zeshin has divided the surface of the lid almost in half with a vertical column, leaving unadorned space in the muted dark olive green textured ground (*seidō nuri*), for which he was noted. A tiny, delicate powdered-gold falling leaf, curled by an updraft, is shown hanging in space. This exquisite and graceful formation serves as an interesting contrast to the rest of the composition, which concentrates on more massive proportions.

Zeshin has simulated in lacquer the tone and texture of the blackish copper and gold alloy known as *shakudō* (in lacquer called *shakudō nuri*), and of the gray copper and silver alloy, *shi bu ichi* (*shi bu ichi nuri*), as well as a stony-surfaced gray-black ground called *ishime nuri*, which form the base of the pillar stone setting, and ground.[1] Black *shakudō* and gray *shi bu ichi* are alloys based principally on copper; when they are "pickled," a chemical reaction of the surface exposed to the solution forms a thin colored skin. The effect in lacquer is achieved by sprinkling the desired area with the actual metal

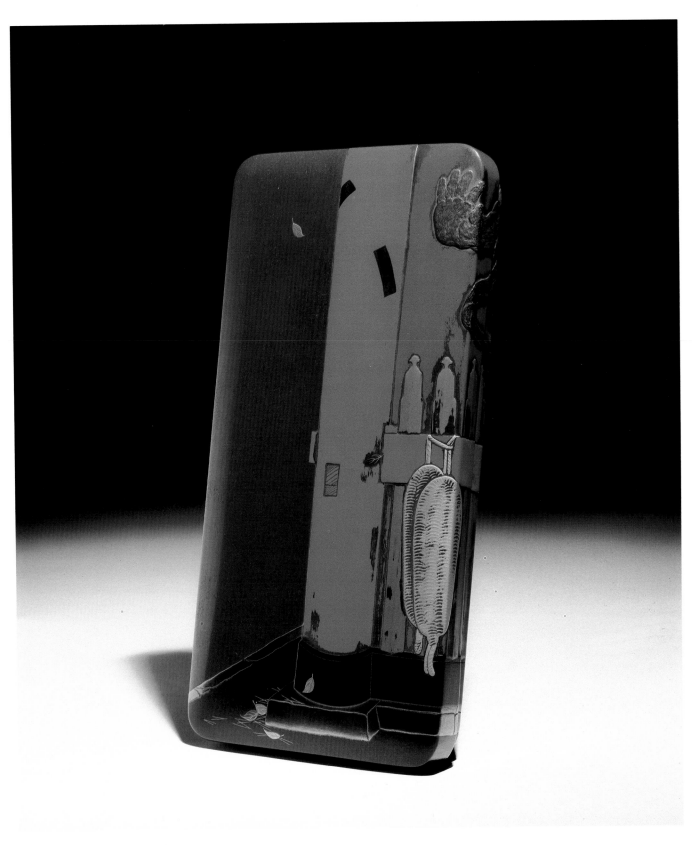

Dimensions: L. 9¼ in. (23.5 cm.)
W. 4⅝ in. (11.7 cm.)
H. 1¼ in. (3.2 cm.)
Nineteenth century.
Signed: *Zeshin*

in pulverized form, with fine silver combined with charcoal, or with only powdered charcoal over a prepared *taka maki-e* ground. This is an exceptional example of Zeshin's skill in simulating metallic surfaces in lacquer.

The hand and scarf of the incomplete figure are of a rusty iron (*tetsu*) texture known as *tetsu sabi nuri*, or *sabi ji taka maki-e*.[2] The color was achieved by using red ochre. Sometimes charcoal is an alternate thickening agent. This mixture was used for both base and finish, its rough surface resulting from the manner in which the compound was applied and finished. The pillars and posts of the gate house that appear in rust and green are of colored *taka maki-e*. A dark brownish-black lacquer was applied as the final coat, and then partially polished away so that only the edges and grooves retain the final darker coat, creating a greater three-dimensional effect.

The gold used for the sandals is in high relief, while the delicate pine needles and the fallen leaves on the lower left are in a combination of relief techniques. Two small silver colored rectangular objects simulating pieces of paper and inscribed with raised characters, float inconspicuously in the wind; yet these seemingly insignificant additions to the composition are of paramount importance, since they identify the possible occasion for which the box was made. On one sprinkled silver surface are the raised characters that any Kabuki fan would recognize as *Sukeroku*. Combined, these two slips of paper refer to the famous theatrical production known as *Sukeroku Yukari no Edo-zakura*, from the Ichikawa collection of Kabuki plays. The Kabuki theater was within strolling distance of the Asakusa Kannon Temple and it seems very likely that this box was made in commemoration of a particular performance. The inner section houses a circular water dropper of copper, the surface of which was first roughened, then covered with rust-colored lacquer to match the feeling of the figure on the lid.

This lacquer box is housed in a wooden storage container that states that the work inside has been authenticated by Chikushin, Zeshin's disciple. This is followed by the seal of Zeshin's son, Reisai. Recently many objects of questionable design supposedly by Zeshin and stored within a box testified to by Chikushin, have suddenly appeared in the market. It should be remembered that where there may be a question of authenticity, final judgement must be made on the basis of style.

Notes:

[1] *Ishime nuri*, as formulated by Matsuda Gonroku, requires the mixing of *ki urushi*, strained egg white, pigment, and bean curd to form a compound that eventually is applied to the surface to form the grainy finish common to the grounds of Zeshin's works.

[2] *Sabi ji* and *sabi urushi* are terms often used interchangeably.

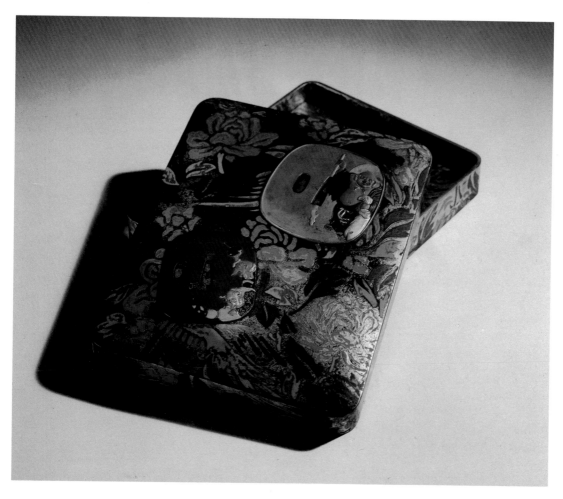

Dimensions: L. 8½ in. (21.6 cm.)
W. 6⅝ in. (16.8 cm.)
H. 1¼ in. (3.2 cm.)
Nineteenth century.

33. Inkstone Box (*suzuri-bako*)

One of the most difficult problems confronting a connoisseur presented with an unsigned object in the style of a renowned master is whether the piece is actually by that master and was left unsigned or whether it is the product of an exceptionally talented student who has copied his master's work. In the case of Zeshin, authenticating an unsigned Zeshin is more difficult than separating out poor pieces with seemingly good signatures. Although this and the next piece are related, for various reasons to be discussed, the two boxes will be treated separately.

This inkstone box displays a surprising blend of features. Its color and patterning are unusual as this type of multicolored stencil design is rare in lacquer. The entire box was first finished with a black ground. Three stencils were then used to create the floral and bird designs in red, yellow, and green, respectively. After the colors had dried, silver leaf was added to the four outer surfaces of the lid, while gold leaf was applied to all the inner sides. Next, the outsides of the lower half were silver-leafed only where that area would show, below the bottom edge of the lid; the hidden upper section was gilded. The artist knew that the surface of the design would resist the metallic leafing to some degree so that the combination of color and ground produced soft edges and muted tones. A final polish removed even more of the metal, and the blending of tonal qualities were further emphasized.

97

Details of stencil patterning

Finally, lacquer facsimiles in high relief appliqué of such sword furnishings as the sword guard (*tsuba*) and the side dagger (*kozuka*) were added to the cover. Sword furnishings often appear on lacquer storage containers of various types attributed to or signed by Zeshin, but are rarely seen on inkstone boxes. Stencil patterning by Zeshin is even more rare, however, and no reference concerning its use by him existed until 1981, when a new publication included a picture of a large *inrō* storage box. Appearing as the decoration on the front of its drawers was a pattern resembling the one shown here, but there was not enough detailing of surface evident to make a firm connection. One year after that photograph appeared, this writer was privileged to view the box, and inspection revealed that the inside of the lid which covered the front of the chest, and had not been published, contained patterning in the exact same color and design as appears here. (see above photo, far left)[1]

Another coincidence was the appearance of the same four sword furnishings, exactly duplicated in size, form, and color, on both this and the Hatakeyama example. These similarities raise many questions requiring more space than is permitted here, and only a few will be discussed in the next entry.

Note:

[1] Also see Gōke Tadaomi, *Shibata Zeshin Meihin Shū* (Masterpieces by Shibata Zeshin), Gakushū Kenkyūsha, 1981, Vol. I, illustration #55. An *Inrō* storage box from the Hatakeyama Museum, in Tokyo.

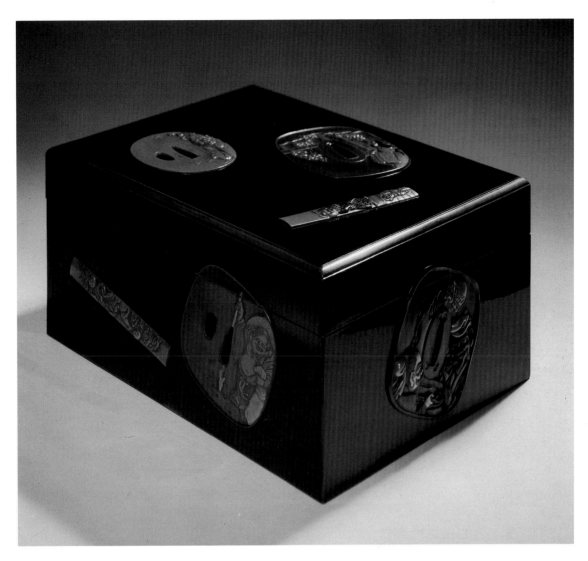

Dimensions: L. 9⅝ in. (24.4 cm.)
W. 7¾ in. (19.7 cm.)
H. 4¾ in. (12.1 cm.)
Nineteenth century.

34. Stationery Box (*ryōshi-bako*)

The shape of this box, with its flat surfaces and sharp corners, is typical of document or stationery storage containers of the last half of the nineteenth century. The formal elongated *fu-bako* of earlier days (see cat. no. 7) and the flattened, shallower stationery box (see cat no. 19) both gradually went out of style to be replaced by this singular, more functionally shaped form. Its outer surfaces are decorated with a variety of appliqué designs, a style that Zeshin probably introduced and certainly popularized. This and the inkstone container just discussed (see cat. no. 33) bear a marked similarity to the published example found in the Hatakeyama Museum in Tokyo.[1]

There are conflicting scholarly opinions as to how Zeshin was able to reproduce appliqués identical in shape, size, and color. The idea that a mold might have been used, and then the surface finished further with colored lacquers had traditionally been discounted, since Japanese lacquerers have the ability and patience to make many duplicates of any single design. Although this is true, further

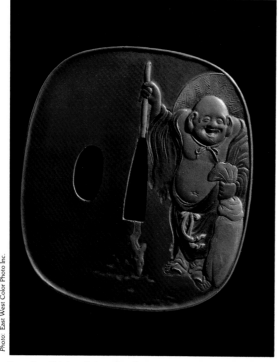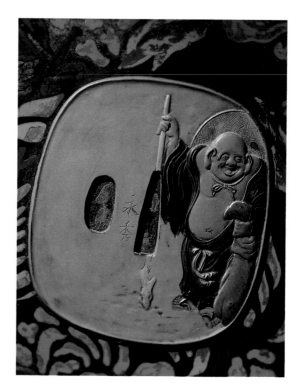

Details of high relief appliqués.

research disclosed that there were indeed two related techniques in the nineteenth century for the building of high relief that did include a mold; both are called *taka maki-e hō*, literally "method of making of high sprinkled picture." One of the major problems in using a mold was the necessity of finding a successful solution that would allow the piece to be stripped from its form (*hakurizai*) since the upper surfaces of the design, in this case simulated sword furnishings, were molded face down.[2]

Soap, paraffin, oil, and starch were all tried as the protective liner between the mold and the compound. Unfortunately soap left a film; paraffin had to be heated and was not soluble for easy cleaning; oil has an affinity for *urushi* and would not permit drying; and starch left the surface rough and pitted. Finally, two techniques were perfected, but both required having the normal lacquering process applied in reverse.

In the first technique a model was made in plaster or clay. A solution called "*arguinsan* soda" (known chemically as sodium alginate) was applied as a liner to the surface of the model. After it had dried, a coat of plain or black *urushi* was painted on the surface, which was then sprinkled with gold and silver powders. After the powders had dried another coat of lacquer was applied and dried, and finally an application of thick *shita ji nuri* was added. After this had thoroughly dried, the mold was inserted into water to dissolve the sodium alginate liner, making the removal of the molded object from its confines easy. The freed object was then turned over, its surface finely polished, and additional color or detailing added.

The second method includes everything previously mentioned through the application of the metallic powders with the further addition of: two coats of *urushi*, followed by two more coats of plain or black

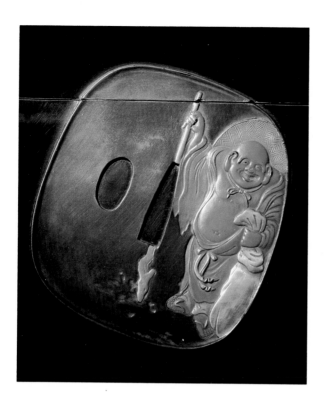

urushi; *naka nuri* and finally, *shita ji nuri* were added to bring the level of thickness to its desired height, usually even with the level of the sides of the mold. The shape was then separated from the mold and finished as described previously. It is this method which would have been used to achieve the degree of thickness found in the replication of the sword furnishing designs under discussion here. The finished form was then inserted into a slight cut out in the lacquered surface of a box and attached with a glue made of rice paste and *urushi*. After insertion, it was given another final polish in the usual manner. These complicated procedures are not in use today because there is no demand for multiple copies of one design using appliqués as seen here. From the available evidence, it seems probable that only Zeshin perfected and utilized this process in order to meet the tremendous demand for this style of work.

The similarity between the Hatakeyama Museum's *inrō* storage box and the stationery container shown here is unmistakable. Both share the same shape, with the top edges recessed so that the sides stand out as panels. Both have their edges finished in opaque gold with all other ground surfaces of the shiny, waxy black lacquer finish known as *ro iro*. Of primary concern to this discussion are the appliqués found on all three boxes. On the lid of the inkstone container, as well as on the side of the box shown here, are the identical renderings of a sword guard showing Hotei, the God of Good Fortune, leaning on a pole and holding his bag of treasures. Behind his head rests a textured straw hat. They both match the one found on the Hatakeyama *inrō* storage box. The only differences in the three are the color of the metal used in the ground, a variation in tone of the coloring of Hotei's garment, and the inclusion of an incised signature on the writing box.[3] (see photo p. 100, right side) However, no individuality was attempted in the renditions of the dagger handles, resulting in three indentical portraits of Shōki, the Demon Killer. (see following page)

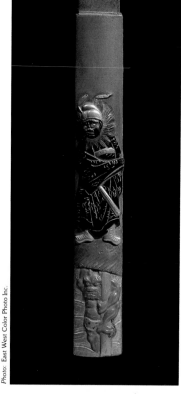 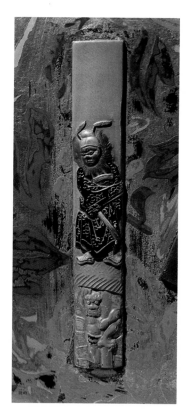 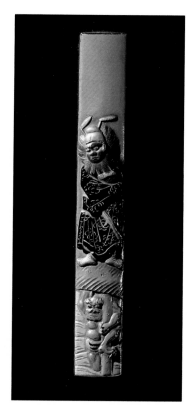

Details of high relief appliqués

The Hatakeyama *inrō* box does have on the top right-hand side of its front panel a sword guard that bears an inscribed Zeshin signature, while the appliqués on this document box bear signatures representing various sword guard makers and other names any one of which could be a "nom de plum." The problem of authentication never rests on signature alone, especially in Japan, where it was the custom for the master to sign his name to his student's work as a sign of approval. In many recorded cases, students working under renowned masters actually did most of the work their teachers signed. This was due principally to illness on the teacher's part, or, more often, when there was a heavy demand for that artist's works. Under the old Japanese system, a pupil usually remained fairly anonymous until his teacher's old age, or demise. Although this box is not signed by Zeshin, the quality of the workmanship is unquestionably that of the master.

Notes:

[1] Because of the seemingly identical rendering of surface decoration the museum consented to photographs of that object being published here. Also see Gōke Tadaomi, *Shibata Zeshin Meihin Shū*, photo #54-60.

[2] See "Taka maki-e hō" in Sawaguchi Goichi, *Nihon Shikkō no Kenkyū*, Tokyo, 1966, pp. 346-347.

[3] The two characters, which read NAGAHIDE, represent the name of a famous *tsuba* maker.

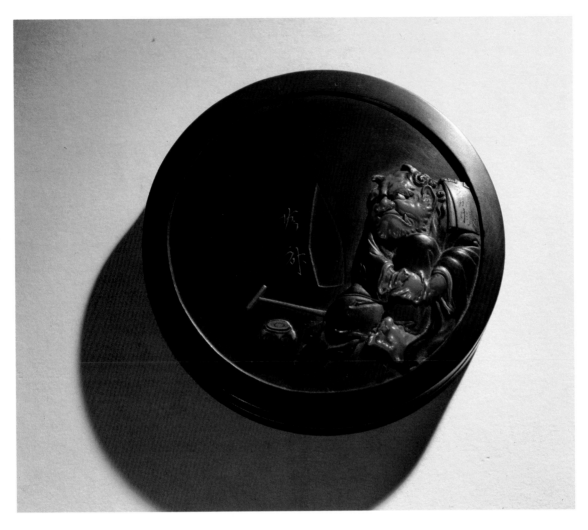

Dimensions: Dia. 3⅛ in. (7.9 cm.)
H. ⅝ in. (1.6 cm.)
Nineteenth century.
Signed: *Chinryū*

35. Incense Container (*kōgō*)

This rounded box is shaped and decorated in lacquer to simulate the appearance of a "soft" metal circular sword guard. During the Edo period sword furniture became progressively more elaborate: heavy and ornate encrustations of gold, silver, and various treated alloys of copper were intricately fashioned as "presentation pieces" serving no function. The generic term "soft" was applied to these later more malleable metallic compounds; the earlier, more practical guards were made of iron. Zeshin and his atelier originated and popularized lacquer facsimiles of such sword accessories and became renowned for his exact reproductions.

This example shows the short-horned demon called an *oni* dressed in a monk's robe. On his shoulder (in powdered silver) is a notebook with a cover bearing the Japanese characters for *hōgachō* a book in which priests record donations. The creature portrayed here is called the *Oni Nembutsu*, in a reference to the repenting of the little demonic creature's evil ways by chanting an invocation in which the name of Buddha brings salvation. The theme is always treated in a tongue-in-cheek fashion, for it is obvious that demons cannot change their true nature.

The figure here is superbly executed, with just the right amount of sardonic humor. On a silver gray *shi bu ichi nuri* ground, thinly sprinkled to allow the natural graining of the wood base to show through, the figure is constructed in high relief. His body is of *aka-gane nuri*, the exact fox-red color and texture

103

of an oxidized copper finish, and his robe is given the same black metallic appearance of *shakudō*. Sprinkled gold has been strategically and sparingly applied to the lining of his garments, to his horns, fangs, bracelets, and toenails, and especially to his eyes, which have been made more lively by the addition of black pupils. The figure is accurately rendered, realistically formed, and distinctively designed, the work of a master. The characters on the left of the simulated blade opening are difficult to interpret, but it is highly probable this *kōgō* was also made by Zeshin, using the rare signature of *Chinryū*.[1]

Note:

[1] The reading of the two characters that make up the signature is extremely difficult and only the first, Chin, is certain. However, the perfection of the work and style identify this piece as undoubtedly Zeshin's. According to M. Fault, the name "Chinryūtai," a rare signature, has been used by Zeshin. Possibly this is a shortened version of that name.

36. Incense Burner (*kōro*)

Ikeda Taishin (1825-1903) was born in Kyoto and began his apprenticeship at the age of ten to Shibata Zeshin, eventually becoming his most outstanding student. At the age of sixteen, he accompanied his teacher on a study trip north to Akita and recorded in brush and ink those renowned religious and historic sites visited earlier by the famed poet Bashō in the seventeenth century. Zeshin felt it important for his students to see through the eyes of the past as well as in the present. Little is known of Taishin's subsequent history, but most probably he accompanied his teacher to Edo and stayed with him in a master-student relationship until Zeshin's death. Certainly Zeshin encouraged his gifted student: they both had entries in the Vienna Exposition of 1873. Taishin won independence in his later years and was finally appointed Court Artist to the Emperor Meiji in 1896. His signed works are as exceptional as Zeshin's, but are fewer in number, probably because most of his life was spent working under his teacher.[1]

There is a simple elegance to this incense burner, as befits an accoutrement of the modified incense ceremony. The stick of fragrance was placed upright in a deep bed of ash, which almost filled the removable liner set into the lacquer base. Taishin decorated the outer lacquered surface by combining

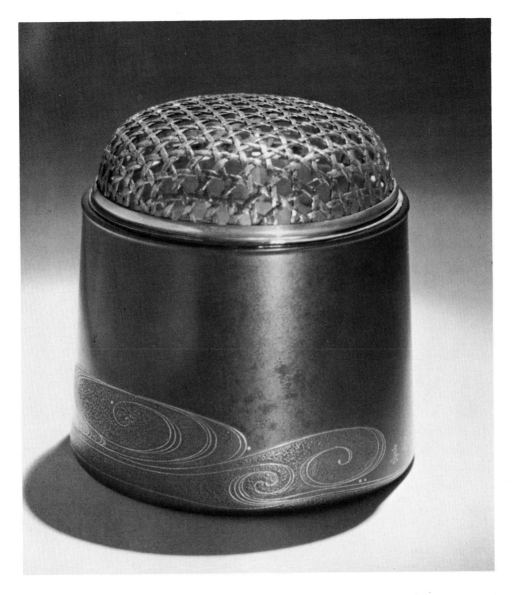

Dimensions: Dia. 2⅞ in. (7.3 cm.)
H. 2¾ in. (7.0 cm.)
Nineteenth century.
Signed: *Taishin*

the gray, pebbly surface of an *ishime* ground with the smoother, minutely textured deep dark-green of his master's noted *seidō nuri* ground. Only thin, sprinkled-gold lines in low relief offer a bright contrast against an otherwise somber coloring. The gold swirls with their tiny droplets suggest either the motion of water or the gentle swirling of smoke, as when incense is burned. The tone of the coloring, composition, and technique are deliberately muted and understated, so as not to stimulate one's sense of sight while one is concentrating on the subtlety of fragrance.

Note:

[1] It seems highly probable that Taishin produced many works of art under his busy master's signature, for Zeshin died only twelve years before him. This means they would have worked together for almost fifty years. Further study on this subject has yet to be undertaken.

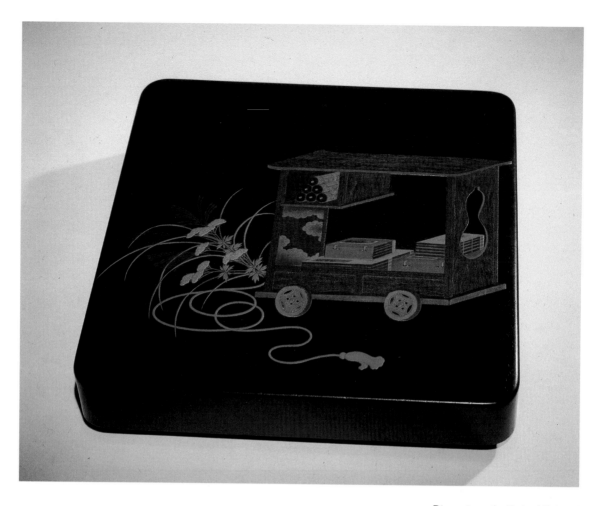

Dimensions: L. 7⅝ in. (19.4 cm.)
W. 7⅝ in. (19.4 cm.)
H. 1½ in. (3.8 cm.)
Nineteenth century.
Signed: *Taishin*

37. Box for Poem Papers (*shikishi-bako*)

Poetry was traditionally written on thin papers of different sizes which were then pasted on to heavier stiffer backing. Afterwards, the calligraphy was often slipped into a special mount for hanging. The various square-shaped mounted papers are called *shikishi*.

On the dark green ground known as *seidō nuri*, Taishin has decorated this container for the storage of decorated poem papers with an amusing design. The artist, a man of great skill and creativity, has distorted Western linear perspective in a fashion that must be a deliberate parody, or at least a commentary on the confusion of the times. Employing fine detailing, extraordinary skill, and color harmony, he has created a composition consisting of a fanciful cabinet on wheels for the storage of books and scrolls, in a shape that suggests an oversized pullcart for a child. The long red twisted cord that lies gracefully on the ground ends in an elegant gold and red tassle. This finely wrought bright red lacquered form in low relief technique, offers strong contrast to the studied, stiffly formed branches of fall foliage comprised of patrina, pampas grasses, and ferns. The top of each bud of the well-known yellow flower has been clearly defined in gold *hira maki-e* and complemented by the soft gray blue of the fern.

The surface of the shelved cart is a masterpiece of the *mokume* technique, a ground that simulates the natural graining of wood. The vertical and horizontal beams of the cart are in high relief, raised in realistic fashion away from the shelving yet harmonizing into the total construction. While almost all the horizontal lines are straight, little attention has been paid to perspective; the right vertical support veers

off enough to the left so the rectangular shape of the cart appears slightly oblique and the side lines of both top and bottom edges are also askew. This odd perspective is compounded by the wrong angularization of the joints of the left side of the cart. This area may be recognized by its inside surface decoration of a pale gold cloudlike formation, with tiny cut gold squares added for highlights. This same section joins the scroll shelf on the left, at its base.

All of this discord is made more amusing by the stylized, disproportionately shaped wheels. These circular shapes have *nashi ji* and powdered gold on their irregular spokes, and the metal edges of the wheels are finished in powdered silver and charcoal, simulating pewter. In contrast, the stacked, bound volumes of books and layers of scrolls resting on the inner shelves are in perfect proportion and angularization, and are finished with exquisite detailing. The fabrics covering the clothbound books are of dark and light *nashi ji*, with a few having a speckled green and gold weave patterning, in low relief. One bound volume has as its title overlay an inlay of shell on which the thin black characters for *saijiki*, are inscribed. The *Saijiki*, a dictionary categorized by seasons, lists the events, flowers, and such associated with each aspect of the year. The general design is of a classic subject, executed with a sharpness of line and detail that seems characteristic of Taishin's compositions.

38. Inkstone Box (*suzuri-bako*)

By the second half of the nineteenth century complicated and elaborate lacquers were produced that demonstrated an extraordinary amount of technical skill. Most of the larger objects were inkstone boxes, replete with water dropper and space next to the inkstone for the storage of writing brushes.

The composition on the lid of this box uses the naturally variegated wood of the cryptomeria tree. Sanded, polished and then thinly lacquered, the dark brown ground serves as a dramatic backdrop for the *netsuke*, *ojime*, and *inrō* ensemble in high-relief that is embedded on its surface. The artist has tastefully positioned his objects with an eye to compositional balance and color harmony. The surface of the trefoil shaped maple leaf which serves as the *netsuke* appears to be decorated in the typical diaper patterning associated with the carved red lacquer technique known as *tsui shu*. Close examination however, reveals it to be made from the thick, moldable compound called *sabi urushi*, which, after it has partly dried, can be more easily worked. In this case, only a few coats of red lacquer have been added to simulate the appearance of the more difficult and time-consuming Chinese method.

The bead-shaped slide fastener, known as an *ojime*, is of a brilliant but clouded glassy green and is probably dyed agate. The bead is in perfect proportion to the ovular-shaped inlay in the form of a four-case *inrō*. Its surface design is that of a serpent wrapped around the body of a pheasant. This subject is an allusion to an old Japanese tale with Buddhist overtones. The legend relates how a snake devours a pheasant, who in turn has eaten a worm. A wild boar then consumes the snake. A hunter, about to kill the boar, stops himself, thus ending the karmic chain of death. (Had he not done so, the story continues, the fierce mythological creature known as a *tengu*, who was watching the man, would have slayed him.)

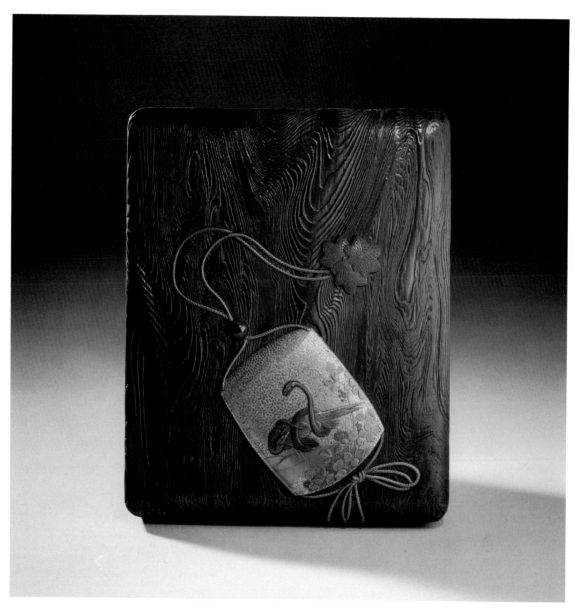

Dimensions: L. 10 in. (25.4 cm.)
W. 8¼ in. (21.0 cm.)
H. 2 in. (5.1 cm.)
Nineteenth century.
Signed: *Koma Koryū saku* (made)

The ground of the *inrō* is in the yellow orange tone associated with "pear-skin" coloring, but instead of a typical *nashi ji* surface, large, irregularly shaped flat pieces of gold called *oki hirame* are set into the lacquer to form a close mosaic pattern. This field of bright color is a perfect backdrop for the large, extraordinarily detailed figures of the two creatures portrayed in a battle for survival. The pheasant has tiny particles of green shell embedded in its crest, body, and tail feathers, which sparkle in colorful contrast against its otherwise dull-toned body. Every scale of the snake's belly and back is undercut to imitate those of the living creature. The position of the serpent around the bird suggests that the combination was probably rendered more for effect and style of composition than as a realistic portrayal of an actual struggle as the snake is not wound tightly enough around the pheasant's body.

On the inside of the lid is pictured a seascape with two prawns climbing on top of a rocky, encrusted formation, against which waves crash and curl. The brilliant red crustaceans are dramatically set in high relief against the gray rocks, which are imbedded with colorful nuggets of gold and malachite. An

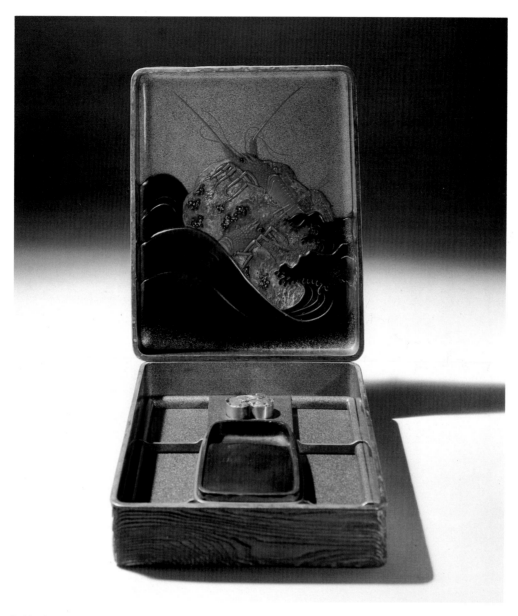

Inside view

unusual feature of the composition is the manner in which the artist has created the transparent effect whereby the back of one prawn appears submerged. At first it seems that the high relief work representing the water, is indeed colorless and that the carapace has been drawn under about a quarter inch of built-up clear lacquer. However, close inspection reveals that the *togidashi* technique was used in the last few upper layers to create the diaphanous effect. After the ground work in high relief was finished in *sabi urushi*, red lacquer powder, used to identify the crustaceans' bodies. was carefully sprinkled and then covered with a few layers of transparent yellow *urushi*. The whole area was then polished down to reveal the skill of the delicate application of powdered red pigment; an additional coat of clear lacquer was next applied over the burnished area. Over this, the finest grade of gold powder was sprinkled with great accuracy and total control on top of the appropriate area, dried, and was then polished. Finally the last coat of transparent *urushi* was added and given a polishing to complete the effects.

Inrō ensembles became a popular subject on boxes during the last half of the nineteenth century, and Shibata Zeshin's atelier was noted for this motif which other artists, probably copied. Hidden under the inkstone is a signature that reads: *Koma Koryū saku* (made).

Detail of Workmanship

39. Brush Box (*fude-bako*)

Ichizō Hashimoto (1811-1882), who worked during the middle part of the nineteenth century, was another great lacquer master; however, he is better known by the art name of Hashi ichi. Although he was noted for his broad range of techniques, his most famous technical achievement was that of imitating the appearance of dry bamboo.[1]

After the box maker had created the core of this box, Hashi ichi covered certain areas with *sabi urushi* for texture. Then, by adding green, yellow, and brown lacquers in extraordinary combinations, he was able to reproduce almost exactly the graining, striations, and spotting of the bamboo stalk itself. The rest of the effect was created through a combination of *hira* and *taka maki-e*, additional *sabi urushi*, and such finishing techniques as grinding and polishing. Furthermore, the box has deeply recessed ends to heighten the illusion of being made of bamboo.

The inside of the brush box is decorated with thick, rectangular-shaped pieces of sheet gold placed into the black lacquered surface; to this, several coats of transparent lacquer were added to protect the glistening yellow metal from wear since it protrudes well above the level of its ground. The contrast of such an elegant interior and a seemingly simple (but actually extraordinarily complicated) exterior must have been amusing to the owner: only he, as he opened it for his brushes, could appreciate it fully. The hinge on the back as well as the four gold and silver metal front mounts positioned for opening the box are in the shape of bamboo leaves, completing the motif.

Note:

[1] Several of his pieces are in the Tokyo National Museum as well as in the museum of the Tokyo School of Fine Arts.

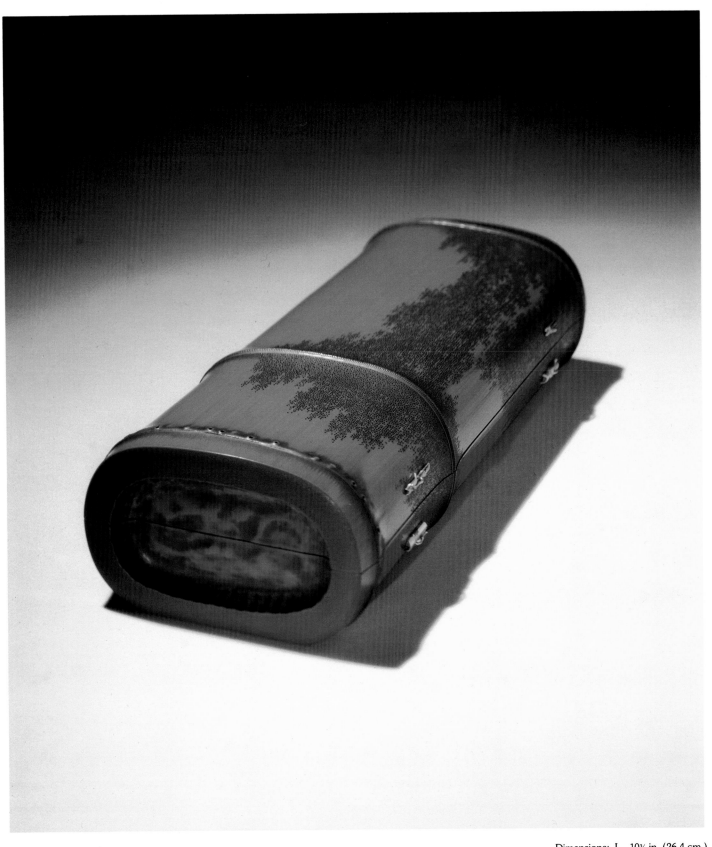

Dimensions: L. 10⅜ in. (26.4 cm.)
W. 4½ in. (11.4 cm.)
H. 2⅜ (6.0 cm.)
Nineteenth century.
Signed: *Hashi ichi*

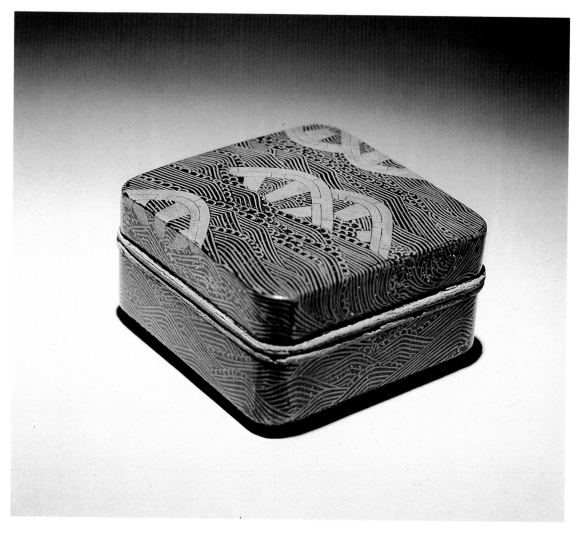

Dimensions: L. 2¼ in. (5.7 cm.)
W. 2¼ in. (5.7 cm.)
H. 1¼ in. (3.2 cm.)
Nineteenth century.

40. Incense Container (*kōgō*)

The "floating-wheel" design shown on the cover of this box first appeared on a twelfth-century cosmetic storage box (*te-bako*). The motif derives from the early practice of soaking the wheels for bullock carts in the Kamo River in Kyoto; wheels thus treated were stronger, kept their shape longer, and resisted warping. The design went out of fashion after the Heian period and was not seen again until the second half of the nineteenth century, when there was a revival of old styles, principally for the foreign market. While the original early renditions showed realistically rounded wheels with their spokes and central hub clearly defined, the design shown here is completely stylized into an almost oval shape. No attempts have been made to copy the older format, but rather the intention is an extrapolation of the theme in an elegant statement.

The flattened form of this box, with only its four corners softly rounded, is typical of the nineteenth century, and the edges of the box, although covered in a pewterlike material, show little if any, oxidation. While the design is in the same coloring (gold and black) and the same technique (*togidashi*) as its twelfth-century predecessor, there is, among other differences, less layering of clear lacquer in the finishing steps before the final polishing.

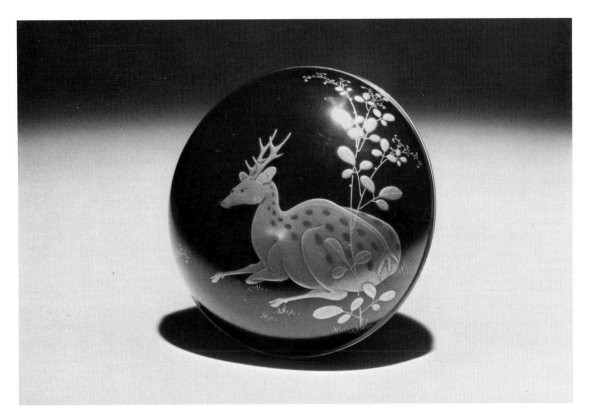

Dimensions: Dia. 4¾ in. (12.1 cm.)
H. 3 in. (7.6 cm.)
Nineteenth century.

41. Box for Sweets (*kashi ki*)

The Rimpa school of painting was patronized principally by the merchant class. Its distinctive format included the application of a gold or, more rarely, a silver-leaf ground on paper (for scrolls or screen painting) to which a characteristically Japanese design in vivid colors was added. Rimpa influence on lacquer was immediately evident, for two of the school's earlier artists — Kōetsu and later Kōrin (probably indirectly) — worked in the medium. Although the Rimpa style in art was fashionable until the middle of the nineteenth century, its direct influence on lacquer, with the exception of two revival periods, ended during the mid-eighteenth century, following Kōrin's death. The first revival period was in the early part of the nineteenth century (see cat. no. 8), the second occurred toward the end of that century, when this box was made.

Several famous early Rimpa works in painting and lacquer incorporated deer and autumnal grasses as their central themes, notably Sōtatsu's deer scroll and Kōetsu's lacquered flute case covered with figures of deer in shell on a gold ground.[1] On the rounded domed surface of this box is a typical autumn theme. The artist has tastefully placed a spotted deer in a resting position on a small bed of grasses, with occasional sprouts of bush clover providing interesting breaks in space. The animal's body, of thick gold powder (*fun-dame*), is set off by the dark black glossy ground. The leaves on either side of the deer and the flowers of the bush clover are in both low and high relief, carefully placed to balance the mass of the deer's body. The inner surfaces of both sections of the container are covered with stylized maple leaves in *togidashi*, with gold lacquer dewdrops applied to their surface.

The shape of the box is unusual. Boxes for sweetmeats are usually square-shaped and are called *kashi-bako*; circular-shaped containers such as the one shown here are based on an earlier Chinese form and are called *kashi ki*. This same rounded shape also appears in Ryūkyū Island lacquers.

Note:

[1] As seen in the collection of the Yamato Bunkakan in Nara, Japan.

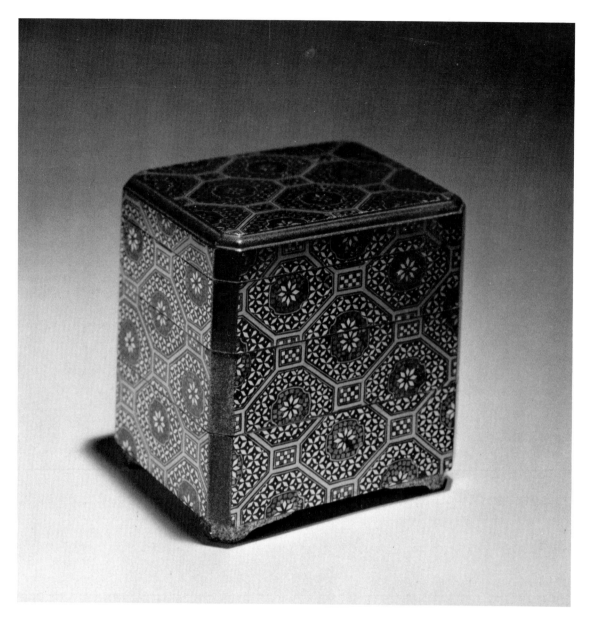

Dimensions: L. 2⅜ in. (6.0 cm.)
W. 1⅞ in. (6.8 cm.)
H. 2½ in. (6.4 cm.)
Nineteenth century.

42. Tiered Incense Box (kō jū-bako)

During the Tokugawa period there was a substantial increase in lacquer production throughout the provinces. While Kyoto and Edo were the two major centers of this art form (followed by Wajima on the Noto Peninsula), its development was also encouraged in many areas by local *daimyō* seeking new sources of revenue. As a result, certain localities became known for specific techniques. In the eighteenth century Somada Kiyasuke (active about 1716-1736) traveled south to Kyūshū and settled at the port of Nagasaki, where he learned the Chinese technique of inlaying thin iridescent scales of shell on lacquered objects.[1] After returning to his home in the northeastern province of Toyama (now Ishikawa Prefecture), he combined this shell technique with cut gold and silver leaf to develop what is termed the "Somada" style of inlay.

Later in the town of Kaga (bordering on Toyama), Somada Gempo (active ca. 1815) produced another unique type of design. Of the same line as Somada and working at the Daisho-ji Temple, he combined tiny square-cut pieces of shell with gold and silver triangle-shaped inlays to form geometric

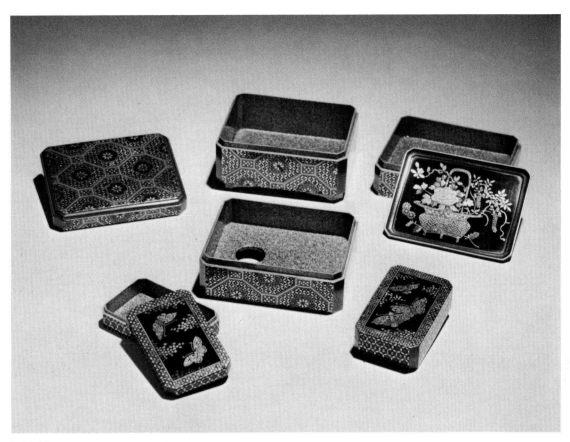

Inside View

patterns against a jet-black lacquer ground. (Black lacquer is the traditional ground for this type of shell, since it deepens the color of the opaque shell resting on its surface.)

In all probability this small three-tiered footed incense box was made by a direct descendant of Somada Gempo, although the box is unsigned.[2] The lid and sides, as well as the two smaller fitted containers within, are in the geometric and mosaic floral patterning for which the master was noted. The construction is characteristic of many similarly designed sets dating from the nineteenth century. The floor of the middle tier, which contains two tightly fitted smaller boxes, has a finger hole to push one inner box free from its confines without damaging the other. This distinctive feature is also found in the large, more complicated earlier sets and shows a direct relationship between the construction of the two types.

The two interior rectangular boxes are decorated with butterflies inlaid in slivered shell, gold, and silver. The inset tray on which the answer paper for the incense game would be placed is richly decorated in the form of a basket of mosaic flowers. The outside of the bottom tier is footed, a characteristic of Chinese influence. This decorative technique produces a colorful effect touched with dramatic elegance.

Notes:

[1] The thin iridescent scales of shell come from the abalone. In order to obtain the extraordinarily thin sheets used, the mollusk must be at least seven years old (judgment is made by experts who recognize age by the degree of shell development). After being boiled and cooled in a consecutive pattern over one month, the scales can then be peeled off.

[2] It has been theorized that these small, comparatively tiny tiered boxes were part of a simplified version of the incense game to be played by only two people. More rudimentary in practice than the elaborate and complicated aristocratic versions, such sets were probably innovated for merchants. Interviews with the Grand Master Sanenori-Sanjonishi of the Oie Ryū School of Kōdō, and the Nippon Kōdō, Inc. representative, both in Tokyo, confirms the scarcity of information concerning the stylistic development of any of the lacquers used in the incense game.

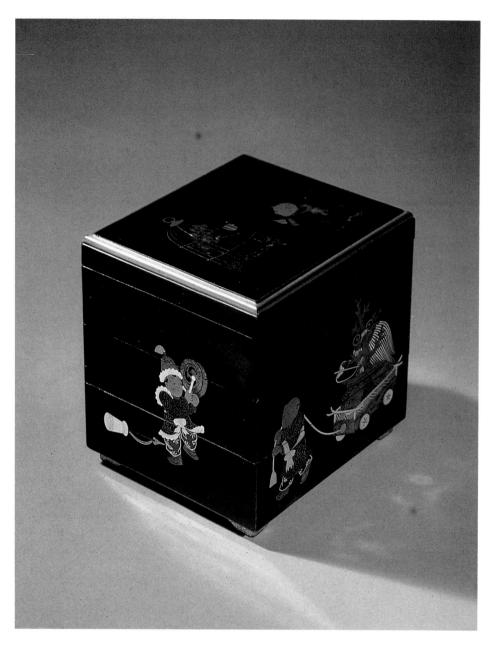

Dimensions: L. 2⅝ in. (6.7 cm.)
W. 3 in. (7.6 cm.)
H. 2⅞ in. (7.3 cm.)
Nineteenth century.

43. Tiered Incense Box (*kō jū-bako*)

During the nineteenth century smaller, more casual, and more intimate sets associated with the burning of incense appeared (cat. no. 42). Less expensive scents in stick form were available in stock sizes, making the more elaborate paraphernalia unnecessary; less wealthy individuals could now enjoy the game on a modest level. Incense was kept in small containers and burned in special burners called *kōro*. (see cat. no 36)

A particular holiday might prompt the bestowal of a gift such as the tiered incense box shown here, made for the annual celebration known as the Seven-Five-Three Festival. On this occasion mementos and sweets are given out at shrines to children of these three specific ages, the three year olds usually wearing the most brilliant attire.

On the sides of this tiered box are scenes of children playing with various toys, including a ball, a drum with the three-comma-shaped symbol of good luck and fortune, kites, and a wagon containing good luck symbols. Among the symbols in the wagon are a branch of coral, considered a precious substance; a round fan, usually representing authority and safety but also Hotei, the god of good fortune; and a feathered garment (*hagoromo*), emblematic of immortality and the desire for perpetual youth. Children at play form the rest of the composition on the outside panels, the inside smaller fitted tray, and the tiny fitted boxes stored within the three-tiered container.

The expert application of tissue thin sliced shell over a black lacquer ground is typical of fine quality Somada style work. The powdered colored lacquers used on the childrens' faces and clothing and on other surfaces are so thinly applied that the entire finish appears flush with the surface, as in *togidashi* technique. On some areas of the clothing, minute cuttings in the shell allow the black ground to show through as part of the pattern of the cloth. While the general construction of this tiered container appears to be similar to that of cat. no. 42, the black color of the ground has "caramelized" to some degree, a factor usually suggesting age. Its' style indicates, however, that it is of a later period than the previous example. This box oxidized more rapidly because its thin finishing layers of clear lacquer allowed easy contact with air.

44. Small Box in the Shape of a Badger (*ko-bako*)

No animal in Japanese folklore is as great an instigator of pranks and practical jokes as the badgerlike animal called the *tanuki*. Although its habitat is the dense forest region of central Japan, in its supernatural form it is found everywhere. The legendary *tanuki* is noted for its ability to change its shape and appearance to that of a human, a fox, or a bear, but its bushy tail is usually evident and reveals its true identity.

Boxes in exotic shapes, such as the one shown here, were not generally made for the home market but, rather for the export trade. The Vienna Exposition of 1873 brought Japanese lacquer to the attention of the West for the first time and created an immediate demand on the Continent. To the Japanese, gold and shell glistening brightly in direct sunlight or electric light took away most of the

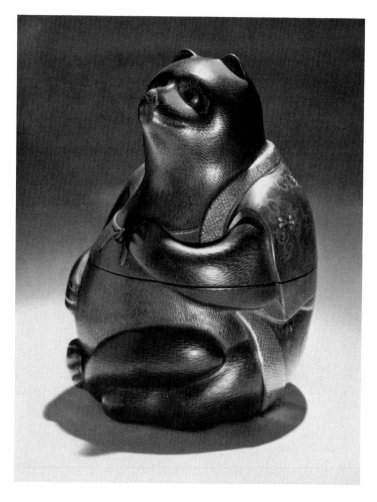

Dimensions: L. 4 in. (10.2 cm.)
W. 2⅜ in. (6.0 cm.)
H. 2⅝ in. (6.7 cm.)
Nineteenth century.

mystery of lacquer. *Sabi* and *wabi*, terms used to express the Japanese sense of subtlety and understatement, were as yet not well understood by the more exuberant European and American populations. Allusion, an integral part of the Japanese poetic nature, had little audience abroad for some time.

The shape of this fat badger is somewhat rare. The lacquer artist enhanced the box maker's unusual form by coating it with a thick mixture of *sabi urushi*, which was then contoured, dried and sanded. Short heavy lines simulating hair were next painstakingly drawn in the thick substance. When these lines had dried and were ground smooth, the entire surface was thinly lacquered again. Then silver-gray *shi bu ichi nuri* was used to cover the animal's body surface, and additional colored lacquers were applied as decorative contrast in various techniques.

The badger is dressed in a type of small padded housecoat used to keep out the chill. This garment was not usually worn in public, but remained hidden under other clothes. Finished in a flaked gold powder that takes a brilliant shine, the coat is decorated with arabesque and floral designs of sprinkled gold, silver, and red lacquers in low relief. Small floral repeats of green lacquer and shell add brilliance and texture. Squares of thin cut gold have been applied on the wide border of the coat, and the front ties that keep it closed are of red lacquer. In an unusual feature, tortoiseshell has been contoured to form the badger's eyes and inlaid with pupils of black sea-pine — a technique often used in *netsuke* but rarely in lacquer.

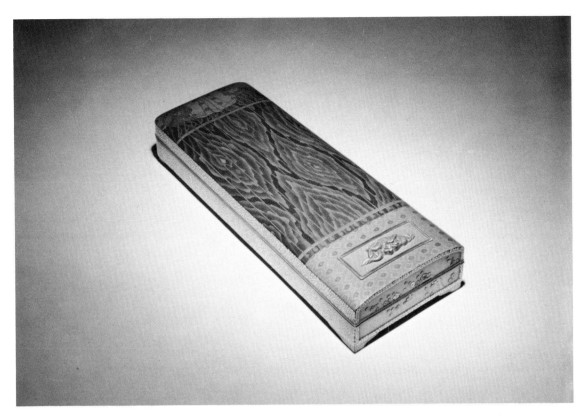

Dimensions: L. 8⅝ in. (21.9 cm.)
W. 3⅜ in. (8.6 cm.)
H. 1½ in. (3.8 cm.)
Nineteenth century.

45. Inkstone Box (*suzuri-bako*)

This inkstone container is in the shape of the thirteen-stringed musical instrument called a *koto*. The complicated shape of this popular instrument inspired lacquer artists in the nineteenth century, who had turned away from the standard sketchbooks and illustrations and had instead begun to reproduce objects of daily use in lacquer.

During the latter part of the Edo period, the *koto* was closely associated with different forms of entertainment, and it was the musical instrument studied most often by female members of the samurai class. The shape and sound of the instrument pleased the senses, and facsimilies of the form, such as shown here, were usually made into lacquer boxes, probably at the request of wealthy merchants. No doubt they appreciated such an object as a sign of education and sophistication. This particular example would have been placed in an alcove where guests might write their names in a book with, perhaps, a favorite line of a poem as a remembrance.

The lid of this inkstone receptacle resembles the typical complex surface of an actual instrument. The lacquerer has simulated the graining of the wood through a technique known as *mokume*, in which gold and silver powders are heaped on a jagged lacquered outline. The powders were then gently shifted inward to form gradations in density. Afterwards, other features of the instrument, such as its strings, were simulated by ridges of gold, using the *taka maki-e* technique.

The short sides of the box have been covered with large, irregular flakes of gold called *oki hirame*; the long sides have tiny inlays in the shape of cherry blossoms that have been made of pure gold, silver, and coral, and then set into a matte-gold ground. A silver inlay in the shape of a dragon decorates the area where the strings are inserted into the body of the *koto*. All the inside edges of the box are lined with silver. Set into the bottom section is a long, narrow inkstone with an oval-shaped water dropper.

119

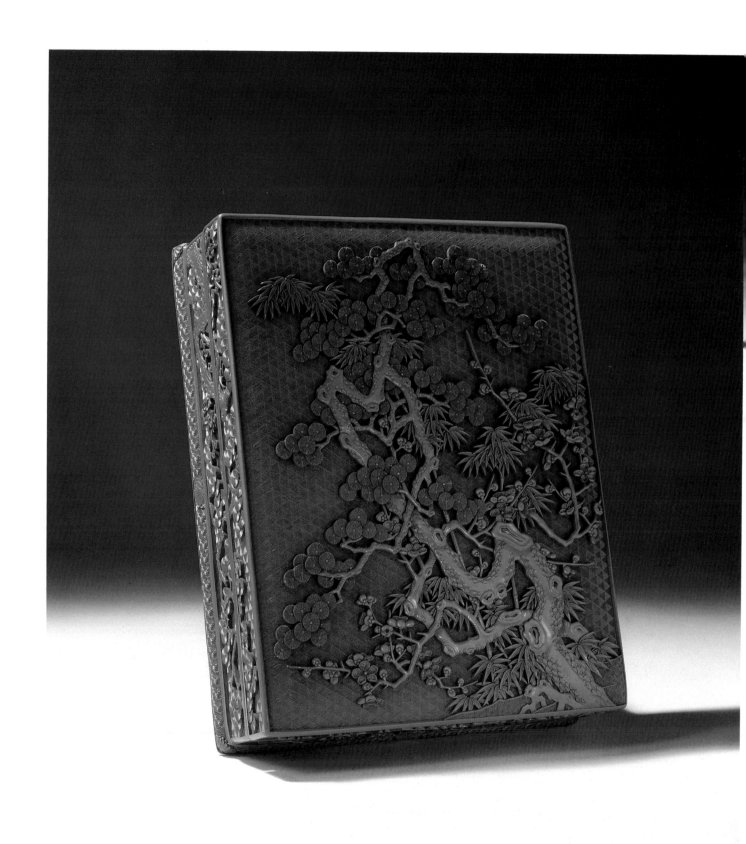

Dimensions: L. 10⅝ in. (27.0 cm.)
W. 8⅝ in. (21.9 cm.)
H. 2⅝ in. (6.7 cm.)
Nineteenth century.

120

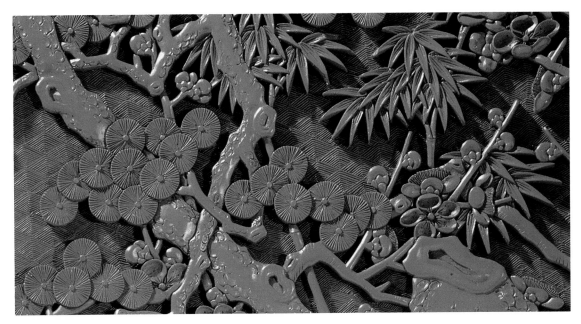

Detail of Workmanship

46. Inkstone Box (*suzuri-bako*)

It should not be forgotten that even during the late nineteenth century the patriarchal system of patronage was still maintained (although to a much smaller degree than previously), and in lacquer, old established schools and lines continued to produce works of extraordinary beauty. The Yōsei line perpetuated the Chinese style of red lacquer carving, known as *tsui shu*. The length of time needed to produce a fine piece in this technique was prohibitive (in most cases, from 50 to 100 layers must be laid down, dried, and polished before carving could start), and consequently few great pieces were created after the third quarter of the nineteenth century.

The origin of the Yōsei line is slightly obscure, but most sources agree that it began in the fourteenth century. Followers cite the eighth-generation master Tsuishu Heijirō (died 1654) as the originator of the line. He is supposed to have taken the name from the two famous fourteenth-century Chinese masters who specialized in this carved-lacquer technique. Their Japanese names were Yōmo and Chōsei, thus the name Yōsei. The eighteenth master of this line, and the artisan responsible for this inkstone box, was named Yōsei Kunihei (1816-1890). He was well known in his time and his name is mentioned in association with fine lacquer work as well as repair on various objects throughout Japan. He is known to have worked directly for the Tokugawa family.

This example is typical of the finest Japanese carved-lacquer work produced. The composition that decorates this box is known as the Three Friends: the pine, the bamboo, and the plum blossom, all symbolic of longevity. The theme was first introduced from China and seems a fitting subject for so elegant an example of *tsui shu* technique. Typical of Japanese workmanship in this medium, is a preference for cutting the surface straight down, as opposed to the Chinese method of using the depth of the lacquer to create softer and more flowing deeply carved forms. The trunk of the pine tree is shaped and contoured, with its gnarls and bark carefully delineated and textured. Each gently formed plum-blossom petal, every variegation of the bamboo leaves, and each needle within the clusters of pine has been carefully defined. The ground, or bottom level, in low relief, is in a repeat diaper pattern. Each of the four sides of the box displays the same Three Friends theme, in as careful a composition as on the lid. Subtly carved on all four lower corners and in the middle of each side of the lower edges are double-petaled half chrysanthemums, a variation on the imperial crest. The original outside wood storage container (*tomo-bako*) that houses this piece has an inscription on its inner surface that states: "Yōsei, eighteenth generation, Meiji twenty-third year," the year in which he died.

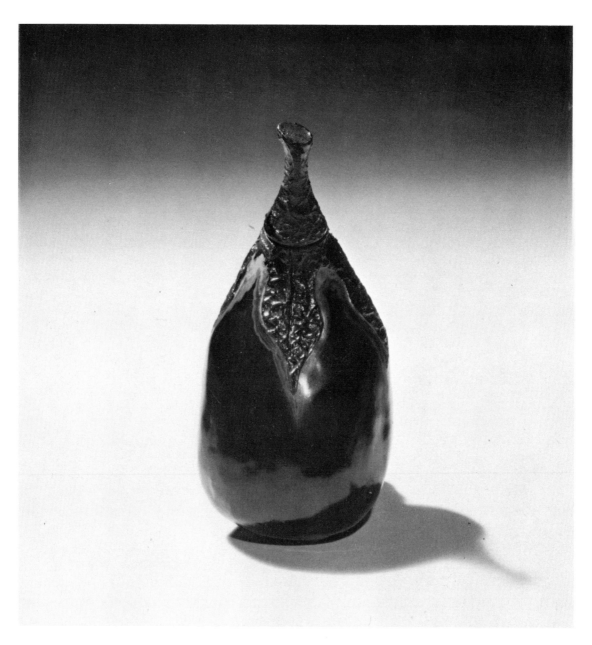

Dimensions: L. 4½ in. (11.4 cm.)
W. 2⅜ in. (6.0 cm.)
H. 2½ in. (5.4 cm.)
Nineteenth century.

47. Tobacco Container (*tabako ire*)

Tobacco was introduced by the Portuguese into Japan in the latter part of the sixteenth century. Shortly afterward, it was planted and successfully grown in the southern part of Japan, in the Kyūshū area. In 1609 the government deemed it both an unsightly and unsanitary habit and passed edicts outlawing the practice. The long-handled pipes (some over 18 inches in length) popular at the time became obsolete and were replaced by a short-stemmed, tiny metal-bowled pipe that was less conspicuous. The edict proved unenforceable, for the habit continued to be practiced in private quarters, even among the *daimyō*. In fact, as gorgeous lacquer smoking utensils came into use in the geisha quarters, pipe smoking became a social grace. The tiny bowled pipe held only enough tobacco for a few puffs, after which the burnt embers were ceremoniously knocked out and the implements cleaned and put away. As the law was never openly defied, smoking implements were not carried publicly on the person during this time.

122

In 1716, in hopes of boosting the economy, the Shogun Tokugawa Yoshimune (1677-1751) repealed all edicts pertaining to smoking and ordered tobacco to be planted. The samurai class was still forbidden its obvious use and concealed it within the kimono when traveling, but those of other classes who did take up its use began wearing ostentatious accoutrements which became fashionable. By the late eighteenth century, eighty percent of the male population was smoking. Even today the tobacco industry is completely owned and controlled by the government. With the advent of the Meiji period the Japanese were introduced to cigarettes, but it was not until the twentieth century that their use spread down to all classes. Meanwhile implements such as the tobacco container shown here were made to store pipe tobacco. No doubt this realistically simulated eggplant-shaped receptacle brought great amusement to its owner as well as his guests.

Its shape was created by the process of layering paper and lacquer (*ikkan-bari*) on the outside (*hari nuki*) of a shaped mold. The dried form was then cut in half and removed, then rejoined. The center horizontal seam was deliberately left as evidence of this method, as were thumb indentations resulting from the handling and pressing of the material to the mold. Thick, colorful applications of lacquer constitute the final coatings and follow the multicontoured surface. The stem-shaped lacquered-paper stopper fits precisely into an opening on the base of the eggplant to form a perfect seal. The container is light in weight, will not warp, and is both suitable for its function and amusingly shaped.

The undercolors of yellow and red, showing through where leaves appear attached to the body of the vegetable, blend perfectly into its dark, bulbous body. The stem and leaves are contoured of *sabi urushi* and resemble perfectly the texturing of an actual eggplant. This is not a slick composition to be sold to the export market, but a charming creation made for home use. The smell of stored tobacco, having thoroughly permeated its inner walls, still emanates from it and leaves no doubt as to its original purpose.

48. Inkstone Box (*suzuri-bako*)

The Shiomi and the Shunshō were two great families who specialized in the flattened, burnished-lacquer technique know as *togidashi*. Both lines date from the second half of the seventeenth century. The Shiomi line began with Shiomi Masanari (about 1647-1725) of Kyoto. While the Shunshō specialized in themes from *ukiyo-e* (floating-world pictures) and compositions of great detail and delicacy on black lacquer grounds, the Shiomi were noted for their animal subjects, such as rats, oxen, and horses, executed in broad expanses of color, often on gold grounds. The ink stone shown here is a typical example of Shiomi style.

Three is considered among the most significant of lucky numbers in Japanese symbolism. It is an odd number, thus representing the masculine principle, and in art is often used to symbolize the elements of water, earth, and air. The horse is connected with fertility and is also strongly associated with masculinity, leaving little doubt as to the sex of the owner of this box.

Three horses, two in sprinkled gold and a third of silver and brown stand in brilliant contrast within the glossy black *ro iro* ground. The overlapping forms and juxtapositioning of the subjects draw the eye to a central point in the spatial plane of the lid. The grace of line and movement evident in the manes and tails of the horses is immediately evident. The muted color of the gray and brown piebald in the foreground prevents an otherwise bright design from becoming too showy.

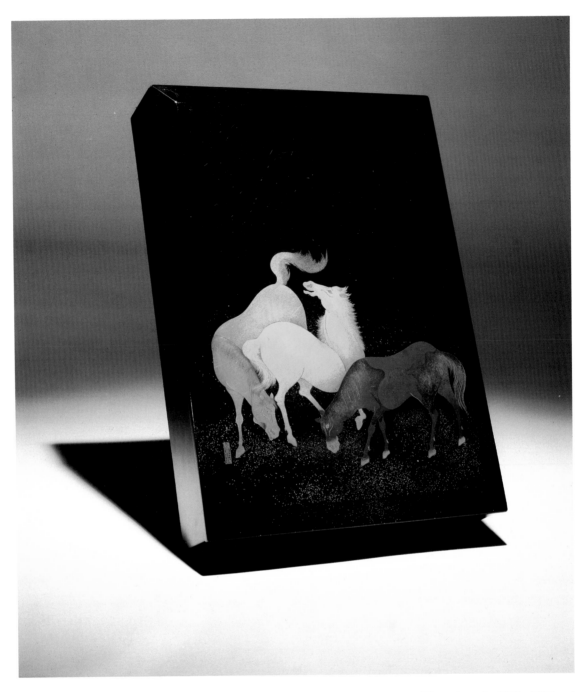

Signed in seal cartouche form: *Shiomi Masanari*

Dimensions: L. 10¼ in. (26.0 cm.)
W. 7¼ in. (18.4 cm.)
H. 2⅛ in. (5.4 cm.)
Nineteenth century.

The achievement of depth and shading through the gradual thickening of powders is a skill notably perfected by Shiomi artists. In all probability this box was made by the last member of the line, for the red rectangular signature, in seal cartouche form (the traditional signature used by the Shiomi for over two hundred years) is on the left side of the composition rather than its customary place on the right. This change in location has only been noted on late nineteenth-century objects, and it seems probable that it served some unknown significant purpose. On the bottom of the outer wood container, which protects the inner lacquer box when stored, is the owner's personal seal and an inscription that states: "This box was received as a gift from Hattori Seitarō."

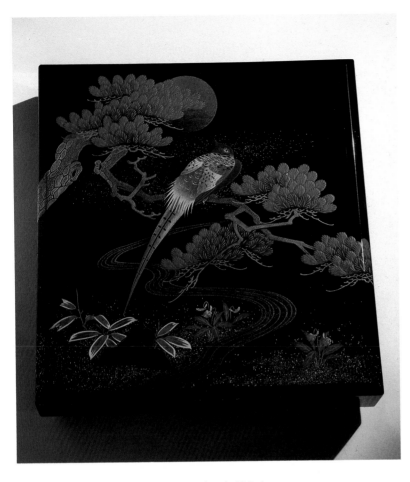

Dimensions: L. 7½ in. (19.0 cm.)
W. 7⅛ in. (18.1 cm.)
H. 1⅝ in. (4.1 cm.)
Nineteenth century.

Signed: *Komura Hakuhō saku* (made) and seal: *Hakuhō*

49. Inkstone Box (*suzuri-bako*)

Although production of regional objects declined during the Meiji period, mainly because of the eradication of the *daimyō* and their provincial form of government, temporary revitalizing help arrived from the government with the introduction of "prefectorial" grouping. One area so affected was the province of Etchū, which was included in the new larger area known as Toyama prefecture. It was there that during the Edo period a type of oil painting was combined with lacquer to form a style of ware known as *jō hana* or *jōgahana* lacquers. Two theories as to the origin of this technique have been proposed. The first is that the technique came from China in the eighth century and then popularized in the sixteenth century. The second, and more relevant, is that the method was introduced by Hataji Goemon Yoshinaga, who is supposed to have studied the style of Chinese oil painting in Nagasaki during the late sixteenth century. In that method, oil paints were made by mixing oil from the perilla plant (also a thinner for *urushi*) with the desiccative lead oxide. After the mixture was boiled pigments were added. In the Tokugawa period the Japanese term *mitsuda sō* was applied to this kind of lead oxide, and therefore decorations using this mixture were called *mitsuda-e*.

A red harvest moon and a winding stream composed of sprinkled gold, are contained in the glossy black ground in *togidashi* technique. This delicate backdrop makes a smooth and quiet setting for the long-tailed pheasant sitting on the extended branch of a tree. The bird, the trunk and branches of the tree, and part of the foreground are composed of a textured oil-base pigment utilizing the new Meiji import shades of blue, pink, gray, and white. The color combinations and the quality of the box date it to the end of the nineteenth century. The wooden storage box is signed *Komura Hakuhō saku* (made), with the seal *Hakuhō*.

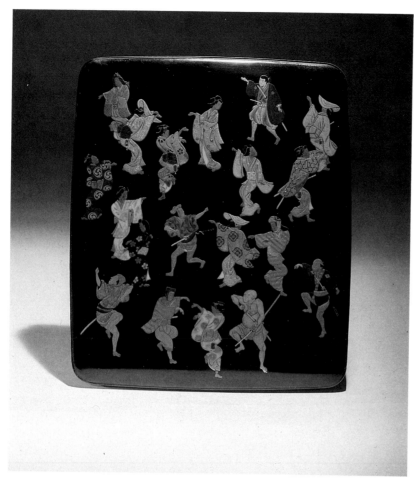

Dimensions: L. 7¾ in. (19.0 cm.)
W. 6¾ in. (17.1 cm.)
H. ¾ in. (1.9 cm.)
Nineteenth century.

50. Inkstone Box (*suzuri-bako*)

The colorful figures on the lid of this softly curved rectangular box are reminiscent of a page from the sketchbooks of the eccentric genius Katsushika Hokusai (1760-1849). Known widely as the "old man mad about drawing," he created an unusual and highly copied compendium of sketches. In one volume, titled *People*, he concentrated on studies of single individuals in a variety of positions, very similar in feeling and attitude to those pictured here.

From the serious and studied movement of the Bugaku to the reckless abandonment of form seen here, the Japanese people have traditionally, always enjoyed the many facets of dance. Holidays in different parts of the country take on regional characteristics, and in these dancing figures may be seen a conglomeration of styles from all over Japan. For example, the Awa Odori, a very rhythmical traditional folk dance celebration found mainly on the island of Shikoku, is suggested by the costuming of the dancers wearing hats and perhaps, performing the "Chasing Bird" dance. Other performers seem to be expressing a style found most in the celebration of the festival Obon, when dancers feel reunited with the spirit's of deceased relatives. The surface design is well thought out, though some of the figures are anatomically distorted they are finished in elaborate detail. On the deep black *ro iro* ground, the figures stand out in low and high relief decorated in colored lacquers, sprinkled gold, and the subtle underlayering of blue-green shell, with an exceptional amount of minute detailing visible in the pattern of the clothing. The workmanship demonstrates a high degree of technical skill, but little depth. Its principal aim is to please visually. The inside of the lid lid of the box is covered in *mura nashi ji*, and a large moon of pure silver has been inlayed in the upper right hand side of the composition. Over it are clouds in gold high relief, to which tiny perfectly formed squares of thin cut gold have been painstakingly placed, side by side, in a mosaic pattern. The rims of the box are also lined in silver.

126

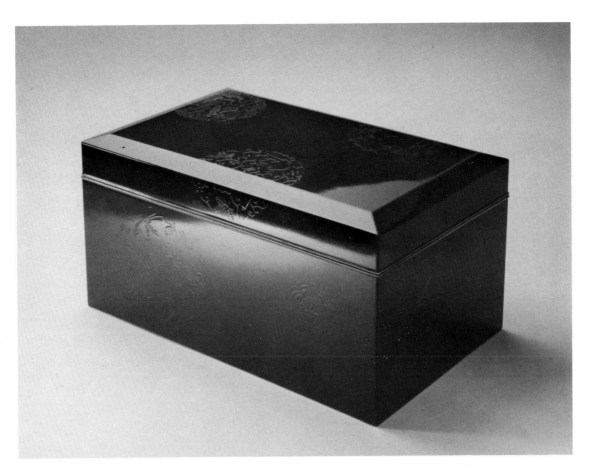

Dimensions: L. 8⅝ in. (21.9 cm.)
W. 5⅜ in. (13.7 cm.)
H. 4½ in. (11.4 cm.)
Twentieth century.

51. Tiered Inkstone Box (*suzuri-bako*)

Double-tiered inkstone boxes were not common. The earliest model of the form similar to the one shown here is Ogata Kōrin's seventeenth century example known as the *Yatsuhashi suzuri-bako*.[1] As customary in this format, the upper tier contains the inkstone and water dropper, while the lower section provides space for the storage of writing papers.

The decorative patterning seen on this dramatically understated rendition incorporates the combination of black, in low relief on black, a technique called *kuro maki-e* (literally "black sprinkled picture"). However it is not executed in the true *maki-e* process. *Yami maki-e* or *yami-e*, both meaning dark (referring to the darkness of night) is another term also applied to what appears to be the same effect, but, the actual techniques differ. In *kuro maki-e*, the design is painted in black lacquer on a black lacquer ground, often using a stencil pattern (as shown here). In *yami maki-e*, the design may be sprinkled on the black lacquer ground in powdered black lacquer made from *kan shitsu*, or charcoal, onto a layer of *sabi urushi*. The difference, therefore, is in the application of the relief design work involving whether it was sprinkled on or applied directly to the ground with a brush. The finish of either technique is seen as a form of *hira maki-e*, usually matching the high gloss of its adjacent ground.

On the inside of the lid of this box are pictured two sailboats, in pale multicolored *togidashi*. The upper tier is fitted with a plain rectangular shaped silver water dropper, and a gold-edged inkstone that has been placed on the far left, leaving a fairly large sloping area for the storage of brushes. All edges are lined with silver.

Note:

[1] For pictures of this box see Jō Okada et al. *Nihon no Shitsugei*, Vol. IV, #83, 84, 85.

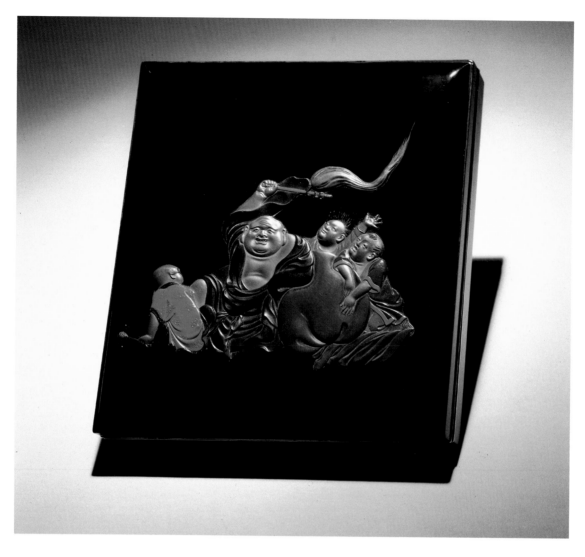

Dimensions: L. 7¼ in. (18.4 cm.)
W. 6¾ in. (17.1 cm.)
H. 1¼ in. (3.2 cm.)
Twentieth century.

52. Inkstone Box (*suzuri-bako*)

The concept of the Seven Gods of Good Fortune or Seven Household Gods was introduced into Japanese tradition in the seventeenth century: most of these gods are Chinese in origin. The subject on this lid is *Hotei* (Chinese *Pu tai*), the God of Abundance. Traditionally he is shown holding a fan and/or a Buddhist whisk, two attributes deriving from the legend that he was originally a Chinese monk (named *Ch'i-tsu*, died about 905). As is customary, he is accompanied by clamoring, happy children for whom he has a huge sack said to contain the *takara mono* or "precious things" that children are said to want.

Against the *ro iro* ground, the figures are built-up of high *taka maki-e*. The childrens' garments are of that combination of green and red, often seen in late lacquers which may be symbolic of spring and fall. Hotei's garment is the dark gray of *shi bu ichi nuri*, while his bag is covered with powdered silver. The bodies of the god and the children are covered in the bright gold finish known as *kin ji*.

All the figures are well contoured, rendered in an extremely realistic manner and finely finished. Examination shows that the entire decoration was done separately and then inset into a prepared area on the surface of the lid. Dating can be determined by the style of the composition with its use of broad massses of solid color. Also the flattened shape and sharp squaring of the corners are characteristic of boxes made during the late nineteenth to early twentieth century.

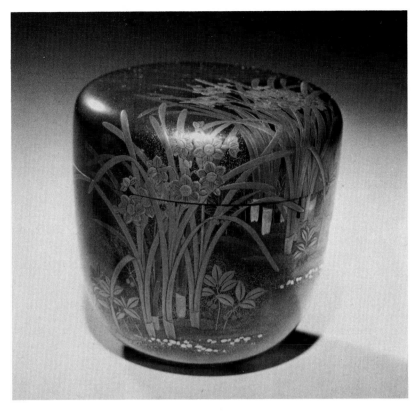

Dimensions: Dia. 2⅞ in. (7.3 cm.)
H. 2⅞ in. (7.3 cm.)
Twentieth century.
Signed: *Shōtei*
with seal: *Matsu.*

53. Lacquered Tea Caddy (*natsume*)

In the codified aesthetic of the tea ceremony, the Japanese people have combined their love of formality, discipline, and ceremony with their sense of beauty. The drinking of green tea (imported from China) was first popularized in the thirteenth century, but the formalization of the complicated ritual — in which aristocratic aesthetic sensibilities blended with the more earthy simplicity of humble surroundings — began in the sixteenth century. Three men, of which Sen no Rikyū (1521-1591) was the youngest, formulated a particular style that persists today.

The objects used in the tea ceremony have been more or less standardized since the seventeenth century and the accoutrements owned by any particular individual reflect both his pocketbook and his aesthetic inclination.[1] One of the utensils central to the ceremony is the tea container, and its style depends on its use. Two kinds of powdered tea are usually served: *koi cha,* a tea that is served in a thick consistency, and *usu cha,* which is thinner in body. It is customary for ceramic tea containers with ivory or wooden lids called *cha ire* to hold *koi cha* tea, while *natsume,* lacquered tea caddies like this one are usually used for the serving of *usu cha.* The *natsume* were so named because it was thought their outline resembled the shape of the jujube (*natsume*) fruit.

This example, delicately decorated with daffodils in *togidashi* technique is of medium size and in the Rikyū shape, named after the previously mentioned master. In this style there is a decided curve from the base that swells to the final low arch of the lid, and its construction called *inrō-buta* involves a proportion in which the lid is usually about half the size of the body. The soft muted tones of the sparkling plain matte gold, silver-gold, and pale green color of the flowers and their stalks are applied to a darkened *nashiji* background. Tiny red berries under the flowers draw the viewer's eye to the area of rectangular shaped scales of gold added in the foreground. The wooden storage box is signed by the contemporary artist *Shōtei* with his seal *Matsu.*

Note:

[1] The bibliography contains a few books on this subject.

Dimensions: L. 7¾ in. (19.7 cm.)
W. 4⅝ in. (11.7 cm.)
H. 1½ in. (3.8 cm.)
Twentieth century.
Signed: *Sa* and seal: *Sadae*

54. Lacquered Tea Caddy (*natsume*)

Using the small core of the Rikyū style, the contemporary lacquerer Sadae Walters, has decorated a delicate but dramatically colorful tea caddy. Born in Tokyo, the artist moved with her family to Hiroshima prefecture during the war. Early in life she studied ink painting, and after her arrival in the United States in 1951 had a show of her works in Baltimore. In 1964 she went to Okinawa, where she studied the basic techniques of lacquer and apprenticed to the former National Living Treasure, Shōzan Takano (1889-1976), until 1972, when she returned to America.

This *natsume* is in a technique called "*kasane nuri togidashi*" that involves many layers of black lacquer followed by red in a manner similar to that of cat. no. 16 . However, instead of carving the layers, Ms. Sadae exposes the free-form black patterning underneath by a polishing-down process similar to that of *togidashi*.

Fine *natsume* are made by a process known as *kiri aikuchi* (literally, smooth-joint forming). In this method the lid and body of the core are in a closed position after the *naka nuri* process is completed. Lacquer is then applied to its outer surfaces, allowing the viscous fluid to enter the slight opening at the joining. The container is then submerged in hot water until the air inside becomes so hot that its expansion forces the lid and body apart. The edges are then ground and polished. The gracefully modern design created through laborious time-consuming processes, and decorating this caddy, is just one of the hundreds of techniques possible by an artist of Ms. Sadae's stature.

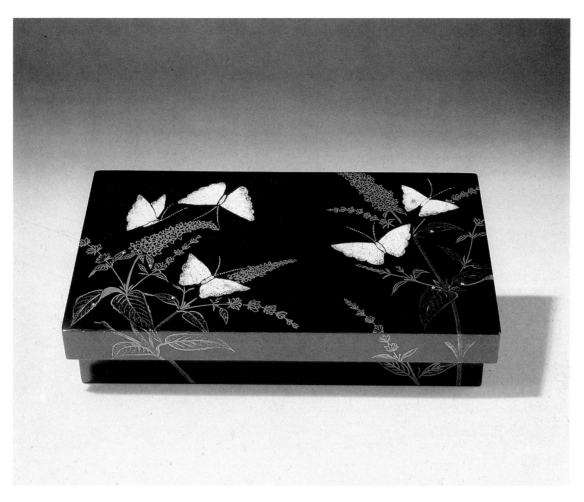

Dimensions: L. 7¾ in. (19.7 cm.)
W. 4⅝ in. (11.7 cm.)
H. 1½ in. (3.8 cm.)
Twentieth century.
Signed: *Sa* and seal: *Sadae*

55. Small Box (*ko-bako*)

On the lid of this box, set against a dramatic jet-black *ro iro* ground, are butterflies fluttering around a "butterfly bush" (buddleia). The bodies of the insects are composed of quail egg shell (*rankaku*) in the technique called *rankaku togidashi*. The shell of the quail egg is extraordinarily white and has only minor blemishes, which are occasionally bleached out, making it ideally suited for this type of work. Different areas of the foliage are in the same level as the ground, while the rest is of sprinkled gold in low relief.

It takes superb skill and patience to form each butterfly since the crushed shell is set into a mosaic form piece by piece. After all the inlay work was completed, the surface was given a clear coat of the finest *urushi* and then tiny gold particles were applied sparingly on two of the insects' wings. Then, tiny silver drops suggesting early morning dew and recalling early Rimpa styling, were inlayed into the design. Finally, the entire surface was re-coated and given a final polish.

Detail of workmanship

56. Cosmetic Storage Box (te-bako)

The contemporary artist Mizuuchi Kyōhei (1910—) creator of this prize-winning masterpiece, lives and works in Kyoto. Now in his seventies, he is the author of several books and articles on various aspects of lacquer as well as being a master artisan and teacher. While working in the style of carved Chinese lacquer (chō shitsu), he also is renowned for his other technical and artistic achievements. In this example he has applied his knowledge and skill in an extremely wide range of techniques in an original and innovative composition.

Traditionally, te-bako were used to store cosmetics and ladies toiletry accessories. With the advent of the Meiji period and the introduction of wall mirrors, mirrored dressers, and other types of Western furniture, many traditional objects such as the te-bako became obsolete, yet regardless of the design, contemporary artisans still use the old nomenclature for boxes of this general shape and size.

The ground of the box is of light cypress wood. The core had to be sturdy but as light as possible, because the many coats of lacquer make the finished object heavy. After the undercoatings were completed, all the sides were covered with linen in the traditional Kyoto technique. The artist himself prepared the naka nuri and uwa nuri processes — an unusual procedure for today, but he felt the necessity of knowing that the core had been fastidiously prepared. He then began the laborious process of decorating the outside surfaces. Over thirty layers of red lacquer (each dried and polished before beginning the next) were applied before he was finished with this aspect of the decoration. Since red lacquer darkens somewhat erratically, each layer acquires its own tonal variation. Because this particular artist cuts the shu on a slant, rather than more typically cutting straight down (see cat. no. 46) the beauty of the lacquer's natural coloration is exposed, lending rich tonal and textural variations to the composition. This kind of lacquer is slow to dry thoroughly, and the artist can pace his time. While newly applied red lacquer is easy to carve for about a month, it later becomes brittle and eventually extremely friable, making carving impossible. Because of the time, patience and intensity required for this work, tsui shu artists are extremely rare in Japan today.

After Mr. Mizuuchi finished applying the red lacquer body work, he traced the surface design on roughly and proceeded to expose the multitoned layers, knowing exactly how far down to cut without piercing the wood core. The inside of the box was then finished with a rich black ro iro ground, to which large flakes of gold were added, and a final lacquer coating was applied and polished. Returning to the surface of the lid, he completed the gold maki-e work, adding mother-of-pearl inlay and a final finish of large sprinkled coarse gold filings. After the final polishings of the decorative materials, the surfaces were lacquered three times with the best-quality transparent urushi. This example is a reminder that the evolution of an art form well over a thousand years old still continues as a vital part of the Japanese conciousness.

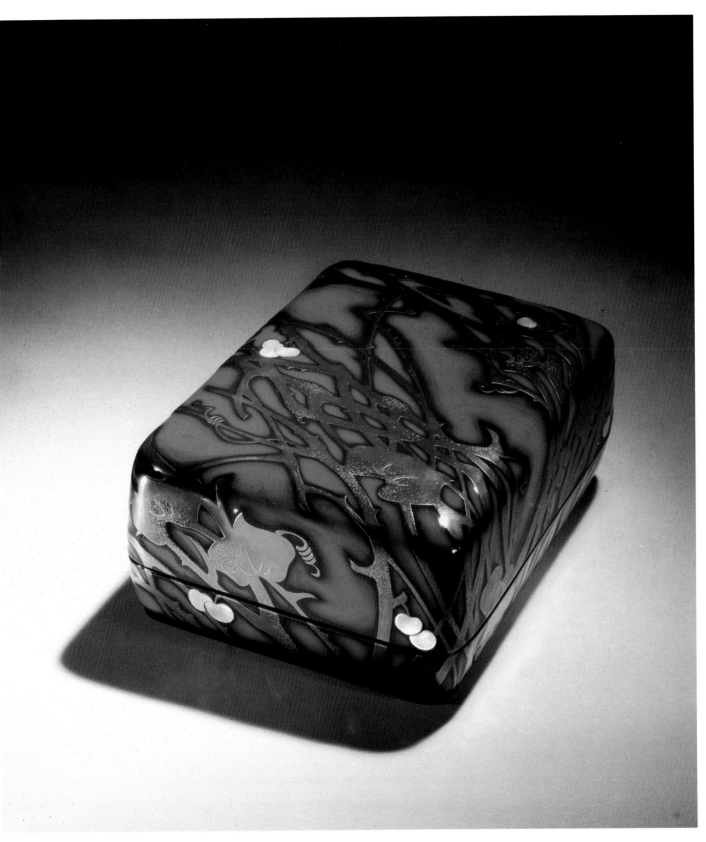

Dimensions: L. 10⅝ in. (27.0 cm.)
W. 8 in. (20.3 cm.)
H. 4½ in. (11.4 cm.)
Twentieth century.
Signed: *Kyōhei*

Additional Boxes in the Collection

18TH Century

1. Instone Box (*suzuri-bako*) The outer lid is decorated with a tiger and cub in a bamboo grove in *hira* and *taka maki-e* with *oki hirame* on a *nashi ji* ground. The interior of the lid is decorated with the Chinese legendary sages Hu-Yeo and Ch'ao Fu (circa 2300 B.C.) The box is fitted with tray, inkstone and water dropper.
L. 9″ x W. 8½ x H. 2″

19TH Century

2. Inkstone Box (*suzuri-bako*) In miniature form (from a child's set). The lid is designed as a gift pack and decorated with a hō-ō bird among paulownia branches separated by a narrow key-fret pattern. In gold, silver and red *hira maki-e* on a *nashi ji* ground.
L. 4″ x W. 2½ x H. ¾″

3. Small Box (*ko-bako*) In the shape of handmirror — covered with natural bark and decorated with leaves and vines in varying tones of gold, bronze and pewter coloring in *taka maki-e* technique. Leaves and flowers appear on the interior of the lid in *taka maki-e* and inlaid pottery. Sparse *nashi ji* interior and bottom. The box is fitted with a tray.
L. 11½″ x W. 8″ at its widest x H. 1½″

4. Small Tiered Box (*kō jū-bako*) Three tiered, depicting a bird perched on a rock. The lid is decorated in *kin-pun*, *shi bu ichi nuri* and *taka maki-e*. Each tier utilizes the different techniques of *nashi ji*, *fun-dame*, *kin-pun* and *gyōbu*.
L. 2⅛″ x W. 2″ x H. 1½″

5. Incense Box (*kō-bako*) The lid is decorated with the theme of "Seven Poets of the Bamboo Grove": in *sumi-e togidashi* on a gold ground. The faces of the poets are of silver lacquer and varying shades of gold decorate the kimonos. *Nashi ji* interior.
L. 2⅛″ x W. 2″ x H. 1½″

6. Incense Container (*kōgō*) Decorated with two ladies watching a small boy playing with a katana. In gold and colored *togidashi* (*urushi-e*). Sparse *nashi ji* interior and bottom. Signed Shiomi Masanari on left side in a red lacquer cartouche.
L. 3¼″ x W. 2¾″ x H. ¾″

7. Incense Container (*kōgō*) The lid's surface is decorated in a divided design. The bottom half with light *nashi ji*, and the upper half with flowers. All in gold and black *togidashi*.
Diameter: 3½″

8. Minature Document Box (*fu-bako*) Decorated with fans and scrolls in *taka maki-e* on a rich gold *nashi ji* ground. *Nashi ji* interior; metal rings are attached to the sides of the lower part of the box.
L. 4½″ x W. 1¼″ x H. 1⅛″

9. Miniature Incense Container (*kōgō*) (From a Boys' Day set). The cover is decorated with rabbits among bamboo, in silver metal and *aōgai* on a *ro iro* ground. *Nashi ji* interior.
L. 2″ x W. 1

10. Inkstone Box (*suzuri-bako*) The surface of the lid shows two prancing horses on a *ro iro* ground with *mura nashi ji* and *kiri-gane*. On the interior of the lid appear grasses in *fun-dame* that are seemingly lit by a full moon. Exterior fittings complete.
L. 9½″ x W. 8¾″ x H. 1½″ Ex-Tomkinson Collection, #437.

11. Stationery Box (*ryōshi-bako*) The outer surface is decorated with two deer made of a gold touched pewterlike material, on a *ro iro* ground. The interior of the lid is decorated with a field of golden maple leaves in *togidashi*. The edges of the box are lined in silver.
L. 9″ x W. 8½″x H. 3″ Ex-Metropolitan Collection.

12. Double tiered Inkstone Box (*suzuri-bako*) Decorated wtih such facsimilies in lacquer as *tsuba* and *kozuka* of gold, silver and colored lacquers on a red ground in high relief. The interior tray is fitted with a water dropper and decorated with sparse *nashi ji*.
L. 8¾″ x W. 5″ x H. 4½″

13. Comb Storage Box of Five Drawers (*kushi-dansu*) The outside of the box is decorated with *mura nashi ji* against a *ro iro* ground. The inside of the front panel is decorated with cranes and leaves in *hira maki-e* also on a *ro iro* ground. The sides and back of the container are cut out in the shape of fans. Stored within is a collection of nineteenth century combs.
L. 14″ x W. 9″x H. 12¼″

14. Small Tiered Box (*ko jū-bako*) Three-tiered, the lid is decorated with the figure of the Bugaku performer know as Ranryō-ō, under a curtain. In silver and gold *hira* and *taka maki-e* on a *ro iro* ground. The sides of the box are covered with maple leaves in *togidashi*. *Nashi ji* interior and bottom.
L. 5¾″ x W. 3½″ x H. 3¾″

15. Incense Box (*kōgō*) Carved of *tsui shu*, the lid is decorated with a pattern of plum blossoms. A key fret pattern circles the sides. The Japanese character *uguisu* (a Japanese nightingale and also the name of a type of special incense) is deeply carved on the bottom. *Ro-iro* interior.
Diameter 3″ x H. 1″

16. Incense Container (*kōgō*) *Tsui shu* in the form of a peach with a small beetle on the top. Black lacquer interior.
L. 2¼″ x W. 2¼″x H. 1¼″

17. Small Box (*ko-bako*) Covered with *tsugaru nuri* (red, yellow, black, brown and olive green.) *Ro iro* interior and bottom.
L. 7½″ x W. 4¼″ x H. 1¾″

18. Marriage Stand (*kagetsu-dai*) The top of the stand is decorated with a landscape depicting cranes, rocks, bamboo and pine trees in *togidashi*, *hira* and *taka maki-e*. The recessed fitted lid contains three slots. A matching set of three red lacquer sake cups used in the wedding ceremony accompanies the stand. Interior of *ro iro*.
L. 7¾″ x W. 4¼″ x H. 1¾″ This elegant set is also used on other special auspicious occasions.

19. Stationery Box (*ryōshi-bako*) Centered on the top of the box is a Chinese jade inlaid plaque surrounded by red lacquer chrysanthemums in *taka maki-e*. Along the sides of the box are a frog, a snail and a fish all in *taka maki-e* on a *ro iro* ground. Though Japanese, the box is in the Chinese style.
L. 7¾″ x W. 5″x H. 3⅛″

20. Inkstone Box (*suzuri-bako*) The lid is decorated with a landscape comprised of a distant figure, crossing a bridge, with trees, mountains and a body of water filling the back and foreground. Most of the scenery is of dark umber colored *shibo taka maki-e* against a lighter umber *togidashi* ground. Fitted with an inkstone and water dropper.
L. 8½″ x W. 6″x H. 2″

21. Inkstone Box (*suzuri-bako*) The unusual and rare shape of this high domed lid is decorated with an inlay of tortoise shell on which a screen representing a temple compound in Nikko has been added. The upper half of this box is extremely light and probably made of *kan shitsu*. The bottom half is extraordinarily heavy as its interior design, representing the floor of a forest, is made of solid lacquer. The water dropper is in the shape of a hut while the unusually thick inkstone is deeply recessed into its' high walled surroundings. Signed: Kōshi.
L. 10″ x W. 8″½ x H. 3½″

22. Large Storage Box (*bunkō*) A large rectangular box decorated with dragonflies in gold and silver *hira maki-e* on a *ro iro* ground. *Nashi ji* interior.
L. 15½″ x W. 16″

Contemporary

23. Tea Container (*natsume*) Decorated in leaves and vines in black *taka maki-e* on a tortoise-colored (deep brown) ground. *Nashi ji* interior and bottom.
L. 2½″ x Diameter on top 3¼″

24. Stationery Box on Tray (*ryōshi-bako*) The lid displays one large elegant peacock feather in gold and silver *hira maki-e*. Signed on the bottom of the tray in seal form: *Zōhiko*.
Box: L. 5½″ x W. 4½″ x H. 1½″ Tray: L. 7½″ x 6½″

25. Incense Container (*kōgō*) In the shape of an eggplant. Finished in deep purple lacquer with the stem of the fruit in contoured *taka maki-e*. L. 3½″

26. Incense Container (*kōgō*) Of rounded form this extremely heavy box is made from many layers (over thirty) of colored lacquers as red, green and yellow. The carving is on the slant (*guri*) enabling the viewer to appreciate the color and workmanship of this style.
Diameter 3″

. Incense Box (*kō-bako*)

7. Incense Container (*kōgō*)

1. Instone Box (*suzuri-bako*)

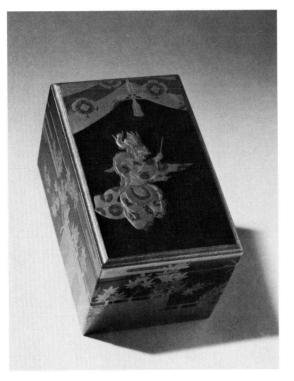

14. Small Tiered Box (*ko jū-bako*)

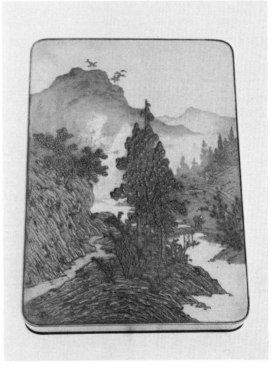

20. Inkstone Box (*suzuri-bako*)

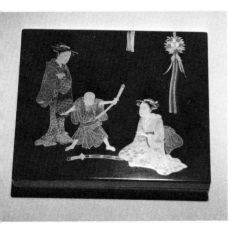

. Incense Container (*kōgō*)

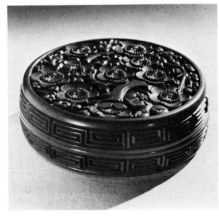

15. Incense Box (*kōgō*)

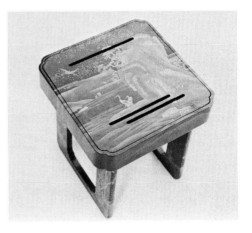

18. Marriage Stand (*kagetsu-dai*)

Selected Glossary of Lacquer Terms

Certain traditional Japanese grammatical rules will be observed in this abbreviated listing. For example, if in the combination of two words the first letter of the second word is changed for euphonic purposes, a hyphen will signal that change: i.e., *bako* (meaning "box") when used in combination with an adjective such as *suzuri* (meaning "inkstone") will read *suzuri-bako*. For those words, such as *maki-e*, in which the use of the hyphenated *e* (meaning "picture") has become conventionalized, a small "c" will precede the listing.

age muro A low-humidity chamber for the curing of freshly lacquered objects.

aka-gane nuri The fox-red metallic finish that results when a special mixture or "pickle" is applied to a copper alloy base; the chemical reaction forms a skin on the exposed surface. The "skin" is then scraped off and the resultant powder sprinkled on wet lacquer.

ao-gai A blue green iridescent shell derived from the abalone. Usually used in inlay work.

aokin fun The bluish gold metallic powder that results from mixing silver and gold powders; sometimes called *koban*.

byakuro A pewterlike metal.

chinkin-bori The technique in which lines are engraved on a lacquered surface, then filled in with gold powder or foil, so that the incised design is clearly revealed.

chō shitsu The Chinese method of carving multilayered lacquer (see *tsui shu* and *tsui koku*).

dakkan shitsu A hollow dry-lacquer technique used in the Nara period. A casting or mold was taken of a clay image; the clay image was removed and the inside of the cast was coated with lacquer, bark, and cloths soaked in lacquer. After the inside cloth-lined shape had hardened, the outside mold was broken away, leaving the new dried-lacquer figure to be finished by polishing and decoration.

c. **e-nashi ji** This term is used when the "pear-skin" ground (*nashi ji*) technique has been employed in the pictorial element of the composition. (see *nashi ji*)

fun-dame A gold powder sprinkled on heavily that is so thinly ground it cannot usually be polished. Therefore, the surface obtained remains duller than those involving more coarsely ground powders.

furo A wooden chamber into which wet lacquer pieces are placed to harden by curing. The sides are usually sprayed with water, or wet cloths are hung inside, to provide the necessary humidity of 80 to 85 percent required for this process.

hakurizai The solution used as a liner between a mold and the substance being molded.

hari-gaki (or hikkaki) A design technique of the Momoyama period whereby a needle or other pointed instrument is used to incise the decoration on the lacquered surface.

hari nuki The process whereby layers of lacquered paper are applied to the outside of a mold in order to create a form.

heijin Found mainly on Nara and Heian objects, it is the process whereby coarse, irregularly shaped gold particles sparsely sprinkled, are used as a ground.

c. **hira maki-e** Literally, "low or flat sprinkled picture." Known as low relief, this technique was introduced in the Kamakura period. Only one layer of lacquer above the ground is sprinkled with gold or silver powders and then dried; a small amount of thin lacquer is applied over the area to affix the particles to the ground and is then polished.

hirame ji The technique in which slightly irregular flattened particles of gold are sparingly sprinkled over moist lacquer and, when dry, are re-lacquered and polished.

hyōmon The technique in which the image or decorative pattern is cut from thin sheets of metal and then pasted on a finished surface. After several finishing coats of lacquer are applied, the surface above the metal design is polished or scraped away, exposing the metal's color.

ikake ji The process whereby a ground is created by the heavy sprinkling of gold or silver powder in one coat. *Ikake ji* was the precursor of *fun-dame*.

ikkan-bari The process whereby layers of lacquered paper are applied to the *interior* of a mold.

inrō A portable tiered container worn on the person for the purposes of carrying medicines in the form of pellets or powders. Originally this container may have carried the ink and seal of the individual, and some *inrō* so fitted are still extant.

ippen ji nuri The "first ground coating."

c. **iro-e togidashi** The technique in which colored pigments (other than *only* gold or silver) in powder form are used for creating the pictorial image. After the colored pigments and/or metal powders have been sprinkled on, the surface is covered with repeated layers of lacquer (usually black). The surface is then polished down until the composition is revealed (see *togidashi*).

kagami-bako The storage box for a round mirror.

kaki-gama The instrument used for scoring tree trunks in order to collect *urushi*.

kaki hera A curved instrument for lifting the exuded *urushi* from the tree.

kaki wari The technique in which the design element, such as the veining of a leaf, is left in reserve, allowing the background to provide the contrast.

kana-gai Sheet metal (usually gold) cut into various sizes and applied as decorative highlights.

kan shitsu A less complicated "dry-lacquer" form than

the *dakkan shitsu* method. Also a term applied to dry powdered lacquer.

kashi-bako A square box for holding sweets.

kashi ki A circular box or container for holding sweets.

katami-gawari A Momoyama design motif shaped like a lightning-bolt graphic.

keuchi A variation of *hira maki-e*. In this technique the edges of leaves, flowers, or other designs are emphasized with an additional layer of clear lacquer and then sprinkled with gold powder to obtain an outline effect.

kiji A core, ground, or base, usually made of wood.

kime tsuke The technique of applying pasted patches of silver on finished design work to vary texture or add highlights.

c. **kingin-e** The technique whereby gold or silver metals in powder form are mixed with glue and then applied as the pictoral element in a design.

kin ji A heavily sprinkled powdered-gold ground that takes on a shiny finish when polished. This term was introduced only in the late Edo period.

kiri-gane A decorative technique employing thin pieces of cut gold leaf in various shapes, often forming a mosaic.

ki shōmi (or ki jyōmi) Unprocessed Japanese middle trunk *urushi*.

ki urushi Literally, tree lacquer.

kō Incense.

ko-bako A small box.

kō-bako A box or container for the storage of incense.

kō-dansu A portable cabinet for the storage of accoutrements for the incense game.

kōgō An incense container.

kō jū-bako A tiered container for holding incense and other small objects such as mica.

kuro maki-e The technique in which black lacquer in a design or pattern is applied on to a black lacquer ground.

kurome The procedure by which excess water in the sap is removed in order to allow uniformity of drying.

kuro urushi The dark, lower-quality lacquers to which black, in the form of iron powder or fillings, is added before cooking begins.

mage mono Literally "bent work" or "bent thing." A term most often applied to curved strips of wood.

maki-bokashi A term applied to the application of sprinkled gold powder in a graduated manner.

c. **maki-e** Literally "sprinkled picture"; the technique of sprinkling metallic and/or pigmented powders in a composition or design on a wet lacquer ground.

c. **maki-e shi** The lacquer artist who creates and finishes the surface design element.

maki hanashi A Momoyama technique in which the design, made of sprinkled gold, receives neither a final coat of additional lacquer for a final polishing.

makkinru The precursor of the burnished *maki-e* technique know as *togidashi*.

matsukawa-bishi An early design technique so named because it is similar to the pine-bark lozenge effect seen on a certain type of pine tree. This design technique was introduced in the Muromachi period but is found more commonly in Momoyama lacquers.

c. **mitsuda-e** A decorative design element using lead oxide with color pigment.

mokume A design technique simulating the natural graining of wood.

mura nashi ji The technique where by the application of the *nashi ji* simulates the appearance of floating clouds.

naka nuri Middle undercoatings, applied to a base or core utilizing black *urushi*.

nashi ji A ground named because small, irregular gold flakes are sprinkled in several layers in an orange-toned lacquer medium and then polished so as to resemble a "pear's skin."

nashi ji urushi A transparent lacquer with a yellow-orange color achieved through the addition of a tree resin powder called *gamboge*. (*see shiō*)

nihen ji nuri A mixture of medium-grade baked clay in combination with *urushi* literally, "second-ground coating."

nuri tate An oil-added unpolished final coating of black lacquer used as an undecorated surface finish on the insides and bottoms of many boxes created from the Taishō period to present.

oki hirame Large, irregular gold flakes, usually placed separately on a finished surface and then covered with a final coat of lacquer. It is sometimes confused with *gyōbu nashi ji*, the difference being that *gyōbu* particles are generally suspended in *nashi ji urushi*.

raden A mother-of-pearl inlay technique.

rankaku The technique in which a surface is decorated with tiny particles of egg shell, usually derived from the quail.

rantai The technique whereby bamboo strips are woven into shapes and coated with lacquer.

ro iro A technique using the highest quality oilless black *urushi* applied in several layers. Polishing and grinding is required after each layer, which results in a shiny black waxy ground. It is only used on the highest quality boxes.

ryōshi-bako A box for storing papers or stationery.

sabi urushi A combination of pulverized pumice, *urushi*, and water.

sage-dansu A portable cabinet.

sage-jū bentō A portable picnic set.

sanben ji nuri The third and final ground coating.

seidō nuri The dark matte green textured finish, probably innovated by Shibata Zeshin in the nineteenth century.

seisei The term applied to processed cooked lacquer.

shakudō nuri An alloy of copper and gold that, when placed in a solution or "pickle" forms a black or sometimes purple-colored skin surface. The "skin" is then scraped off and as a powder sprinkled on wet lacquer.

shibo urushi A process whereby black lacquer is combined with a stiffening agent, such as bean curd.

shiō (gamboge) An orange to brown gum tree resin that is bright yellow in powder form.

shippi Hide, usually that of a cow or wild pig, which is

softened by soaking and wrapped around a mold until dry and then lacquered.

shita ji nuri The primary underseals or undercoatings applied to the core.

shitan nuri A technique simulating the finish of rosewood.

shu Cinnabar.

shu ai urushi A compound made by adding cinnabar to plain oil *urushi*.

suke urushi Plain lacquer to which light coloring material and/or oil may be added.

suki Processed.

suri urushi A wash of thin lacquer usually added to "fix" the powder more firmly to the ground before polishing.

suzuri-bako A fitted box containing writing materials, such as a water dropper, brushes, and an inkstone.

c. **taka maki-e** Known also as "high relief," it is the technique whereby a design is built-up using two or more layers of lacquer or lacquer compounds. The final surface is usually decorated.

te-bako A box that is usually used to store cosmetics and is small enough to be lifted easily ("by a lady's hands").

tetsu sabi nuri A technique simulating a rusted iron finish; perfected by Zeshin.

c. **togidashi maki-e** The technique also known as "burnishing," wherein the design is first drawn on a ground in wet lacquer, and then metallic or pigmented powders are sprinkled over the moist composition. When the surface is completely dry, additional layers of black lacquer are added to coat this surface, thus building up infinitesimally small mounds. The design area is then carefully ground down until the original sprinkled design is revealed.

tomo-bako The original wooden box that an object is stored in when finished by the artist, and usually signed.

tonoko Pulverized pumice.

tsui koku (or shu) The Chinese-derived method of applying, then carving multilayered lacquer, either black (*koku*) or red (*shu*).

urushi ya A processing plant and store house: an importer from which lacquer stores buy their supplies: a place that sells lacquer.

uwa nuri The final top coatings applied to a core.

c. **yama maki-e** Black lacquer made from *kan shitsu* or charcoal sprinkled on a layer of *sabi urushi*.

yasuri fun Coarse metal fillings derived from rubbing a file over a piece of gold.

Selected Bibliography

"A Lacquer Box," Kokka #228. Tokyo: The Kokka Publishing Co., May 1909, pp. 359-362.

Akiyama, Terukazu. Japanese Painting. New York: Crown Publishers, Inc., 1961.

Arakawa, Hirokazu. Maki-e (Sprinkled Picture). Nihon no Bijutsu #35, Edited by the staff of the National Museums of Tokyo, Kyoto, Nara. Tokyo: Shibundō, 1969.

——. "Kōgō," Pyramid. Tokyo: Gimmi Shuppan. Nov. 1977, pp. 36-39.

——. Shitsu Kōgei (Lacquer Work). Tokyo: Hoikusha, 1982.

Baekeland, Frederick. Imperial Japan: The Art of the Meiji Era. Ithaca, New York: Herbert F. Johnson Museum of Art, 1980.

Boyer, Martha. Catalogue of Japanese Lacquers. Baltimore: The Walters Art Gallery, 1970.

——. Japanese Export Lacquers from the Seventeenth Century in the National Museum of Denmark. Copenhagen: The National Museum, 1959.

Brower, Robert, and Miner, Earl. Japanese Court Poetry. Stanford: Stanford University Press, 1961.

Bunka Chō, ed. Mukei Bunkazai Kiroku, Kōgei Gijutsu hen #4: Maki-e (Record of Intangible Cultural Properties: Technique of Craft #4: Sprinkled Pictures). Tokyo: Daiichi Hōki Shuppan, 1973.

Bushell, Raymond. The Inrō Handbook. Tokyo: Weatherhill, 1979.

Casal, U. A. Japanese Art Lacquers. Tokyo: Sophia University, 1961.

Castile, Rand. The Way of Tea. New York/Tokyo: Weatherhill, 1971.

Dower, John W. The Elements of Japanese Design. New York/Tokyo: Walker/Weatherhill, 1971.

Fujioka, Ryōichi. Tea Ceremony Utensils. Translated and adapted by Louise Allison Cort. New York/Tokyo: Weatherhill/Shibundō, 1973.

Gōke, Tadaomi. Shibata Zeshin Meihin Shū (Masterpieces by Shibata Zeshin), 2 Vols. Tokyo: Gakushū Kenkyūsha, 1981.

——. Shibata Zeshin Ten (Exhibition of Shibata Zeshin). Tokyo: Itabashi Museum, 1980.

Grille, Elsie. The Art of the Japanese Screen. New York/Tokyo: Weatherhill/Bijutsu Shuppansha, 1963.

Harich-Schneider, Eta. A History of Japanese Music. London: Oxford University Press, 1973.

Hayashiya, Seizō. Chanoyu: Japanese Tea Ceremony. Translated and adapted by Emily J. Sano. New York: Japan Society, 1979.

Herberts, Kurt. Oriental Lacquer: Art and Technique. London: Thames and Hudson, 1962.

Jahss, Melvin and Betty. Inrō and Other Miniature Forms of Japanese Lacquer Art. Rutland, Vt./Tokyo: Charles E. Tuttle Company, Inc., 1971.

Joly, Henri L. Legend in Japanese Art. Tokyo: Charles E. Tuttle Company, Inc., 1967.

Kaiyama, Kyusaburō. The Book of Japanese Design. Translation and commentary by Sylvia Price Mueller. New York: Crown Publishers, Inc., 1969.

Kawahara, Masahiko. "Ninsei," Nippon Toji Zenshu #27 (Pageant of Japanese Ceramics). Translated by Nishida Hiroko, Tokyo: Chūōkōronsha, 1976.

Kobayashi, Takeshi. Nara Buddhist Art: Tōdai-ji. Translated by Richard L. Gage, New York/Tokyo: Weatherhill/Heibonsha, 1975.

Kokin Waka Shū: Nihon Koten Bungaku Taikei (Collected Works of Japanese Classics), #559, Vol. 12, p. 214. Tokyo: Iwanami Shoten, 1958.

Krummel, Otto. "Ritsuō," Künstler Lexicon, Vol. XXVIII., p. 383, Leipzig: Theime-Becker, 1934.

Kyoto National Museum, Kōdai-ji Maki-e. Kyoto: Kyoto National Museum, 1971.

——. Tokubetsuten: Momoyama Jidai no Kōgei. (Special Exhibition: Momoyama Handcrafts of the Sixteenth and Seventeenth Centuries). Kyoto: Kyoto National Museum, 1975.

Lane, Richard. Masters of the Japanese Print. New York: Doubleday & Company Inc. 1962.

Lee, Sherman. Japanese Decorative Style. Cleveland: The Cleveland Museum of Art, 1961.

Lee, Yu-Kuan. Oriental Lacquer Art. New York/Tokyo: Weatherhill, 1972.

Link, Howard A. The Art of Shibata Zeshin. Honolulu: Honolulu Academy of Arts. Robert G. Sawers Publishing, 1979.

——. and Tōru, Shimbo. Exquisite Visions: Rimpa Paintings from Japan. Honolulu: Honolulu Academy of Arts, 1980.

Maruoka, Daiji, and Yoshikoshi, Tatsuo. Nō. Translated by Don Kenny. Osaka: Hoikusha, 1982.

Masaki, Naohiko. "Haryū Zaiku no Hanashi" (Talking about Haryū's Works). Tokyo Bijutsu Gakkō Kōyūkai Geppō, Vol. 9. Tokyo Bijutsu Gakko Kōyūkai, Apr. 1930, pp. 1-2.

Matsuda, Gonroku. Iwanami Shinsho: No 542. Urushi no Hanashi Tokyo: Iwanami Shoten, 1977.

Mene, Dr. Edward. Apercu Sommaire sur Lacquer de Japon. Paris: 1906.

Mizoguchi, Saburō. "Bijutsu Yōgo (Shikkō): Togidashi Maki-e" (Glossary of Japanese Art Terms (Lacquer): Burnished Sprinkled Picture). Museum No. 23, Feb. 1953.

——. Design Motifs. Arts of Japan I. Translated and adapted by Louise Allison Cort. New York/Tokyo: Weatherhill/Shibundō, 1973.

Mizuuchi, Kyōhei. *Cha no Shikki.* (Lacquerware for Tea). Kyoto: Tankōsha, 1981.

Moody, N. H. N. *Japanese Clocks.* London: Kegan Paul, French, Scribner & Co., 1932.

Moriya Kenrō, ed. *Nihon no Shikki* (Japanese Lacquer). Tokyo: Yomiuri Shinbunsha, 1979.

Murase, Kiyeko. *Japanese Art: Selections from the Mary and Jackson Burke Collection.* New York: The Metropolitan Museum of Art, 1975.

National Museum of Modern Art Tokyo eds. *Japanese Lacquer Art.* Translated by Richard L. Gage. New York/Tokyo: Weatherhill/Tankōsha, 1982.

———. *Nihon Shikko* (Japanese Lacquer Craft). Tokyo: Lacquer Craft Association, Mar. 1982.

Noma, Seiroku. *The Arts of Japan: Late Medieval to Modern.* Tokyo/New York: Kōdansha International, Ltd., 1966.

Nippon Kōdō, ed. *Kō-Dō.* Tokyo: Nippon Kōdō Co. Ltd., 1982.

Okada, Jō, Matsuda, Gonroku, and Arakawa, Hirokazu, eds. *Nihon no Shitsugei.* (Japanese Lacquerware) Vols. I-IV; V, VI. Tokyo: Chūōkōronsha, 1978, 1979.

———. *Tōyō Shitsugeishi no Kenkyū.* (A Study of the History of Far Eastern Lacquer Art). Tokyo: Chūōkōron Bijutsu Shuppan, 1978.

Okada, Barbra T. (in collaboration with Neill, Mary G.). *Real and Imaginary Beings.* New Haven: Yale University Art Gallery, 1980.

Papinot, E. *Historical and Geographic Dictionary of Japan.* Yokohama: Kelly and Walsh, 1910.

Pekarik, Andrew. *Japanese Lacquer 1600-1900; Selections from the Charles A. Greenfield Collection.* New York: The Metropolitan Museum of Art, 1980.

Rague, Beatrix von. *A History of Japanese Lacquer Work.* Translated by Annie R. de Wasserman. Toronto/Buffalo: University of Toronto Press, 1976.

Reim, J. J. *The Industries of Japan.* London: Hodder and Stoughton, 1899.

Rosenfield, John, McGrolenhuis, and Elizabeth Ten. *Journey of the Three Jewels.* New York: Asia Society, Inc., 1979.

Sansom, George B. *A History of Japan to 1334: 1334-1615; and 1615-1867.* Stanford: Stanford University Press, 1958, 1961, 1963.

———. *Japan: A Short Cultural History.* New York: Appleton-Century-Crofts, Inc., 1962.

Sawaguchi, Goichi. *Nihon Shikkō* (Study of Japanese Lacquer). 2nd edition. Tokyo: Bijutsu Shuppansha, 1966.

Sekai Dai Hyakka Jiten Vol. III, Tokyo: Heibonsha, 1965.

Shimizu, Yoshiaki, and Wheelwright, Carolyn. *Japanese Ink Paintings.* Princeton: The Art Museum, Princeton University, 1976.

Sōmi, Kōu. "Kankō Geijutsu to Haryū" (The Art of Inlay and Haryū). *Nihon Bijutsu Kyōkai Hōkoku* #33 (Jul. 1934), pp. 8-21; #34 (Oct. 1934) pp. 10-19; #36 (Apr. 1935) pp. 24-29; #37 (Jul. 1935), pp. 14-23. Tokyo: Nihon Bijutsu Kyōkai.

Suguwara, Nobuhiko, et al. *Kindai Nihon no Shitsugei* (Lacquer Art of Modern Japan). Tokyo: Tokyo National Museum of Modern Art, 1979.

Suzuki, Tsutomu, ed. *Shikki.* (Lacquer Works) Tokyo: Sekai Bunkasha, 1977.

Takauchi, Kyūichi. "Ogawa Haryū ō" (Ogawa Haryū as an Old Man). *Shōga Koto Zasshi,* #90 (1915), pp. 11-13; #92 (Feb. 1916), pp. 14-17: #93 (Mar. 1916), pp. 34-37, *Koto Zasshisha .Shōga*

———. "Ritsuō Seisaku no Kōkeisha" (Successor of Ritsuō's Works). *Shōga Koto Zasshi,* Shōga Koto Zasshisha #96 (Jun. 1, 1916), pp. 25-29.

Tanabe, Hisao. *Japanese Music.* Tokyo: Kokusai Bunka Shinkōkai, 1959.

Tanizaki, Jun'ichiro. *In Praise of Shadows.* Translated by Thomas S. Harper and Edward G. Seidensticker. New Haven: Leete's Island Books, 1977.

Tokyo National Museum. *Pageant of Japanese Art,* Vol. V: *Textiles and Lacquer.* Tokyo: Toto Bunka, 1954.

———. *Tokubetsuten: Tōyō no Shikkōgei.* (Special Exhibition: Far Eastern Lacquer). Tokyo: Tokyo National Museum, 1977.

———. *Tōyō no Shikkōgei* (Lacquer Art of the Far East). Tokyo: Benrido, 1978.

Tompkins, John Bass, and Campbell, Dorothy. *People, Places, and Things in Henri Joly's Legend in Japanese Art.* Alexandria, Va.: Kirin Books & Art, 1978.

Urushi Kōgei Jiten. (Dictionary of Lacquerware) Tokyo: Kōgei Shuppansha, 1978.

Volker, T. *The Animal in Far Eastern Art.* Leiden: E. J. Brill, 1975.

Warner, Langdon. *Japanese Sculpture of the Tempyō Period.* Cambridge: Harvard University Press 1964.

Weber, Victor F. *Koji Hōten.* (Dictionary of Things Old) Vol. I, II. Reprinted New York: Hacker Art Books, 1965.

Weintraub, Steven, Tsujimoto, Kanya, and Walters, Sadae. "Urushi and Conservation: The Use of Japanese Lacquer in the restoration of Japanese Art." *Ars Orientalis* XI, 1979, pp. 39-62.

Williams, C. A. S. *Outlines of Chinese Symbolism and Art Motifs.* New York: Dover Publications, Inc., 1976.

Yamane, Yūzo. *Sōtatsu to Kōrin* (Sōtatsu and Kōrin) *Nihon no Bijutsu,* Vol. 18, Tokyo: Shōgakukan, 1976.

Yamato Bunkakan. *Yamato Bunkakan Shozōhin Zuhan Mokuroku 3. Shitsugei* (Lacquer Wares from the Yamato Museum Collection: Illustrated Catalogue Series No. 3). Nara: Yamato Bunkakan, 1975.

Yonemura, Ann. *Japanese Lacquer.* Washington, D.C.: The Freer Gallery of Art, Smithsonian Institute, 1979.

Yoshida, Mitsukuni, ed. *Shikki Nyūmon* (Basic Lacquer): Tokyo/Kyoto: Tankōsha, 1981.

Index